CW00738885

DESIGN AND CREATE
CONTEMPORARY TABLEWARE

Linda Bloomfield

Sue Pryke.

HERBERT PRESS
Bloomsbury Publishing Plc
50 Bedford Square, London, WC1B 3DP, UK
29 Earlsfort Terrace, Dublin 2, Ireland

BLOOMSBURY, HERBERT PRESS and the Herbert Press logo
are trademarks of Bloomsbury Publishing Plc

First published in Great Britain in 2023
Copyright © Linda Bloomfield and Sue Pryke 2023
Images © Linda Bloomfield unless otherwise stated

Linda Bloomfield and Sue Pryke have asserted their right under the Copyright,
Designs and Patents Act, 1988, to be identified as Authors of this work

All rights reserved. No part of this publication may be reproduced or transmitted in any form or
by any means, electronic or mechanical, including photocopying, recording, or any information
storage or retrieval system, without prior permission in writing from the publishers

Bloomsbury Publishing Plc does not have any control over, or responsibility for, any third-party
websites referred to or in this book. All internet addresses given in this book were correct at the time of
going to press. The author and publisher regret any inconvenience caused if addresses have changed
or sites have ceased to exist, but can accept no responsibility for any such changes

A catalogue record for this book is available from the British Library
Library of Congress Cataloguing-in-Publication data has been applied for

ISBN: 978-1-78994-072-5; eBook 978-1-78994-073-2

1 3 5 7 9 10 8 6 4 2

Designed and typeset by Plum 5
Printed and bound in China by Toppan Leefung Printing Ltd

To find out more about our authors and books visit
www.bloomsbury.com and sign up for our newsletters

DESIGN AND CREATE
CONTEMPORARY TABLEWARE

making pottery you can use

Linda Bloomfield and Sue Pryke

HERBERT PRESS

LONDON · OXFORD · NEW YORK · NEW DELHI · SYDNEY

CONTENTS

Forming a spout on a jug. © Ben Boswell

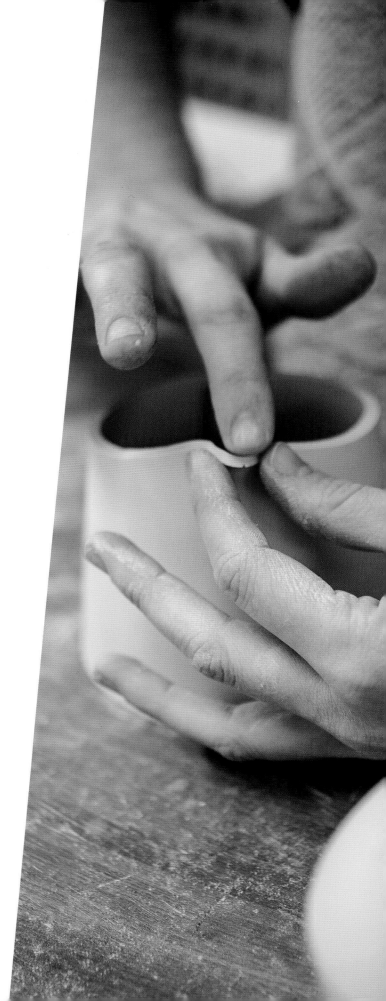

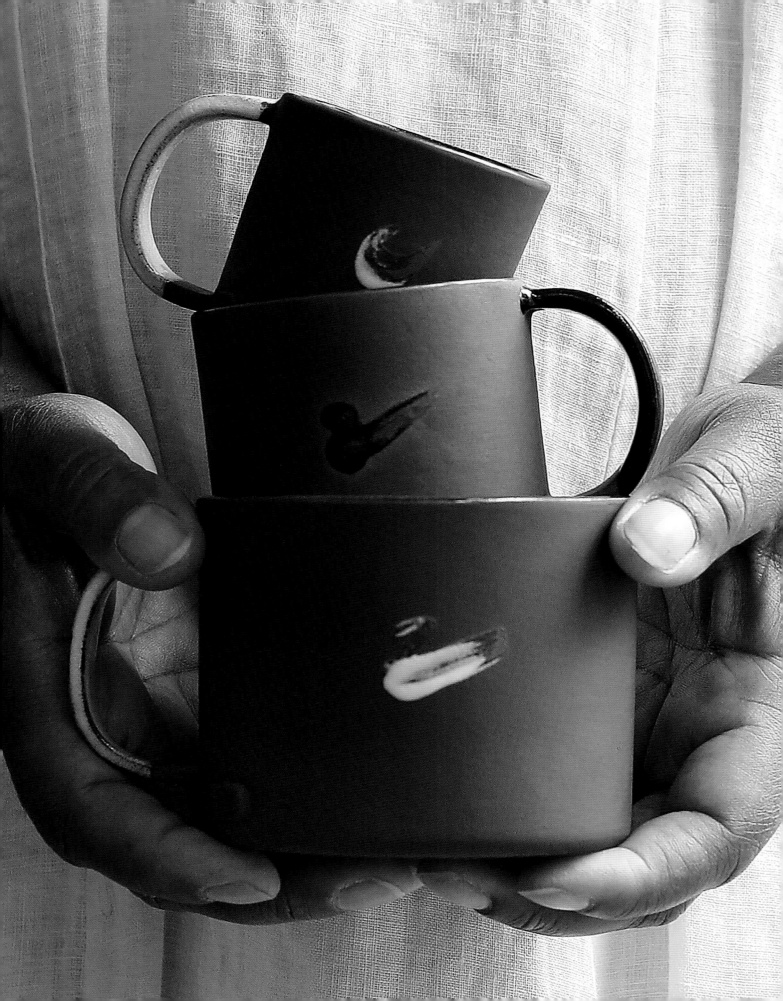

INTRODUCTION

LINDA BLOOMFIELD

The tableware we use is so important in our everyday lives. A simple mug or bowl can give us a connection with the hand of the maker or the mind of the designer and can enhance our experience. For the maker, every aspect of the design needs careful consideration, including the shape, material and glazes used. This book will cover the approaches to take to ensure your work is well designed, with a focus on contemporary tableware and modern design. We include a combination of studio pottery techniques such as throwing, and batch production methods using moulds, more commonly used in the ceramics industry. We will concentrate on the methods most suited to producing multiple pieces of tableware for the home or for restaurants rather than the slower making methods such as pinching and coiling.

In this book the emphasis is on simple shapes and an understated aesthetic. Contemporary tableware inspired by mid-century modern Scandinavian design has simple shapes with clean lines, often with minimal decoration. Stores such as Habitat and IKEA have been instrumental in bringing modern, affordable design

Opposite: Black stoneware mugs by Naked Clay Ceramics. © 2022 Carla Sealey
Right: Dark stoneware plate with white glaze for the Scandinavian restaurant Noma by Tina Marie Bentsen. © Tina Marie Cph

to everyone. IKEA was founded by Ingvar Kamprad in Sweden in the mid-twentieth century, selling well-designed and affordable furniture. The IKEA 365+ range of tableware was launched in 1995, received a Swedish design award and is still in production today. A range of functional tableware for everyday use, it includes white porcelain mugs with squared bases, bowls and plates, and was designed by Sue Pryke, at that time a recent graduate from the Royal College of Art. These were mass-produced in order to make them affordable and the use of dust pressing (clay dust particles pressed in a hydraulic mould) meant that the square plates could easily be manufactured in huge volumes at a low price. The range was made by a number of factories globally; initially made in Portugal, it was soon being manufactured in Eastern Europe and the Far East. It is thought to be the largest selling tableware range in

Top: IKEA 365+ porcelain tableware range by Sue Pryke, Anki Spets and Magnus Lundstrom, 1994–95. Used with the permission of Inter IKEA Systems B.V.

Left: Slipcast black porcelain tableware by Sue Pryke.
© Sue Pryke

Opposite: White porcelain plates and bowls by Linda Bloomfield.

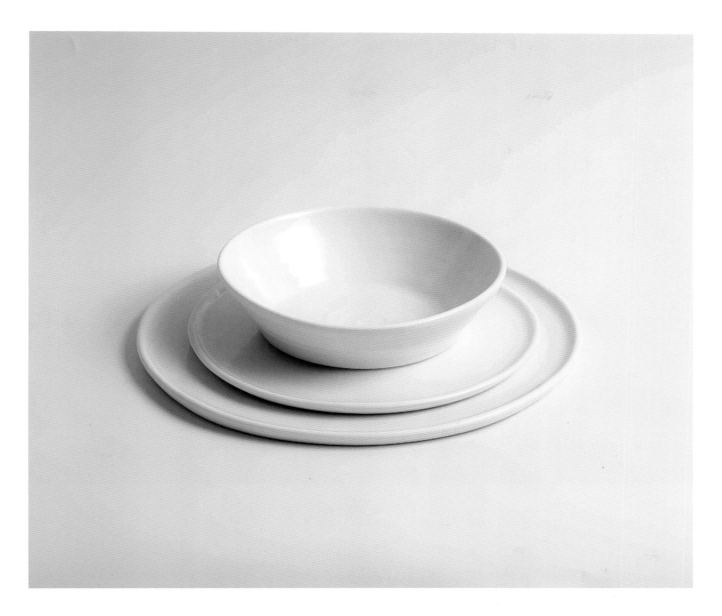

the world, benefitting from the reach of IKEA's stores and their manufacturing capability. In this book we will be focusing on smaller batch production processes, many of which are commonly used in studios, and also looking at processes in industry and how these can be adapted for studio use, or conversely how work can be developed with industrial processes.

Handmade tableware is currently enjoying a revival in high-end restaurants. Influenced by the slow food movement, restaurants are increasingly using local artisan food producers, seasonal and foraged ingredients, and having bespoke tableware made is the obvious next step. Handmade studio pottery became popular in the 1960s and 1970s with restaurants such as Cranks in London, which used tableware made by Winchcombe Pottery, and Chez Panisse in Berkeley, California, where they use locally made tableware by Heath Ceramics. The use of studio pottery in restaurants has seen a revival since the beginning of the twenty-first century.

One of the first of the new wave of chefs to use handmade plates was chef René Redzepi of Noma restaurant in Copenhagen, which opened in 2003. He uses handmade plates in the Nordic rustic style, with speckled glazes on dark stoneware clay, handmade locally by father and son potters Aage and Kasper

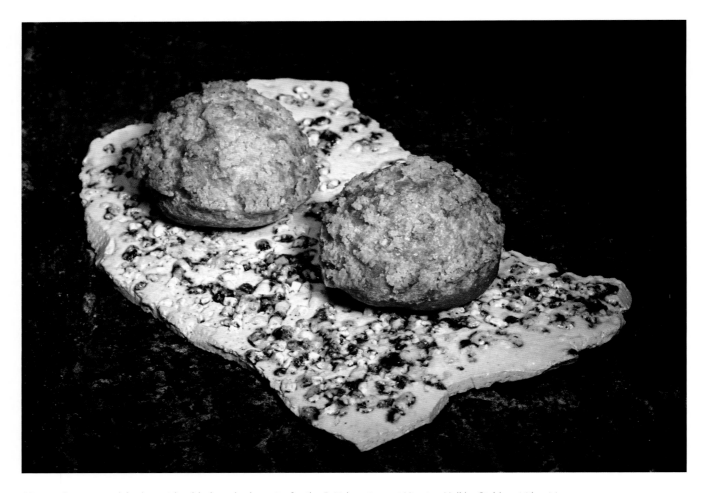

Above: Stoneware slab plate with added crushed granite for the British restaurant Hipping Hall by Siobhan Miles-Moore
© Siobhan Miles-Moore

Würtz and other Danish potters including Tina Marie Bentsen. The Nordic rustic style is similar to the Japanese wabi sabi, with simple forms and a weathered, aged look. This is achieved by layering light coloured glazes over darker clays, to allow the colours beneath to break through to the surface. In contrast with much ceramic art, tableware needs to be subdued so that the food is given centre stage.

In the UK and USA, many restaurants are following this trend by ordering bespoke plates and bowls from local potters, who are able to make in smaller batches with a faster turnaround than large manufacturers. Chefs have discovered that studio potters are able to make plates and bowls in the specific shapes and colours they want to complement a particular dish they have created.

Like regional cuisine and *terroir*, wine or food having flavour imparted by the surrounding environment, bespoke handmade tableware can also be distinctive and particular to the location. This enhances the diner's overall impression that the restaurant's ambience, food and tableware have all been created as one, with special care and attention.

Studio potters have an advantage in that they are able to make in smaller batches, can be more flexible than larger manufacturers and can design bespoke pieces using local materials for particular restaurant dishes. For these reasons, many high-end restaurants are increasingly ordering from local potters. Craft makers are in an ideal position to produce small batches of tableware for local restaurants and discerning local customers.

INSPIRATION

HOW TO DRAW INSPIRATION FROM NATURE, ART AND INTERIOR DESIGN

SUE PRYKE

When I first started working with ceramics I contacted a variety of local potters for work experience. One of the potters, although they couldn't offer me any work, provided guidance on how to draw inspiration from nature. She suggested that I take note of how a twig joins a branch, how one grows out from the other and to think about how a handle can naturally protrude from a mug as though one belongs to the other; how they should work together and look part of the same piece. I have probably sought lots of advice over the years, but this little gem sticks with me. I don't always design with this in mind, but I am aware of it. An appendage such as a handle needs to share a unity with the cup and look like it belongs to the form it is attaching itself to, so that it looks right and natural.

During formal training, such as a degree course, we are taught to research an idea, drawing inspiration from the world around us, using first-hand experience, finding a primary source to inspire us – a particular theme, a colour palette, a landscape, an interior, or a set of textures. We might think about how

the patterns formed in fields of crops may be the catalyst for a textile designer weaving yarns, or how the ripples in a pool may inspire the thrower to develop a tableware range with concentric rings.

There is also secondary research where the influences behind a collection are derived from a secondary source, i.e. work produced by others, such as another artist, designer or maker. This could be from galleries, books, tear sheets from magazines or a scrapbook or sketchbook full of inspirational images and treasures you have found.

After 30 years of working with ceramics I find that I have stored a vocabulary of themes, ideas and directions that appeal to me. It is only recently that I am able to unpick some of these and realise where the ideas come from. I can see that the soft square plates that I designed for IKEA 20 years ago were the legacy from a few pieces of mid-century modern melamine tableware from a BOAC range that I played with as a child. I think my sense of pared-back style is derived from the open landscapes where I grew up on the east coast, and maybe my years

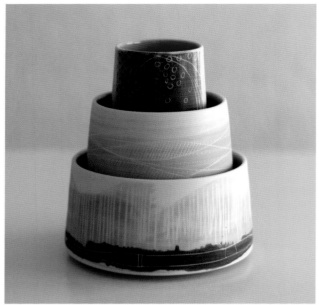

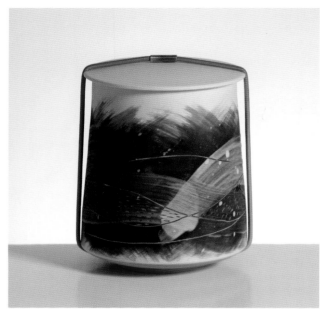

working for a Scandinavian company are also reflected in the subconscious decisions I make when designing. A lot of what we do is innate; it is our inimitable style and handwriting that makes each of us unique.

As a commercial designer working to a client brief, research will almost certainly be directed by what the competitors are doing, the market trends, customer profiles and your own creativity in developing and interpreting those market trends to produce work which represents the client's company style. It has to be a good fit and look as though the designs belong to that company and it needs to be on brand.

Many creatives carry a sketchbook and most of us snap away with a phone to record things that inspire us, whether this is a stunning sunset, landscape, the texture of tree bark or the way a twig grows out of a branch. It is clear to see that seventeenth-century silverware design inspired eighteenth-century creamware designs within ceramics and both drew on architectural patterns, embossed detailing and decorative finials.

The architect David Chipperfield's influences from Mies Van der Rohe (the "less is more" principle) can be clearly seen in Chipperfield's modern aesthetic, pared-back architectural projects, right through to the tableware he designed for Alessi.

If you look at Juliet Macleod's thrown vessels you can see that the surfaces and decoration are directly inspired by the Scottish coastline where she lives. Some potters are driven by a particular technique, such as salt firing for instance; the vessels are simply a vehicle for the technique that they love so much and the forms are designed to be robust to withstand the firing.

In summary, inspiration can be an in-depth exploration of a theme that can motivate a new range of ideas, or it can be sparked by something we've seen made by others that we can develop into a personal agenda. Each have their merits depending on what you are hoping to design and make.

Top left: Breakfast set by Juliet Macleod. Wheel-thrown and turned porcelain nesting bowl, beaker and vase. Decorated with coloured slips using tools handmade from beachcombed wool, rock, rubber, netting and metal. Unglazed polished exteriors, glazed interiors and orange foot-ring. Height 12 cm (4¾ in). Diameter 11 cm (4¼ in). © Juliet Macleod

Top right: Lidded jar by Juliet Macleod. Wheel-thrown and turned lidded jar (with hand-dyed ombre elastic and silver bead made by Gilly Langton). Decorated with coloured slips using tools handmade from beachcombed wool and metal. Unglazed, polished exterior, glazed orange interior and orange foot-ring. Height 13 cm (5 in). Diameter 10 cm (4 in). © Juliet Macleod

Opposite: Tonale tableware by David Chipperfield for Alessi. © Simon Menges

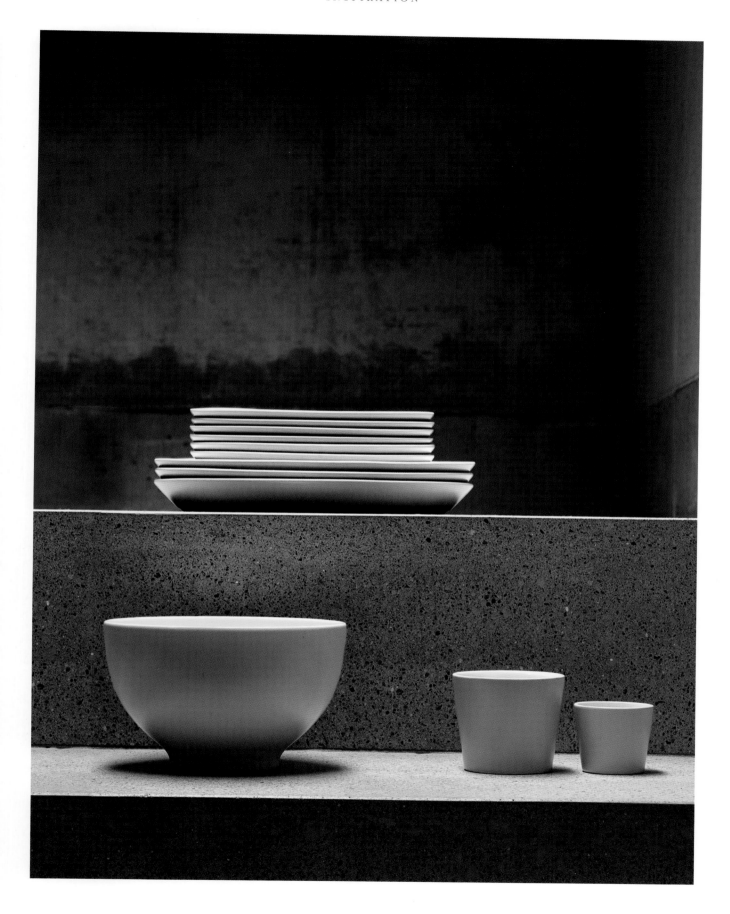

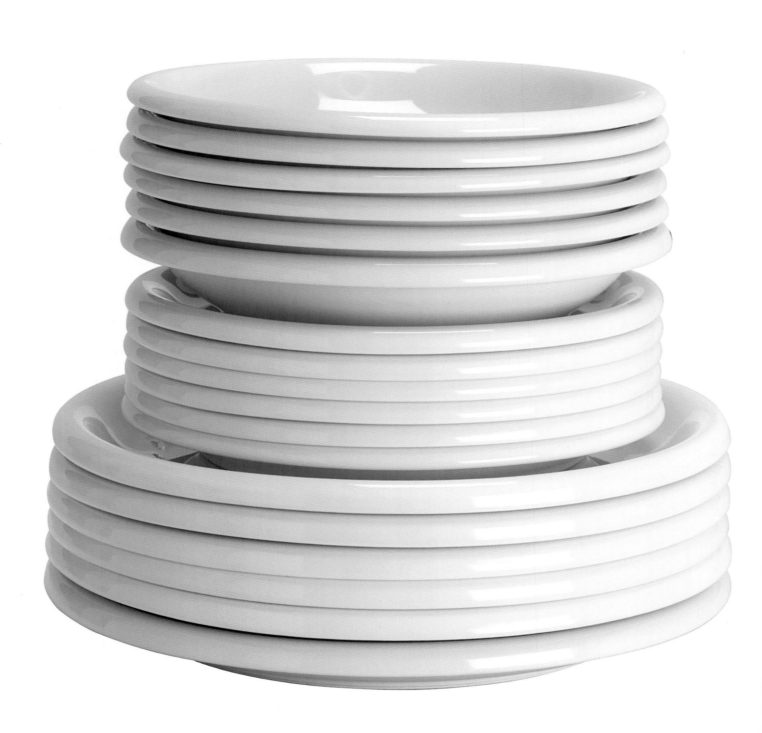

—

DESIGN

HOW TO MAKE A COHERENT TABLEWARE COLLECTION

SUE PRYKE

Behind every design there is usually a set of steps that have been thoroughly explored in order to develop a well-thought-out concept. Early research, whether primary or secondary, is the most exciting part of a design journey, exploring potential design routes which could lead in multiple directions. Paring ideas back to focus on a satisfying solution for a new idea are the rudiments to this practice.

One of my favourite design ranges is a collection from IKEA, designed in the 1960s, called RONDO. The rounded, rolled edges make the range easy to pick up and hold. Each plate fits neatly over the top of a bowl and provides a useful and stable lid either for keeping food warm or for storing leftovers and each piece stacks very neatly inside each other. Details such as this need to be planned from the outset. The design was engineered with the concept of usability at the forefront. This theme would have been planned at the beginning to ensure that the range was cohesive, that each element had the same rim detail and the bowls and also the plates had the same curve. By doing so it creates a family of pieces that belong together.

Tableware design has developed over recent years from a very standard range of shapes with set sizes. There were lists that you could refer to for the size of a plate or a coffee cup, giving measurements and standard capacities for the vessels. Nowadays the design world is far less formal.

The work from Odd Standard in Norway is testament to this. They develop innovative tableware for restaurants who in turn are becoming more progressive and looking for ingenuity. The tableware landscape is looking very exciting and adventurous.

Odd Standard are a Norwegian duo whose backgrounds are solidly based in the ceramic industry but they also have plenty of experience handling clay. Their innovations can be attributed to their explorations with clay in the studio and fondness for rule-breaking; 'breaking rules should always be based on knowledge... we know when rules can be broken, and which ones are better left unbroken.'

Opposite: IKEA RONDO tableware range by Carl-Gustaf Jahnsson. Used with the permission of Inter IKEA Systems B.V.

The Tvigg range they developed for Kontrast restaurant in Oslo does not conform to regular styles of hospitality ware. It is Odd Standard at their best; creativity, risk-taking and the cutting-edge nature of these pieces make them extraordinary.

In a similarly creative fashion, the plate designed for the Rest restaurant in Oslo is made by jiggering the plate, but the twig-like features are actual chicken feet that have been dried in a dehydrator, painted with a food-safe coating, and inserted into two holes in the base.

The general direction is usually identified in the design brief or the outline at the beginning of a project. This can be visual, following a trend or a theme, based on functionality or can be led by price.

There are usually a few key pieces in a tableware collection that set the style of the range. Identifying those lead pieces will define the range, and the earlier these can be defined the easier it is for all the other shapes to drop into place.

Not everything has to be finalised at the outset; there is plenty of time to allow a range to develop and be modified as the range progresses and ideas mature, but key traits are set in place early on.

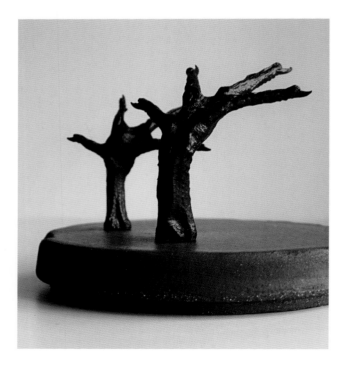

To develop a coherent range of tableware the traits need to work well as a group. It can be colour, texture or shape that holds them all together and they can be intrinsically different, but when they come together they still sit as a family. Having similar shapes makes it easy, each shape following the same format.

At the same time too much similarity can be predictable and monotonous. Adding a few twists mixes up the uniformity and adds another interesting dimension to the range. It does not have to be all the same to have a cohesive look and feel.

It helps to keep a harmony in the details of the collection to keep certain principles the same; the thickness and weight, the colour, the radius of the shapes, or the handles so that each piece can relate to the whole.

Tableware development for The Stratford hotel in East London was an interesting mix of styles from a couple of potters and many other designers and makers, including myself and Owen Wall. The range was designed for use in the hotel's Allegra restaurant, The Brasserie and for the hotel rooms. Alex Kristal was the creative lead and stylist for the project, commissioned to coordinate everything from furniture to tableware. It was a huge task to ensure that the individual styles sit well together and bring diversity and excitement to the tabletop without distracting from the chef's food. I designed new shapes to sit with my existing range and produced some pieces in collaboration with a bone china factory while making other pieces in varying colours in the studio. A mix of materials is a good way to make a collection sing; the bright white china with its lightness and translucency works well with the heavier, coloured porcelain pieces.

Left: Plate with chicken feet for the restaurant Rest in Oslo by Odd Standard. © Odd Standard

Opposite top left: Twig tableware concept for the restaurant Kontrast in Oslo by Odd Standard. © Elisabeth Heier

Opposite top right: Hand-built black clay twig for the restaurant Kontrast in Oslo by Odd Standard. Height 4.5 cm (1¾ in). Length 36 cm (14¼ in). © Elisabeth Heier

Opposite bottom: Hand building twigs in the Odd Standard studio. © Odd Standard

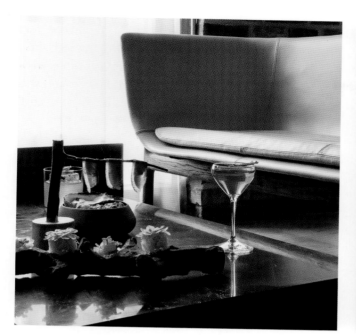
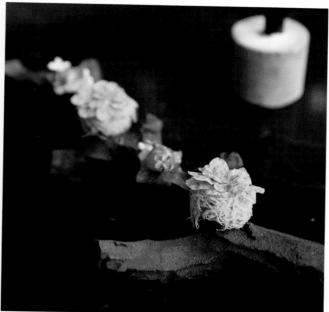
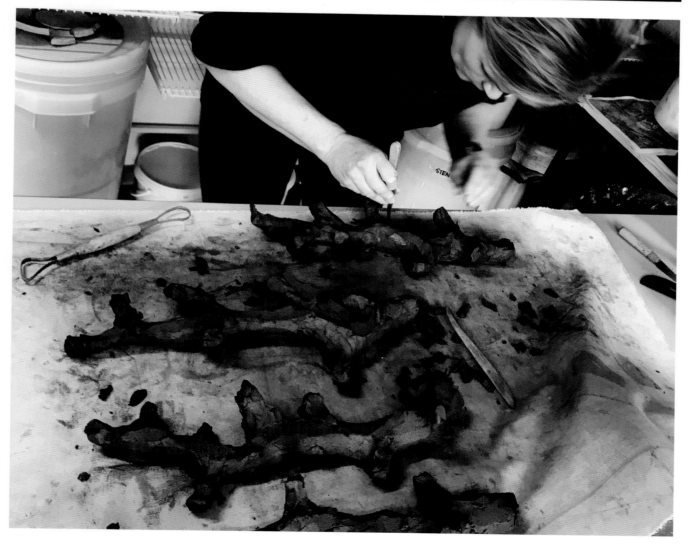

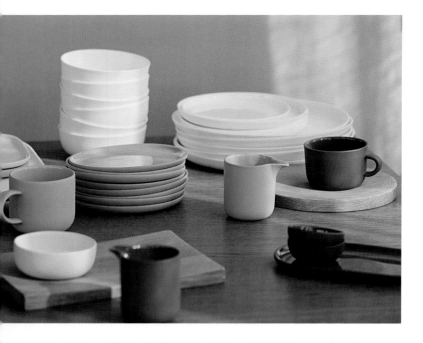

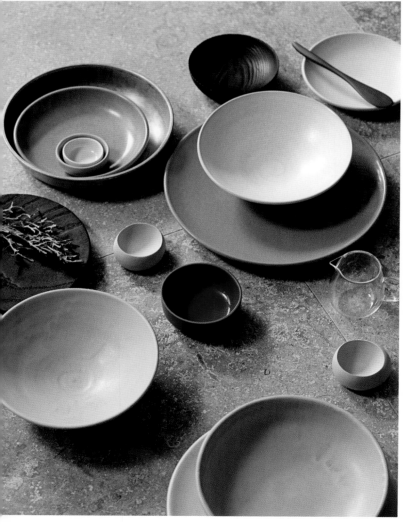

In the Allegra restaurant most of the tableware was designed by Owen Wall which provides a muted frame to the chef's food. The table is dressed with one of my side plates and a ceramic butter knife which I was commissioned to make; a considered piece of theatre when guests arrive at the table.

Collaborating with other designers to create a collection can add a variety of dynamics to a project. The development of the IKEA 365+ collection brought together very different styles from three sources – myself and two Swedish creatives: textile designer Anki Spets and industrial designer Magnus Lundstrom.

The brief was to create a tableware collection that was for everyday use, plus extra occasions. We designed satellite pieces that were slightly more grand for bringing out on those special occasions. As a team we worked to design a variety of shapes that did not necessarily follow the same pattern but would offer vibrancy to the range and would be pulled together by the same colours and materials.

In looking for a less formal shape we developed a square plate, partly sparked by the square melamine set I had as a child, but also in response to recent advances in technology. Dust pressing in volume manufacture meant that any shapes could be formed using clay dust particles pressed in a hydraulic mould, so there was no need to design round shapes for roller pressing.

The square was also mimicked in the foot of the mug as we were looking for a small detail, a twist that could transform an everyday mug shape into something more interesting. Sometimes it is those twists that can elevate an idea and bring a collection together.

Top: Tableware for the restaurant and hotel The Stratford in London, in coloured porcelain and bone china. Designed by Sue Pryke, styled by Alex Kristal and photographed by Kristy Noble. © Sue Pryke

Bottom: Tableware including butter knife for Allegra made by Sue Pryke and Owen Wall, styled by Alex Kristal and photographed by Kristy Noble. © Sue Pryke

Opposite: IKEA 365+ porcelain tableware range by Sue Pryke, Anki Spets and Magnus Lundstrom, 1994–95. Used with the permission of Inter IKEA Systems B.V.

LINDA BLOOMFIELD

Design is a compromise between several different constraints. The ergonomics and ease of use; the aesthetics and visual look; and the technology – the techniques available to use in the making process.

The function of a piece of tableware is its most important quality. A jug should pour without dribbling; its handle should be sturdy and large enough to give the user confidence, and fit the hand or at least a few fingers. The jug should also look beautiful and have the right weight and proportions for its size and material. For example, a bone china jug should feel light but a sturdy stoneware jug is expected to feel heavier. The making method will influence the design, whether it is thrown on the wheel or slipcast in a mould.

When designing tableware, it is important to consider several different elements such as form, surface pattern and colour.

ELEMENTS OF DESIGN

Shape and form. After function, this is the most important part of the design. The form can be cylindrical or spherical, or can be assembled from more angular components.

Line. It is useful to look at the silhouette of, for example, a jug to check the curve of the line from the lip along the rim to the handle. It is important to have a good visual balance between the handle and the lip.

Texture. Decide whether you want a glossy surface, a smooth, satin matt or rough matt surface. You might want a contrast between a glossy glaze and an unglazed foot.

Mark making. There are many ways to mark your pots, either with throwing rings made during the making process, marks incised into the clay when leather hard, or decoration applied using slips, underglazes and glazes. Finger wipes through slips or glazes can give movement and rhythm.

Colour. The choice of glaze colour can change the aesthetic of the tableware. We often associate bright colours with pottery we use when eating outdoors in the summer. This may be because warm countries have a long tradition of painting earthenware pots in bright colours. In contrast, more northern countries in Scandinavia, Korea and Japan have traditionally used more subdued colour palettes. In Japan, different tableware is used for each season – cherry blossoms might feature as decoration on spring tableware and maple leaves in autumn.

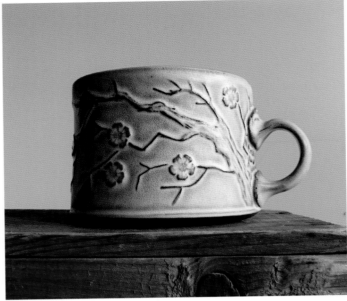

Top Left: Black bone china plate with brushed white slip by Reiko Kaneko. © Reiko Kaneko

Top right: Hand-built textured stoneware cherry blossom mug by Sarah Pike. © Sarah Pike

Bottom: Reiko Kaneko's inspiration came from a dahlia flower in her garden. © Reiko Kaneko

Opposite: Stoneware jugs and mugs with textural hakeme brushwork, fired in reduction by Lexie Macleod. © Dylan Vaughan

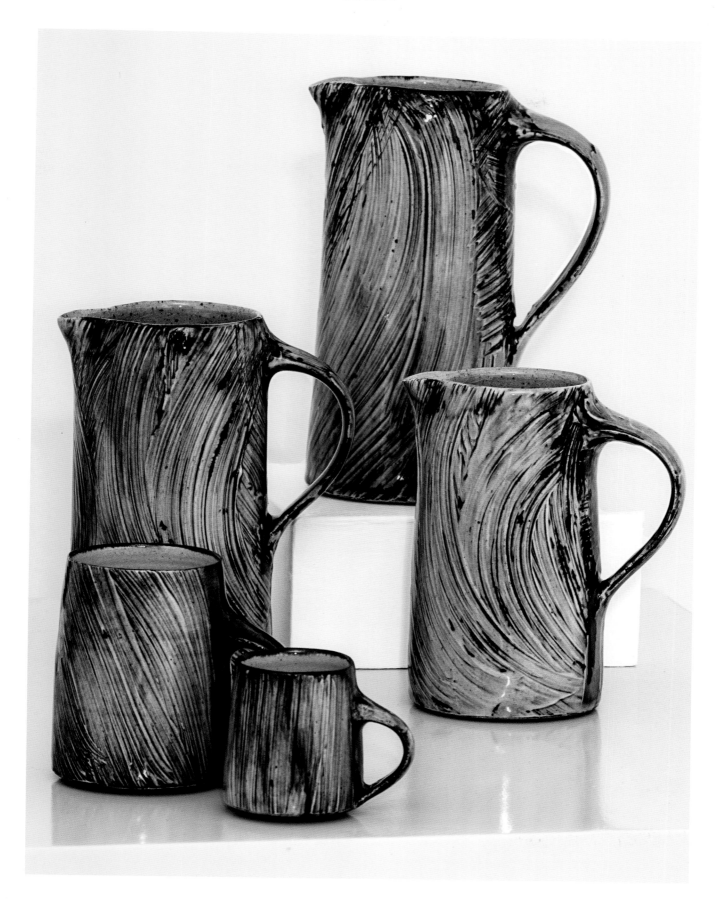

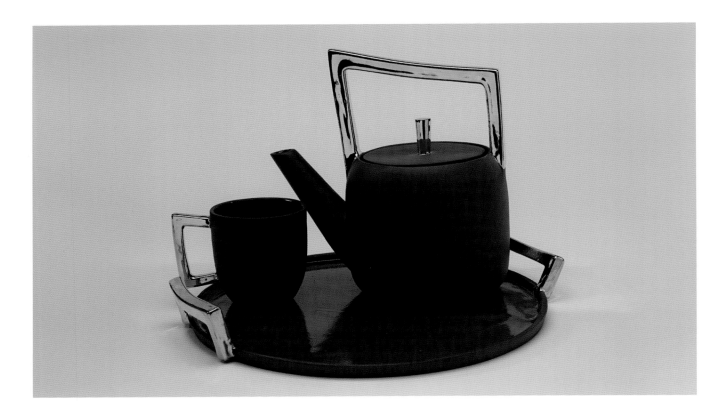

When deciding proportions, the golden ratio can be helpful, a ratio of approximately 1:1.6 found widely in nature and useful for determining proportions. For example, the height of a mug would be 1.6 times the width to achieve pleasing proportions (see image on page 86). As well as the silhouette of the piece, it is useful to think about the volume it will hold, particularly important when designing tea or coffee cups and teapots. Think carefully about the placement of handles and spouts in relation to the body of the pot, to achieve both pleasing proportions and functionality. Handles are often placed centrally, one third down from the rim and one third up from the base, but can also be placed lower or higher to good effect. The same elements of design can be applied across a set of tableware to give unity of form and decoration. For example, the form and handle design could be the same for a mug, a jug and a teapot, unifying them as a tea set.

Visual balance is important. Think about whether you want your pot to be symmetric or asymmetric. The ancient Greeks preferred symmetrical forms, while the Japanese prefer asymmetrical and 'imperfect' pots with forms and decoration inspired by nature.

Asymmetry can be dynamic, giving movement and life to a pot. Think about whether you want the design to be complex or simple; simplicity can be surprisingly difficult to achieve well. Details are important, such as the profile of the rim and the edge of the base. Do you want it to be a smooth curve or an angular transition from wall to base?

The making process often influences the design decisions. Certain shapes, such as tapered cylinders can be thrown easily on the potter's wheel, while other shapes such as oval dishes can be made more easily in a mould. Economy in the making process is a good idea if you are making large batches. Try to reduce the number of steps so that you can produce tableware at a reasonable price, otherwise the owner may decide it is too precious to use. For example, mugs do not need foot-rings, which will collect water in the dishwasher unless you cut notches to let the water drain out. However, foot-rings are useful on bowls to elevate the rounded form above the surface it rests on. Handleless Japanese beakers or yunomi also benefit from the addition of a foot-ring to hold when the tea is hot.

 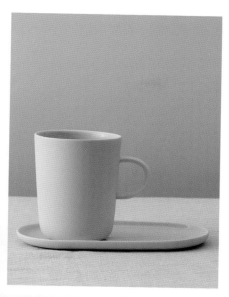 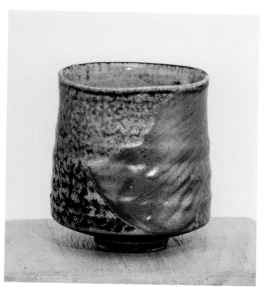

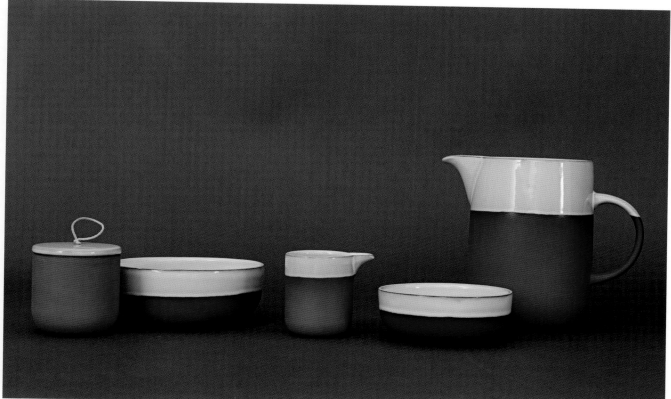

Opposite: Slipcast coloured slip teapot, mug and tray by Holly Burton. © Holly Mai Burton

Top left: Stoneware vase with indigo slip and matt white glaze by Yo Thom. Height 10 cm (4 in). Diameter 5 cm (2 in). © Yo Thom

Top centre: Slipcast cup with oval saucer in coloured porcelain by Sue Pryke. © Sue Pryke

Top right: Thrown stoneware whisky dram with foot-ring, salt and wood fired, wood ash glaze on the inside by Lexie Macleod. © Dylan Vaughan

Bottom: Slipcast terracotta breakfast set by Sue Pryke. Each piece has a tactile, rounded base and is glazed in white on the inside and in a band at the rim. © Sue Pryke

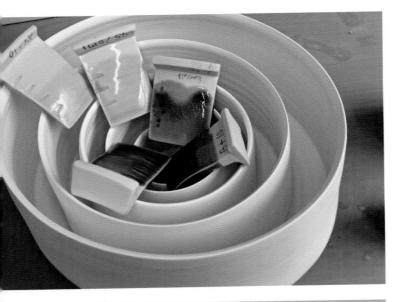

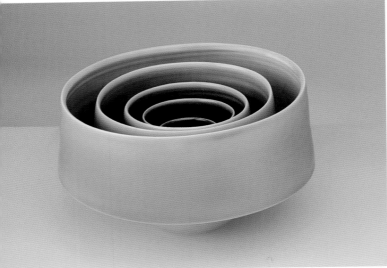

When choosing a colour palette, it is a good idea to look for inspiration in nature, art, interior design and textiles. Think about whether the colours are complementary or harmonious, pastel or saturated.

It is important that your palette of colours works together aesthetically. It is better to limit your palette of glazes to a few colours, rather than using a huge range in all the colours of the rainbow. When choosing colours, it can be useful to look at a colour wheel. Complementary colours such as orange and blue are opposite each other on the colour wheel and can produce clashing vibrations. Some potters paint a thin line of a complementary colour at the rim or foot of a pot to bring out the main body colour. Analagous colours are those next to each other on the colour wheel, such as green and blue. In combination, they are harmonious to the eye and can work well together with a third, neutral colour such as grey.

Research on gastrophysics by Professor Charles Spence of Oxford University has shown that flavour perception can be influenced by the colour, texture, weight and

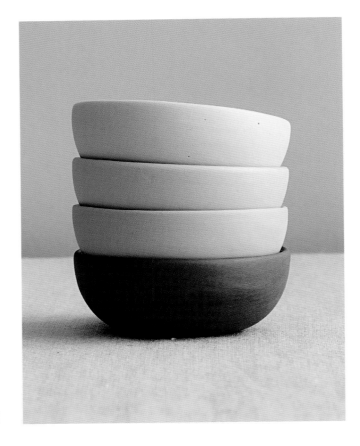

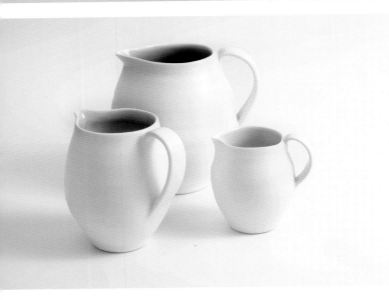

shape of the tableware. A set of plates to enhance flavour was designed by Reiko Kaneko for home appliance manufacturer NEFF.

As Professor Spence observes: "Our brain plays tricks on us about what our taste buds are tasting. There have been experiments showing that eating popcorn from a blue bowl tastes saltier than from a white bowl. Similarly, when it comes to shape, an asymmetric, angular plate can bring out the sourness and acidity of food much more than a round plate does. Working with NEFF to apply some of these principles to plateware design has

been a really interesting challenge and opportunity to see the gastrophysics insights used as inspiration for plateware design creation".

Reiko Kaneko, the ceramicist behind the creation of this set of plates, explains: "Ever since I've discovered Charles Spence's work, I've been fascinated with the different dimensions that impact taste. Playing with colour, shape and texture with the goal of ultimately influencing how diners will taste food has opened up a lot of creative avenues which are reflected in my designs."

Opposite top: Nesting bowls with glaze tile chips by Louisa Taylor. Inspired by museum collections of eighteenth-century dining wares, this piece reflects the traditional oval shape of serving tureens. Each bowl within the nest is paired with a contrasting glaze to create a sequence of gradient colour. © Louisa Taylor

Opposite centre: 'Zing!' nesting set by Louisa Taylor, 2016. Thrown and assembled porcelain, glaze, 1280°C (2336°F). Height 14 cm (5½ in). Diameter 17 cm (6¾ in). Width 21 cm (8¼ in). © Matthew Booth

Opposite bottom left: Three jugs with turquoise, pale blue and grey on the inside and a satin matt glaze on the outside by Linda Bloomfield.

Opposite right: Slipcast bowls in coloured porcelain by Sue Pryke.© Sue Pryke

Left: Inspired by the energy of the sea waves, this fine bone china plate by Reiko Kaneko is designed to intensify the taste of seafood or fish-based starters. Reminiscent of the sea world through the white and blue glazing and bearing a rough, fish-scale like texture, this plate heightens the perception of saltiness through its angular shape. © Golin

Centre: This angular, black stoneware bowl by Reiko Kaneko enhances the sensation of spiciness. The rough, sandpaper texture of the bowl heightens the taste of ginger, making it ideal for serving dishes like Thai green curries. © Reiko Kaneko

Right: Inspired by the shape of a raspberry, this dessert bowl by Reiko Kaneko is designed to bring out the fruity flavour of desserts. The pink colour boosts the perception of sweetness, whilst the outer, rounded, raspberry-like texture triggers associations with the fruit. © Golin

MUGS, CUPS, BEAKERS, EGG CUPS

Mugs can be cylindrical, conical (either tapered or flared towards the rim) or a more rounded, bellied shape. The rim is very important; it should be fine, smooth and feel good to drink from. A slightly turned out rim is easier to drink from than one that is turned in. The rim can be bevelled to make it thinner at the outer edge of the wall but not so thin that it will chip easily; the rim needs to be rounded, with a radius on the edge, rather than too angular and sharp. Modern mugs need to be big enough to hold a cup of tea or coffee and often have boiling water poured in straight from the kettle so new clay/glaze combinations should be tested for thermal shock; a mismatch in thermal expansion between the glaze and clay body can cause cracking.

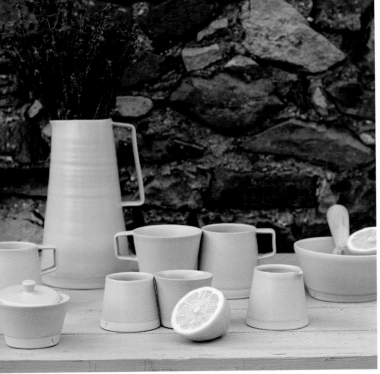

Top: Thrown porcelain cup by Alexandra Nilasdotter. The translucent properties of porcelain can be seen here with a thin potting and high temperature firing, giving extra appeal to this contemporary teacup form. © Ruben Schildt

Bottom: These lemon yellow mugs and jugs from the Arran Street East collection have angular handles placed high on the pot. The flared and tapered mugs fit cleverly side by side. Photograph by Alex Calder. © Arran Street East

1: Mug by Sue Pryke, slipcast in coloured porcelain. The rounded base is smooth, unglazed porcelain. The ergonomic shape is a considered piece of design with tactile smooth matt surface and uninterrupted curvaceous shape. © Sue Pryke

2: Tulip teacup in charcoal grey porcelain by Sue Pryke. It is drawing inspiration from eighteenth century English creamware with paredback detailing on the handle which is a nod to the decorative detailing of ware from the 1770s. The robust rounded form and curved functional handle is particularly comforting to hold. The handle has a relatively large surface area for better attachment to the mug. © Sue Pryke

3: Thrown porcelain mug by Susan Frost with relief detail, a flared conical form and fine lip. Height 7.5 cm (3 in). Diameter 9 cm (3½ in). Photograph by Michael Haines. © Susan Frost

4: This cylindrical mug by Pottery West has a pleasingly-placed low handle and a section of unglazed clay near the base. Stoneware, fired to cone 10 in an electric kiln. © Pottery West

5: Porcelain cups by Linda Bloomfield. The cup with the out-turned rim is easier to drink from.

6: Thrown porcelain cup and saucer by Linda Bloomfield.

7: 'Olive' embossed mugs slipcast in bone china by Repeat Repeat. Relief detail is possible with slipcasting and needs to be shallow enough so that the pattern won't hinder the cast piece being released and dropping out of the mould. © Repeat Repeat

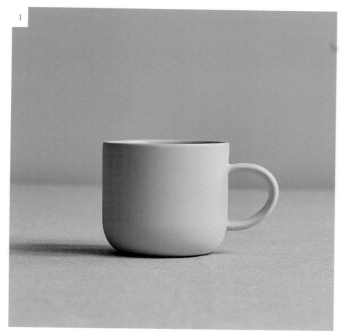

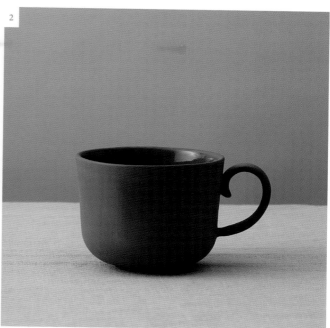

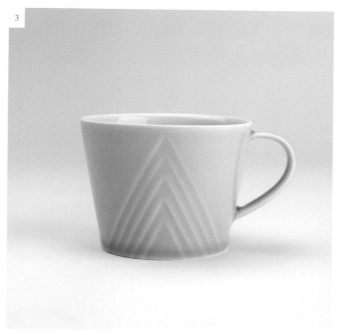

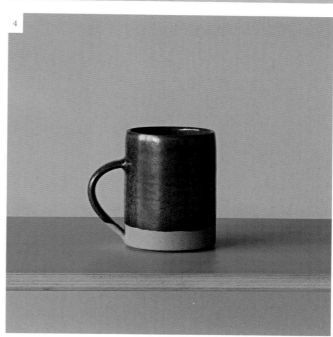

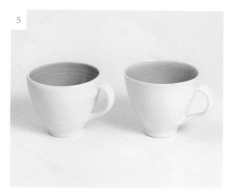

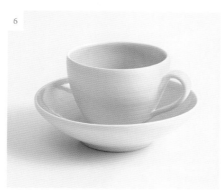

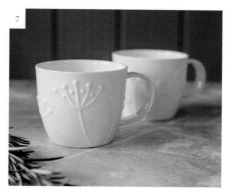

The handle should be comfortable to hold and big enough to fit several fingers through. The handle can be placed centrally or lower down the side of the mug. It is not just visually important but practical too, as a handle too high can pull the shape out and too low can potentially drip glaze on the kiln shelf.

Beakers to drink from are often made in the form of a flared cone but can be any shape. Reiko Kaneko has designed a beaker inspired by bamboo stems, with the node in the stem used as a feature placed halfway up the beaker to stop it slipping when gripped. Egg cups can be in the form of a beaker, or a taller, waisted cylinder or a goblet with a foot and stem. The diameter at the rim should be 4.5 cm (1¾ in) to hold a hen's egg.

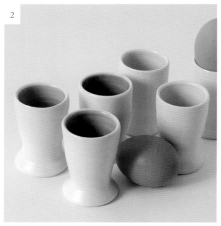

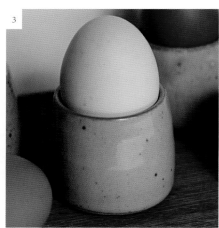

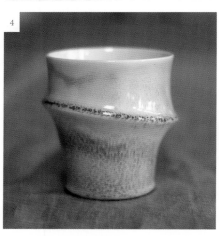

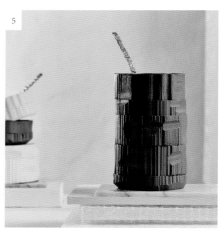

1: Thrown porcelain beaker with a flared conical form by Susan Frost. Height 8 cm (3¼ in). Diameter 8.5 cm (3½ in). Photograph by Michael Haines. © Susan Frost

2: These stoneware egg cups by Ali Herbert have a pleasingly convex cylindrical form. © Julian Herbert Images

3: Porcelain egg cup in the form of a waisted cylinder by Linda Bloomfield.

4: Slipcast bone china cup inspired by bamboo by Reiko Kaneko. © Reiko Kaneko

5: This slipcast beaker by Natascha Madeiski references the rough surface textures of mountainous landscapes. © Natascha Madeiski

6: Egg saucer in earthenware slipcast by Yoyo Ceramics. © Helen Johannessen

7: Egg cups in slipcast coloured porcelain by Sue Pryke. © Sue Pryke

Above left: Turned beakers, coloured clay with grog by Elliott Denny. © Elliott Denny

Above right: Coloured porcelain cups by Feinedinge. The detailed ribbing on the outside of these cups shows how impactful complex shapes can be in multiples. Such detail lends itself to slipcasting. © Feinedinge

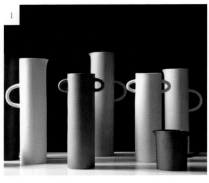

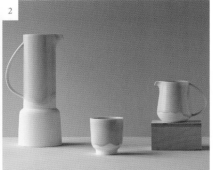

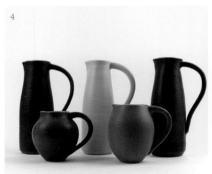

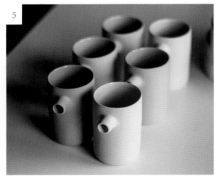

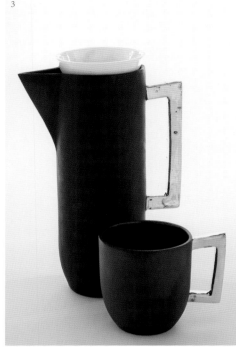

JUGS

Jugs can be cylindrical, conical, bellied or baluster shaped. They need a sturdy handle and should be light enough that they can be lifted with one hand when full of liquid. The handle on large jugs should be large enough to fit the whole hand through. Smaller jug handles should be big enough to fit a few fingers. The lip or spout should be sharp enough at the edge to cut off the flow of liquid to avoid dripping, but not so sharp that it chips easily.

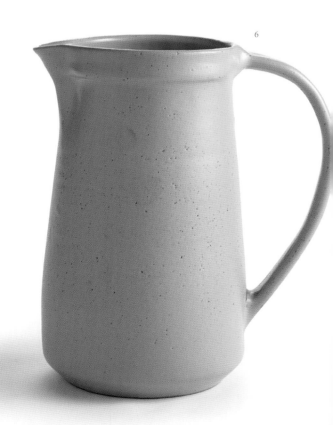

1: Jugs and vases by Georgie Scully made from slipcast cylinders. © Georgie Scully

2: Slipcast pitcher, jug and cup by Laura Plant. © Laura Plant

3: Slipcast coffee pot and mug by Holly Burton. Holly uses a coloured porcelain body to slipcast her vessels and uses gold lustre on the handles to elevate the forms. © Holly Mai Burton

4: Thrown earthenware jugs with coloured matt glazes by Lucy Burley. © Lucy Burley

5: Slipcast coloured porcelain jugs by Kira Ni. The addition of a spout gives the form a contemporary style matched by the array of bright colours. © Kira Ni

6: Stoneware thrown jug by Owen Wall. The handle is generous enough to balance with the shape and size of the main body, the extra rim detail around the top gives the handle extra support and makes it look like it's flowing from the form © Matthew Booth

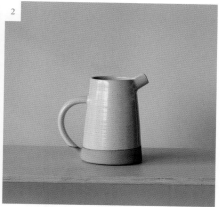

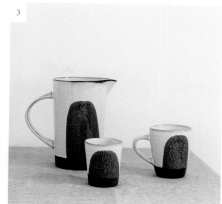

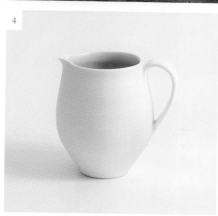

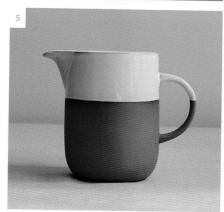

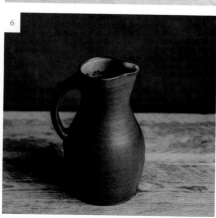

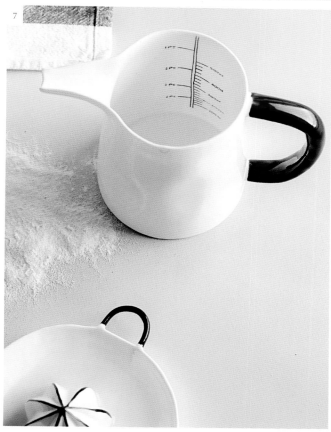

1: Slipcast bone china cream jug with debossed pattern by Repeat Repeat. © Repeat Repeat

2: Stoneware jug by Pottery West with a tapered conical form, the lower portion left unglazed. The spout is thrown separately. Height 17 cm (6¾ in). Diameter 13 cm (5 in). Capacity 1060 ml. © Pottery West

3: Earthenware cups and jug with cylindrical form by Silvia K Ceramics, decorated with coloured slip. © Silvia K Ceramics

4: Wide-bellied thrown porcelain jug by Linda Bloomfield. © Henry Bloomfield

5: Slipcast cylindrical terracotta water jug by Sue Pryke. The lip has been carefully modelled so that it pours well. The base is smooth and rounded at the edge where it meets the table.. © Sue Pryke

6: Reduction-fired stoneware jug by Ali Herbert. This is a modern version of a baluster jug, with the handle applied at the neck, using the negative space to fit the hand. © Matt Austin

7: Measuring jug by Feldspar Studio, slipcast bone china and hand-painted cobalt details. © Feld-spar Studio

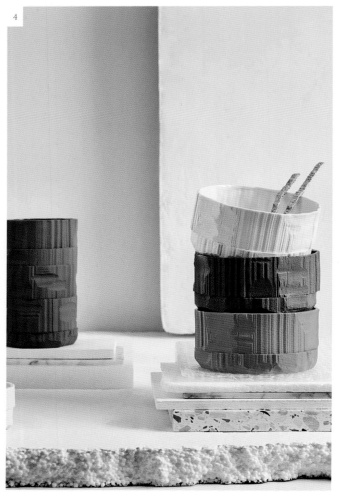
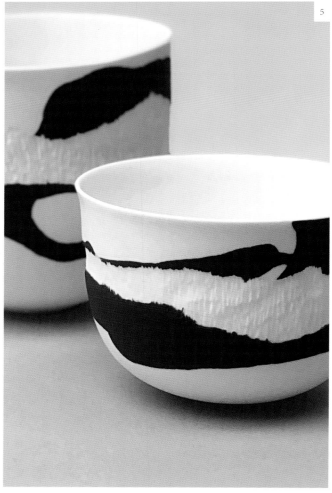

BOWLS, POURING BOWLS, SAUCERS, BREAKFAST SETS

Bowls can be conical or V shaped, they can be cylindrical or U shaped, a combination of these two shapes or any number of variations in between. Bowls can also be fluted or flower petal shaped. Think about how the bowls will stack so that they don't take up too much cupboard space. Bowls are often made with a foot-ring, which enables the rounded form to sit on a flat surface. Oriental ramen noodle bowls sometimes have a wide rim on which a lid or smaller upturned bowl can be placed. Pouring bowls have a pouring lip added, for use when making cakes or pancake batter. Saucers are shallow bowls with a well in the centre where the foot-ring of the cup rests to prevent it sliding around.

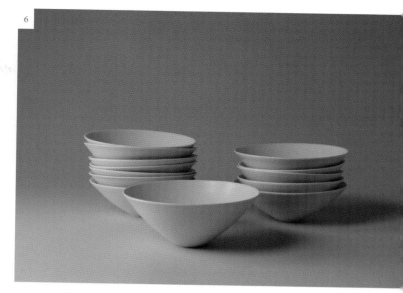

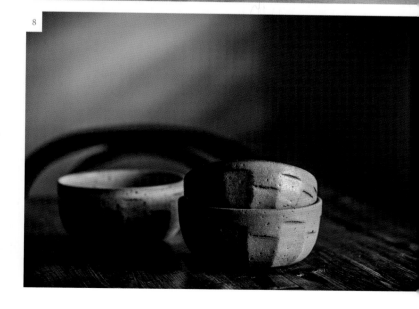

1: Parabolic curve bowl, stoneware with a chun glaze by Ali Herbert. The rim is flared outwards, making this shape less likely to warp during firing. © Matt Austin

2: Ramen noodle bowl with lid in the form of a smaller bowl by Tom Knowles Jackson. The wide, unglazed stoneware rim prevents the lid from slipping. Photograph courtesy of Article Studios, © Tom Knowles Jackson

3: Classic shallow bowl, nuka glaze, wood fired by Rebecca Proctor. © Rebecca Proctor

4: Coloured slipcast bowls by Natascha Madeiski. © Natascha Madeiski

5: Slipcast bowls by Saskia Rigby. Coast vessels, with eroded surface technique. © Saskia Rigby

6: Porcelain bowls with a soft V shape by Lilith Rockett. © Lilith Rockett

7: Rebecca Proctor's stoneware pasta bowls are shallow and can be stacked easily. © Rebecca Proctor

8: Carved stoneware 'Quarry' bowls by Sophie Moran. When stacked they take up more space in the cupboard as they are relatively deep bowls. © Sophie Moran

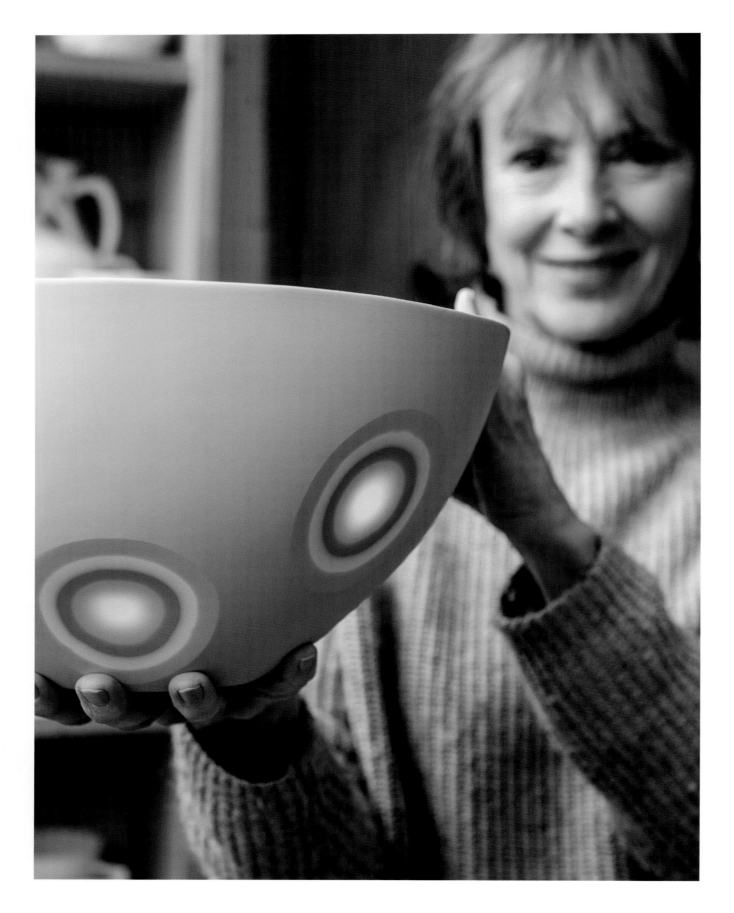

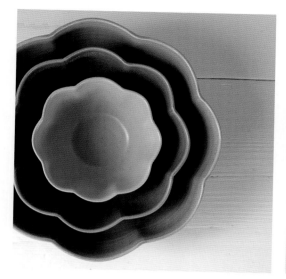

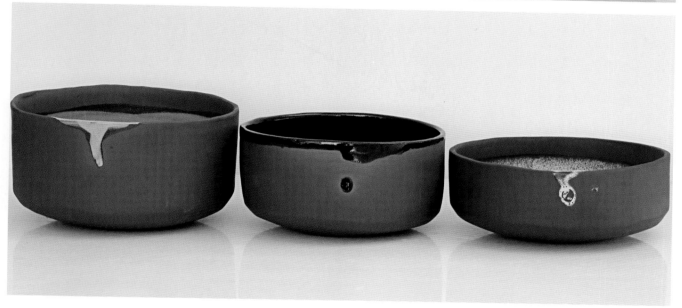

Opposite: Slipcast porcelain bowls by Sasha Wardell. Sasha uses layers of coloured slip to create her work, and carefully pares back areas to reveal the underlying layers. © Sasha Wardell

Top left: Fluted stoneware bowls, thrown and altered by hand by Makiko Hastings. © Makiko Hastings

Top right: U-shaped porcelain bowls, thrown and turned by Jaejun Lee. © Jaejun Lee

Centre: Slipcast black stoneware bowls with a flattened U shape by Carla Sealey. © 2022 Carla Sealey

Bottom right: Slipcast coloured porcelain tableware by Feinedinge. © Feinedinge

PLATES, SERVING DISHES, DINNER SETS, RESTAURANT TABLEWARE

Flat or coupe plates are easier to make than plates with wide rims; horizontal rims tend to slump in the firing so they are usually made to slope upwards slightly. Flat plates should have a high enough rim that any sauce or gravy does not spill when the plate is carried. An advantage of flat plates is that they have a wider surface area for food and can be used to display cakes. One method of making plates into cake stands is by adding a high foot-ring, which can be attached after firing to prevent the plate slumping, using an epoxy resin or tile adhesive. An example can be seen in the section on turning plates, (see page 103).

There are several sizes of plate; a small bread plate has a diameter of 15 cm (6 in), a larger salad or dessert plate is 20 cm (8 in), and a dinner plate is 25 cm (9¾ in). Plates made from slabs or by slipcasting can also be made rectangular or oval. Large serving dishes can also be made using slabs or in a press mould.

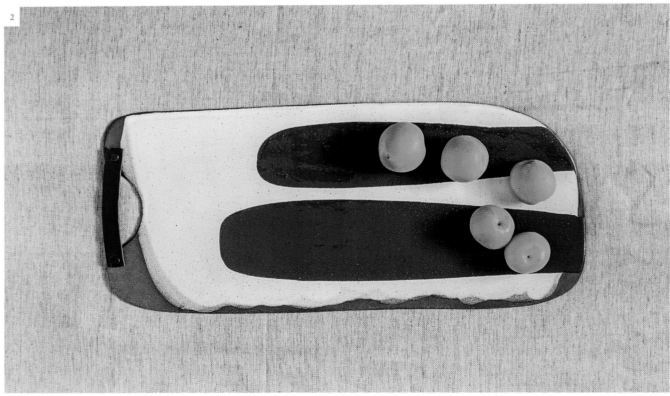

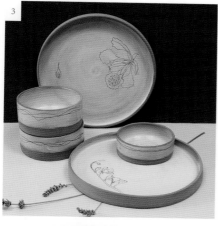

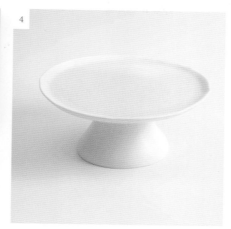

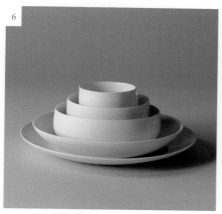

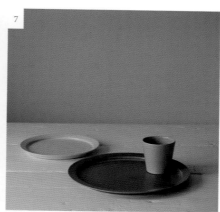

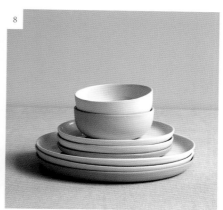

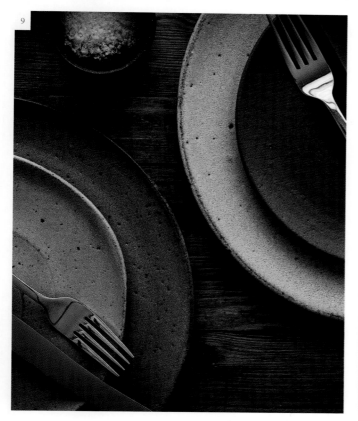

1: Slipcast coloured porcelain plates by Natascha Madeiski. You can see how the textured outside of the plate forms the inside shape. Keeping the shiny glaze to the inside makes the piece very practical and highlights the sculptural textures on the outside. © Natascha Madeiski

2: Slabbed terracotta serving platter with a leather handle by Silvia K. © Silvia K Ceramics

3: Plates and bowls in terracotta clay with slip and sgraffito decoration from the 'Under the Gulmohar Tree' range by Vallari Harshwal. © Vallari M Harshwal

4: Porcelain cake stand by Linda Bloomfield.

5: Melisa Dora thrown stoneware mug and plate. Photo Alexander Edwards, stylist Aurelien Farjon.

6: This dinner set by Lilith Rockett is a series of five finely-thrown porcelain bowls with gradually decreasing radiuses and increasing heights. © Lilith Rockett

7: Thrown and turned stoneware plates with a well-defined flat rim by Makiko Hastings. © Makiko Hastings

8: Slipcast coloured porcelain by Sue Pryke. © Sue Pryke

9: Sophie Moran stoneware Quarry plates. These plates show spiral traces of the throwing process and have a tactile matt glazes in earthy colours with the dark clay breaking through at the rims.

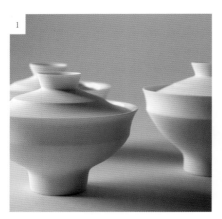

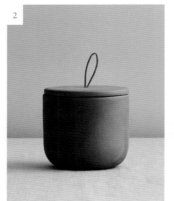

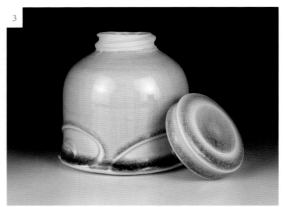

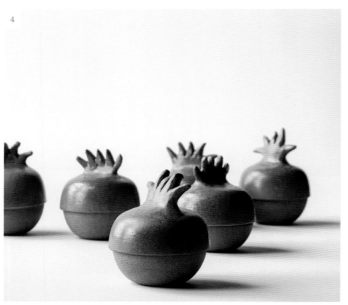

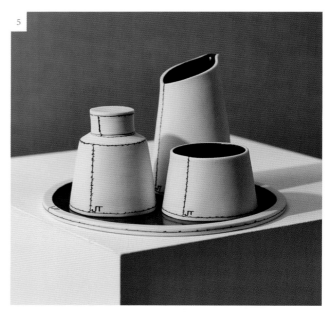

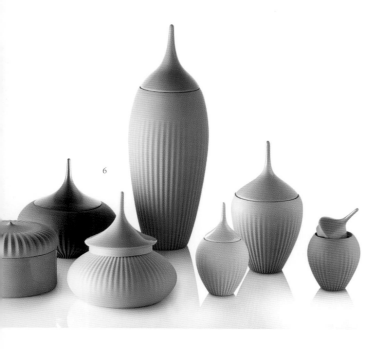

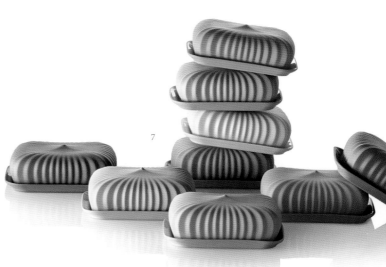

LIDDED POTS

There are a number of possible lid styles, either resting on a gallery on the inside of the pot rim or a cap that rests on the rim or a ledge on the outside of the pot. A flange on the underside of the lid prevents it from falling off. The knob can be integral to the lid design or added later. It is also possible to make a ceramic screw-top jar (see *Pioneer Pottery* by Michael Cardew). Butter dishes are often made with a dome resting on a flat dish. Lidded bowls can be made by using a smaller bowl as a lid, resting on a gallery or flattened bowl rim, with the flared foot-ring being used to pick up the lid. These types of lidded bowls are used for ramen noodle soups.

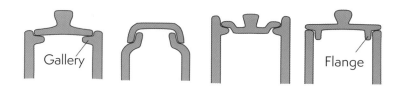

1: Lidded porcelain bowls by Lilith Rockett. The lids are made from smaller bowls with a flared foot-ring to make them easy to pick up. © Lilith Rockett

2: Lidded jar in black porcelain by Sue Pryke. © Sue Pryke

3: Screw-threaded porcelain jar by Patia Davis, slip trailed, with a wood ash glaze fired to cone 10/1300°C (2372°F) in a gas kiln. © Patia Davis

4: A playful selection of press moulded and hand-built stoneware lidded jars by Odd Standard for a restaurant project. The quiffs on the top of the bowls are hand modelled and snipped using scissors, so each one has its own character and individuality. © Odd Standard

5: Hand-built porcelain condiment set by Jessica Thorn consisting of a pourer, a sauce pot and a condiment jar. © Jess Hand

6: Slipcast coloured porcelain by Feinedinge. This array of lidded vessels is quite dramatic in terms of scale, colour and contrast. The addition of a glossy lid contrasts well with the matt unglazed body. The forms are architectural and elegantly designed so that the shape rises to a pinnacle at the top, drawing the eye across the form. To the contrary, the cylinder piece has a matt lid against a glossy base, which works well and is a thoughtful addition to the collection. It demonstrates that all pieces in a collection do not necessarily need to be identical to work well together. © Feinedinge

7: Butter dishes, slipcast coloured porcelain by Feinedinge. © Feinedinge

Top: Diagram of different types of lids. Flat lid resting on a gallery; cap lid resting on the shoulder of the pot; recessed lid resting on a gallery; flat lid with flange underneath.

Upper centre: Butter dish and salt pig in a Cabbage glaze by Arran Street East, with wooden scoop and butter knife by Eoghan Leadbetter. Photograph by Matthew Thompson. © Arran Street East

Bottom centre: Four tall, lidded, stoneware jars by Pottery West. Each lid has a flange underneath to prevent it sliding off the pot. © Pottery West

Bottom: Slipcast butter dishes by Helen Johannessen from her series cast from plastic 'Is That Plastic'. © Helen Johannessen

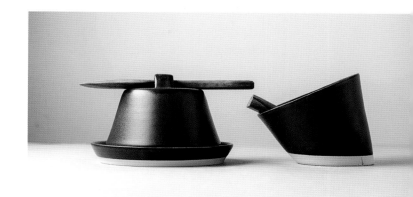

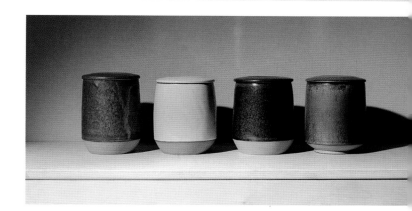

TEAPOTS, TEA SETS

Teapots are the most difficult shape to design, as they are made from several components; body, spout, handle and lid, all of which have to work together visually and also function well. The teapot body can be spherical, cylindrical, cubic or cone shaped, or it might have a more organic form. Before attaching a spout, holes can be pierced in the body wall to act as a tea strainer. It is also a good idea to put a hole in the lid to let air in and enable smooth pouring without glugging. The lid needs to stay on while pouring, so a deep flange can be added to lower the centre of gravity. The handle can be added to the side opposite the spout or over the top of the teapot, and can be made of different materials such as wood, metal, wire, akebia vine or cane, attached to clay lugs. Side handles attached at 90° to the spout are sometimes used in small, oriental-style teapots. Large teapots sometimes have an extra lug handle placed sideways above the spout to make it possible to lift using two hands. One of the most important features of a teapot is the shape of the spout and how well it pours. Cutting the end of the spout so that its inner edge is sharp can ensure that the teapot doesn't drip by cutting off the flow abruptly when the teapot is set down. Spouts that are thrown on the wheel sometimes twist during firing so the end should be cut at an angle, slightly lower on the left if looking at the spout end on, so that it ends up symmetrical after firing. The tip of the spout should be higher than or level with the highest level of liquid in the teapot.

Tea sets can be made with matching teapot, milk jug and sugar pot, all with unified form and colour.

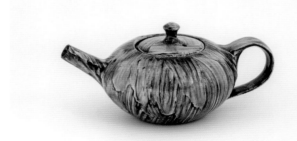

Top: Bone china slipcast teapot by Alexandra Nilasdotter. The squat teapot and flat lid give it a very contemporary feel, especially with a short pouring snip (a short spout). © Ruben Schildt

Centre: Stoneware teapot by Lexie Macleod with slip decoration in the form of a flattened globe. ©Dylan Vaughan

Bottom: Tea set by Sue Pryke and her husband John Tildesley, from the Mr & Mrs Collection with Wild + Wood, slipcast in earthenware and bone china. © Sue Pryke

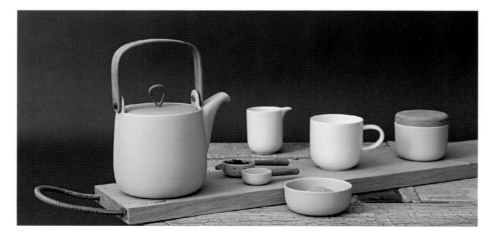

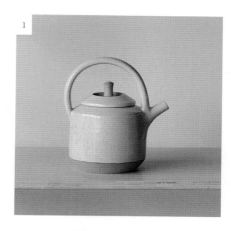

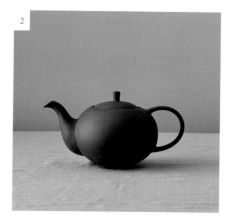

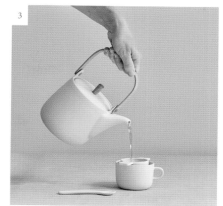

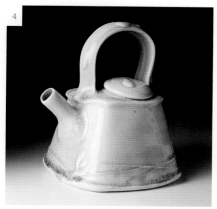

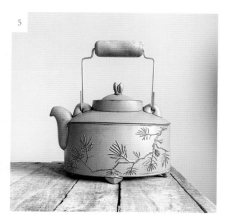

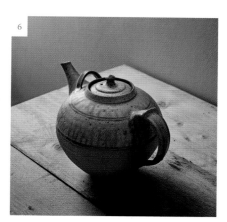

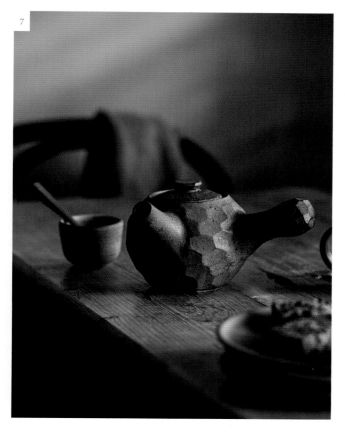

1: This thrown stoneware teapot by Pottery West has a cylindrical form and handle over the top. The clay knob has been left free of glaze so that it doesn't slip when gripped. © Pottery West

2: Slipcast coloured porcelain teapot by Sue Pryke. This teapot has a classic globe-shaped body and curved swan-neck spout.

3: Teapot, cup and spoon by Sue Pryke and John Tildesley, from the Mr & Mrs Collection with Wild + Wood, slipcast porcelain. Polished on the outside, it balances the natural beauty of wood and ceramic, giving a pared-back, simple aesthetic. The teapot has an oak knob and steam-bent handle made by John. © Sue Pryke

4: Conical porcelain teapot by Patia Davis with an apple wood ash glaze fired to 1300°C (2372°F) in a gas kiln. ©Patia Davis

5: Slab-built embossed pine branch teapot by Sarah Pike, made in the style of a metal kettle with a steel wire and reclaimed wood handle. © Sarah Pike

6: Teapot, ash glaze, reduction-fired stoneware by Tom Knowles Jackson. This large teapot has a lug handle about the spout so that it can be lifted when full using both hands. The main handle has a thumb stop to prevent the hand slipping. Photograph by Article Studios, © Tom Knowles Jackson

7: This small, carved teapot by Sophie Moran has a Japanese-style side handle. © Sophie Moran

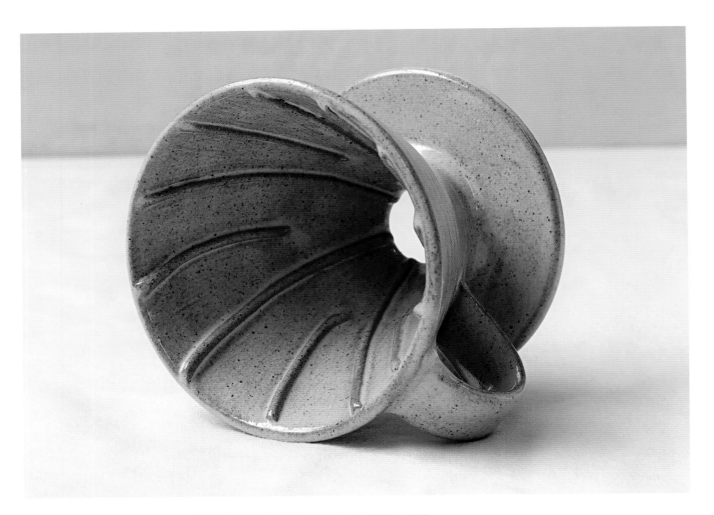

COFFEE DRIPPER/ POUROVER

Coffee drippers are used to hold a coffee filter paper containing coffee grounds. They are made in the form of a cone sitting on a flat base to rest on a cup or jug with a hole in the centre to allow the coffee to drip through when hot water is poured on. The cone needs to have ridges on the inside to keep the filter away from the sides so that coffee doesn't leak from the filter paper across the underside of the ceramic base. A flange can be added to the underside to prevent leaking. A dripper usually has between one and three small holes in the base to restrict the flow and give the coffee more time to steep, while a pourover usually has one 2 cm (¾ in) wide hole.

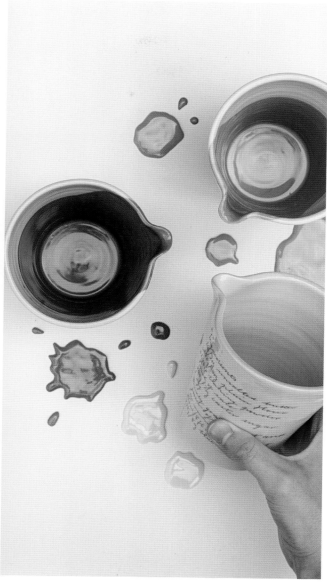

KITCHEN POTS, CITRUS JUICERS, COLANDERS, RAMEKINS

Many potters make a whole range of pots for use in the kitchen. Citrus juicers can be hand built, made in a mould or thrown on the wheel, beginning with a double-walled cylinder, closing the inner wall into a dome and fluting when leather hard. Bowls can be made into pouring bowls by adding a lip, or pierced with holes to make colanders. Any pots such as ramekins or baking dishes that are used in the oven need to be tested for thermal shock by pouring boiling water in and making sure there is no cracking.

Opposite top: Pottery West, stoneware coffee pourover, showing the ridges to keep the filter away from the sides. © Pottery West

Opposite bottom: Stoneware coffee dripper with three small holes in the base by Arran Street East. © Arran Street East

Above left: Pourers in black clay with coloured glazes by Naked Clay Ceramics. © 2022 Carla Sealey

Above right: Pouring jugs by Alice Funge. © Alice Funge

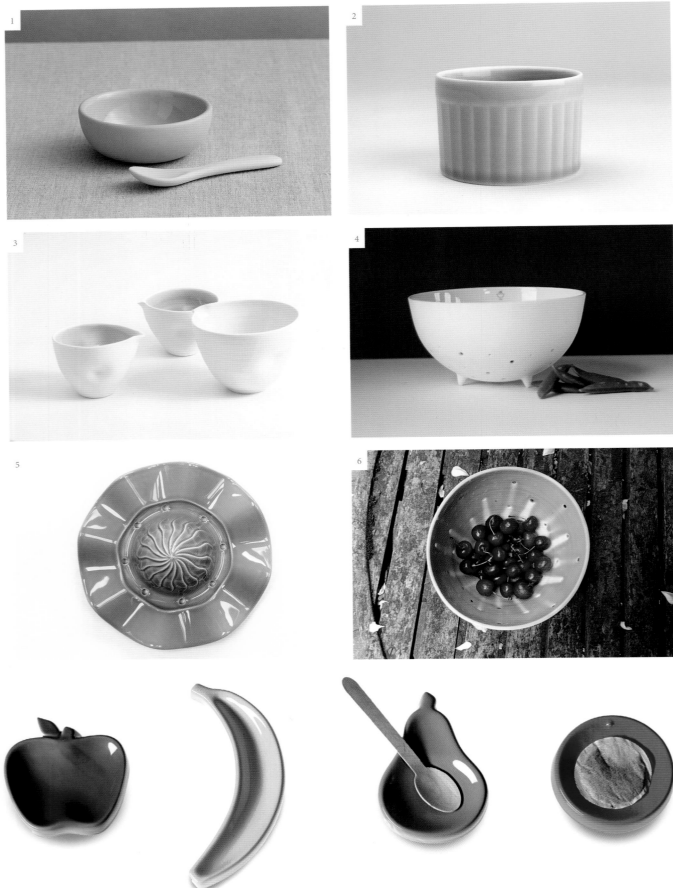

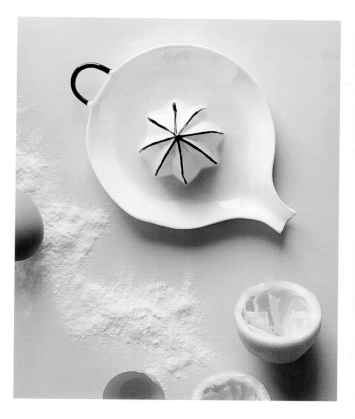

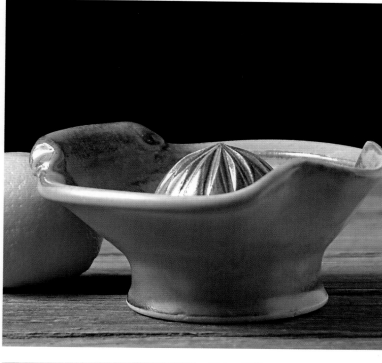

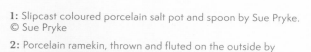

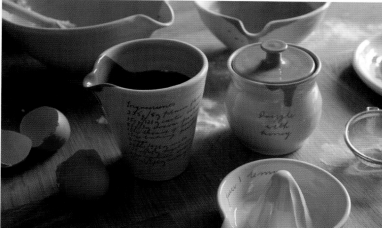

1: Slipcast coloured porcelain salt pot and spoon by Sue Pryke. © Sue Pryke

2: Porcelain ramekin, thrown and fluted on the outside by Susan Frost. Height 6 cm (2½ in). Diameter 8.5 cm (3¼ in). Photograph by Michael Haines. © Susan Frost

3: Thrown porcelain pouring bowls by Linda Bloomfield. © Henry Bloomfield

4: Bone china colander with varyingly-sized holes by Reiko Kaneko. © Reiko Kaneko

5: Slipcast lemon squeezer, earthenware and coloured glaze by Sue Pryke. © Sue Pryke

6: Thrown porcelain colander by Linda Bloomfield.

Opposite bottom: Kitchen tidy pieces by Yoyo Ceramics, slipcast in earthenware with coloured glazes. These fruit-themed pots are a colourful and clever addition to the kitchen, as spoon rests or tea bag holders. Such a simple concept, but cleverly executed, each fruit shape is stylised but easily recognisable and coloured accordingly to create an easy to pick up and giftable item. © Helen Johannessen

Top left: Lemon juicer, slipcast in bone china by Feldspar Studio. © Feldspar Studio

Top right: Thrown stoneware lemon squeezer by Lucy Fagella. © Lucy Fagella

Centre: Kitchen bowls, pourer, honey pot and lemon squeezer by Alice Funge with recipes in her grandmother's handwriting. © Alice Funge

Bottom: Porcelain lemon squeezer thrown on the wheel by Linda Bloomfield. © Henry Bloomfield

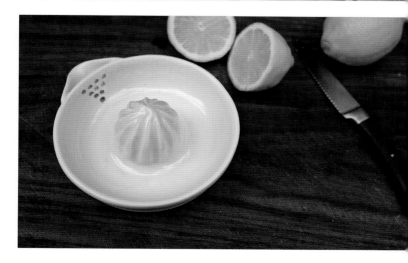

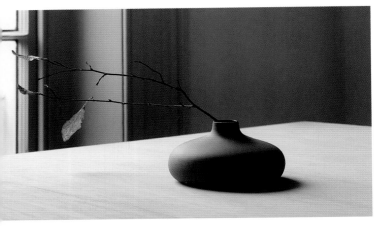

VASES

Vases can be cylindrical, spherical or a more organic shape, but the size of the opening at the top is important. A narrow neck may only fit a few stems, while too wide a neck may cause the stems to fall sideways. The base should be wide enough to make the vase stable. Vases also need to have a sufficient capacity at the base to hold water. The clay and glaze combination chosen must not be porous to water; low-fired raku and earthenware clays often remain porous, particularly when the glaze is crazed.

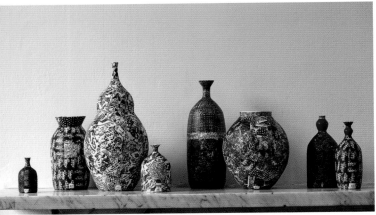

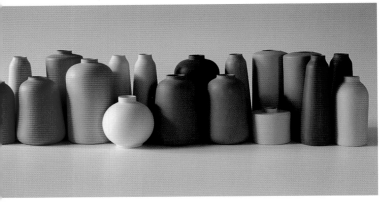

Top: Slipcast black porcelain 'Oli' vase by Sue Pryke. © Sue Pryke

Centre top: Thrown and slipcast vessels with transfers by Carolyn Tripp. The variety of shapes and differing styles of pattern work well across this collection of work; the blue cobalt brings the range together and the addition of the red pop of colour confirms that these shapes truly belong together. It is a considered way of working, the rich pattern concepts are strong enough to make the range cohesive. ©Yeshen Venema

Centre bottom: Thrown vases with coloured glazes by Natalie Bell Ceramics. The accumulation of a series of shapes and vibrant colours make a strong statement; the shapes vary but all tend to have a similar shape with a small collar and shoulder. Even the cylindrical piece sits well within the group. © Natalie Bell

Bottom: These slab-built vases by Sarah Pike are inspired by the shape of metal oil cans. © Sarah Pike

Opposite top left: Slipcast cylindrical vases with handles by Georgie Scully. © Georgie Scully

Opposite top right: Slipcast coloured porcelain by Katie Lowe. Katie makes her vases in multiples with varying percentages of colour for each vessel. The addition of the middle vase in reverse is an extra detail that adds to the collection. © Katie Lowe

Opposite bottom left: Porcelain vases thrown on the wheel by Linda Bloomfield. © Henry Bloomfield

Opposite bottom right: Slipcast vases by Eradu Ceramics with interesting details at the base. © Eva Radulova

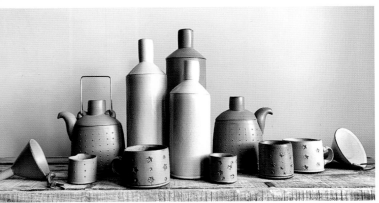

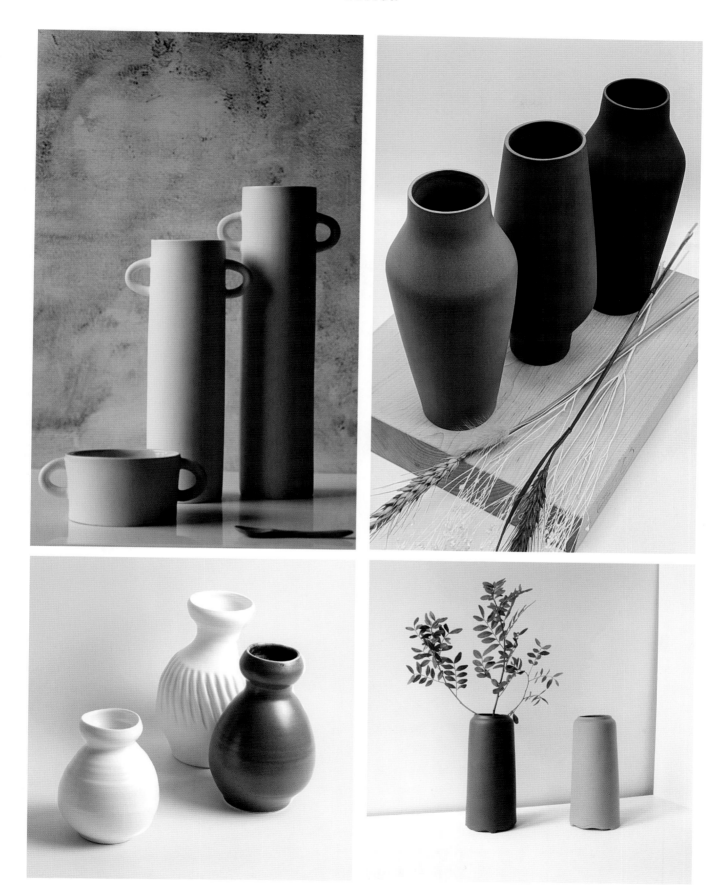

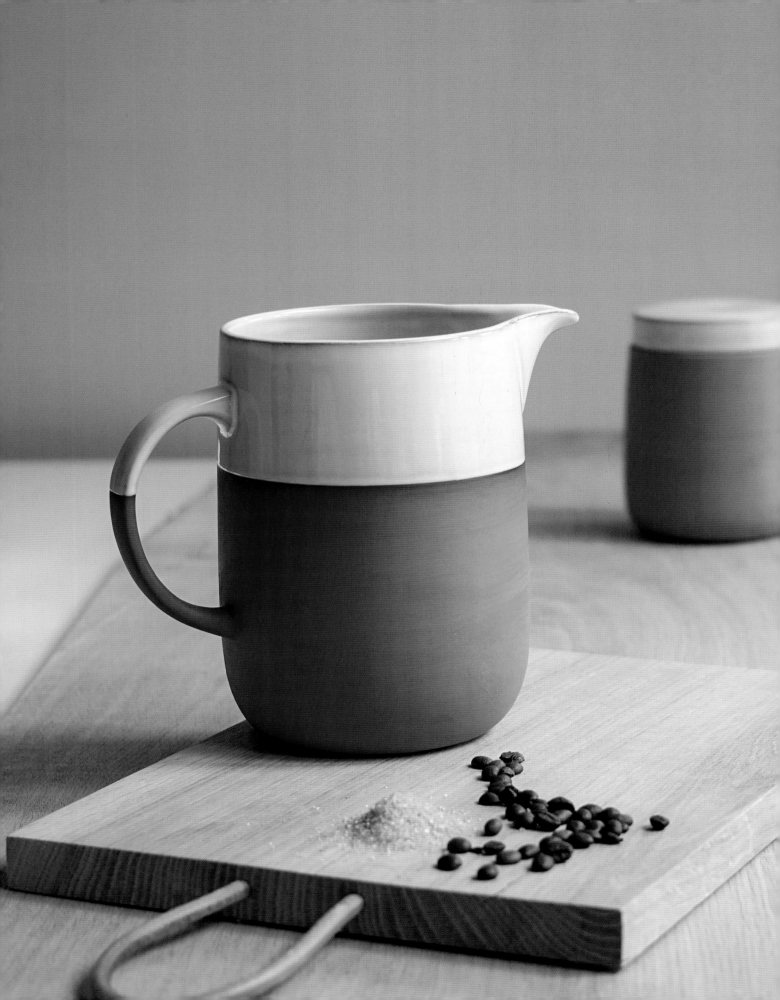

—

MATERIALS

LINDA BLOOMFIELD

TYPES OF CLAY

Each type of clay is suited to making different types of tableware. Red earthenware has traditionally been used to make cookware and teapots, owing to its insulating qualities, while the strength of porcelain and bone china make them suitable clays for making thin, light plates for fine dining.

There are three main types of clay: earthenware, stoneware and porcelain. Earthenware includes both naturally occurring red clays and industrially produced white clays, and is fired to low temperatures around 1060-1120°C (1940-2048°F), usually remaining porous after firing.

Stoneware clay is usually made by mixing several types of naturally occurring clay, including ball clay, china clay and fireclay that fire to a higher temperature around 1240-1300°C (2264-2372°F), becoming vitrified and non-porous. Stoneware clay can also have added sand or grog (particles of fired clay) to reduce the shrinkage when making large ware and iron oxide, chips of granite or feldspar for colour and texture.

Porcelain is a manufactured clay made from pure, white kaolin (china clay), feldspar, quartz for hardness and a small amount of bentonite – a very plastic clay – to enable it to be thrown on the wheel. Bone china is similar to porcelain but also contains bone ash and is more suited to slip-casting. Porcelain and bone china are fired to high temperatures, similar to stoneware. The higher the firing temperature, the harder and more vitrified the fired clay becomes.

Opposite: *Terracotta jug and lidded jar by Sue Pryke. © Sue Pryke*

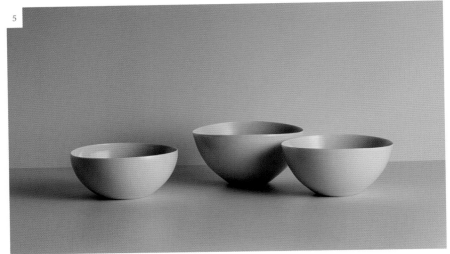

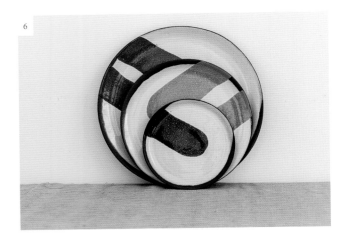

1: Thrown pouring bowl made using grogged stoneware clay by Tom Knowles Jackson. Photograph by Article Studios. © Tom Knowles Jackson

2: Slipcast terracotta serving bowl by Eva Radulova. © Eva Radulova

3: Slipcast bone china pinch mug by Reiko Kaneko. © Reiko Kaneko

4: Mug and teaspoons by Sue Pryke, coloured porcelain. © Sue Pryke

5: Gwyn Hanssen Pigott's finely-thrown porcelain bowls. © Brian Hand

6: Terracotta plates fired to 1190–1200°C (2174-2192°F) by Silvia K to make them vitrified and non-porous. © Silvia K Ceramics

CLAY BODIES

Kaolin, also known as china clay, is the whitest and purest clay, found in China, Eastern Europe and Cornwall where it was formed millions of years ago from decomposed granite. Because it is a primary clay, found in the place where it formed, it has remained white and pure. Secondary clays that have been washed down rivers and deposited in lakes and estuaries usually pick up impurities on the way including iron oxide, which causes them to become darker in colour. Iron oxide acts as a flux and high levels can melt the clay during firing. For this reason, naturally red clays can often only be fired to earthenware temperatures, around 1100°C (2012°F). In Staffordshire, a type of red clay called Etruria marl was traditionally used to make earthenware pots. This red clay can be dug from the ground and used as it is but other clays are made from several ingredients to achieve the properties required: colour, plasticity and firing temperature. In the 18th century, Wedgwood developed a cream-coloured clay body by mixing china clay and ball clay, a grey clay found in Devon and Dorset that is more plastic than china clay. A clay body is a manmade mixture of china clay, ball clay, flint and feldspar. The flint makes the clay body hard when fired and the feldspar helps it to vitrify and become non-porous. The china clay makes the body whiter, while ball clay makes it more plastic and workable. The advantage of using earthenware clay is that it needs less energy for firing, shrinks less during firing and the finished ware is lighter than stoneware. However, if the ware is not glazed all over then it may be porous and any absorbed water may render it unsafe to use in a microwave.

Another type of clay found in the Midlands and Scotland is fireclay. This clay is associated with coal beds and has higher alumina content than other clays, making it able to withstand higher temperatures. The fireclay is the remains of the soil that the Carboniferous rainforests grew in millions of years ago. The trees absorbed minerals such as calcium, potassium and silica from the soil, leaving it high in alumina, which was not absorbed. These trees eventually became coal, which is found above the layers of clay. In Stoke-on-Trent, the clay was used to make pots and the coal was used to fire the bottle kilns. Fireclay is used to make kiln shelves and props, as well as being a useful addition to stoneware clay bodies to enable them to be fired at high temperatures. The advantage of stoneware is that, once fired, it is harder, more durable and chips less than earthenware. Stoneware is vitrified and non-porous and can be used in a microwave oven. Be aware when designing tableware that stoneware clays shrink by around 12% from wet to fired clay, while earthenware clays shrink by 8-11%.

Top: Porcelain clay body from Stoke-on-Trent, Staffordshire, made from china clay, feldspar, quartz and bentonite.

Bottom: Red stoneware clay from St Agnes, Cornwall, made from fireclay, ball clay and red iron oxide.

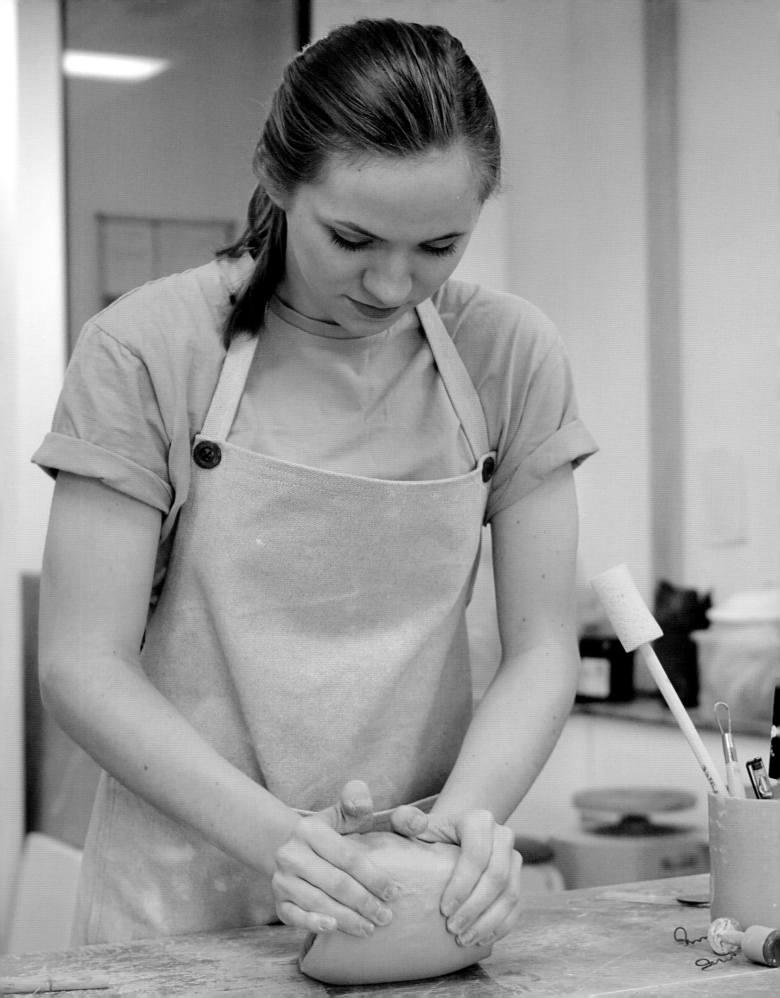

—

CLAY PREPARATION AND RECYCLING

LINDA BLOOMFIELD

Clay can be dug from the ground, mixed with water, sieved and dried out on a plaster batt ready for use. However, many potters find it easier and less time consuming to buy their clay ready made. It needs to be prepared before use, either wedged and kneaded ready for throwing or blunged with water to make slip for slipcasting. It is also possible to buy ready-made slip.

There are several wedging and kneading methods. The aim is to get the clay evenly mixed throughout so that it has a workable consistency with no hard lumps or air bubbles. Wedging consists of cutting a lump of clay in half and slamming one half down on top of the other on a sturdy work bench or table. This is repeated many times, stacking up the layers in the same direction so that the number of layers doubles each time. After ten times cutting and slamming, you will have 1024 stacked layers and the clay will be evenly mixed. Additionally, most potters then knead the clay. The main methods are ox-head and spiral kneading. Ox-head kneading uses two hands, placed on either side of a lump of clay, which is pushed away onto the bench, then brought back in a rolling motion so that clay forms the shape of an ox head. Spiral kneading is more asymmetrical with one hand closer to the body than the other, both hands working together on gradually kneading and rotating a large mass of clay, forming a spiralling cone, which takes some practise to achieve. In large, well-equipped potteries, a pug mill is often used to mix the clay.

Opposite: *Alice Funge preparing clay for throwing in her studio.* © Alice Funge

Clay scraps can be recycled. Any completely dry scraps can be added to a large bucket of water, then left to settle and the excess water poured off. If clay is dried out it breaks down in water more easily than leather-hard clay. Throwing slip and water from the wheel tray can also be saved and added to the mix, as these contain the smallest, most plastic clay particles. The clay then needs to be dried out on a plaster batt, wedged and kneaded. Some potters like to add recycled clay to new clay as the recycled clay can sometimes be more plastic than new clay straight out of the bag.

SLIPS

Slip can be made by mixing clay and water and sieving. Slips can be used for slipcasting using plaster moulds, decorating or coating the whole surface of the pot with a different colour clay. They are usually applied when the pot to be decorated is at the leather-hard stage. A mixture of slip, glaze or frit and colouring oxide or stain is called an engobe or underglaze and can be used for decorating biscuit-fired ware.

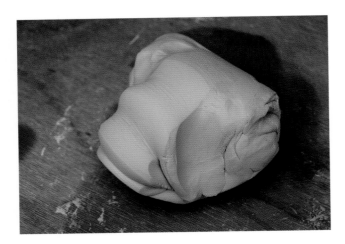

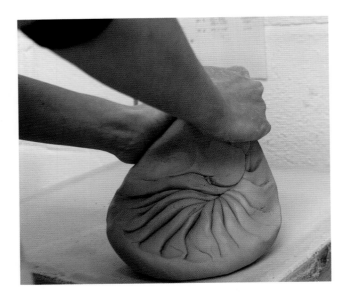

Top left: Ox-head kneading.

Bottom left: Alice Funge demonstrating spiral kneading © Alice Funge

Right: Preparing plastic clay for slip. © Sue Pryke

SUE PRYKE

CASTING SLIP

CONTROLLING THE CASTING SLIP PROCESS

Plastic clay has around 20% water within the clay body but casting slip requires the addition of much more water to produce a fluid clay mix; optimal casting requires the clay to have around 30-40% water.

In order to keep the clay fluid, casting slip needs the addition of deflocculants, such as sodium silicate and soda ash added to clay and water to enable the clay particles to suspend in the water so that the clay can remain fluid and does not clump and separate in the bucket.

Clay particles are hexagonal and flat, like a pack of cards, and they float over each other and move around with the addition of water. If you add sodium silicate and soda ash into the mix, it causes the particles to repel each other, as they both contain sodium ions or charged particles and can change a thick sticky clay into a thin watery clay.

A good balanced casting slip requires the right mixture of clay, water and deflocculant. It is fairly straight-forward to mix your own casting slip, either by hand in a bucket or in a much larger blunger. Clay suppliers will provide a recipe for mixing your own slip. The proportions will vary depending on the type of clay, but the proportions are generally one 12.5 kg (27.6 lb) bag of clay to 1500 ml (50.7 fl oz) water and 25 g (0.9 oz) deflocculant.

Add the plastic clay in small chunks or slices to the blunger along with the water and deflocculant. It is key to add the sodium silicate in small amounts; if you add too much, you will need to add more clay to the batch. It is better to add more deflocculant a little at a time once you find the correct weight.

When the batch is fully blended together, you will need to weigh 500 ml (17 fl oz) of slip to check that the consistency is correct. It should weigh between

900g to 1020 g (31.7 oz to 36 oz) . Traditionally slip was measured in the ceramic industry by the pint weight; many potters still use this and use a standard pint jug for consistency. An accurate set of scales and a clean measuring jug will be just as good.

Ideally a good batch of slip will have good flow, or viscosity, which means it flows easily, it casts cleanly and does not leave wreaths of clay in the cast. The thickness is important and so is the casting time. Slips vary; bone china casts quickly in around 5-7 minutes and a good porcelain will take around 10 minutes to cast to 3 mm (⅛ in) in the mould. An earthenware slip could easily take 15 minutes. If your casting takes a couple of minutes, it is too thick; if it takes 20 minutes to build up to a 3 mm (⅛ in) cast, it is too thin and will need more clay to be added.

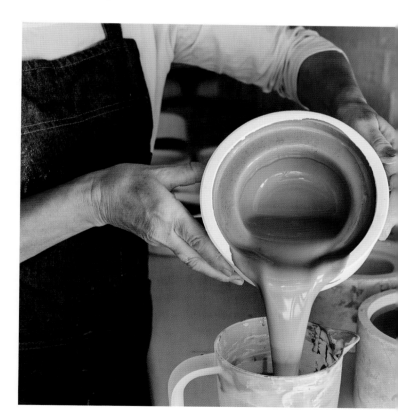

Above: Casting slip with a good flow or viscosity. © Sue Pryke

ADJUSTING SLIP

If the slip weighs more than 1020 g (36 oz) it is too heavy and needs more water. If the weight is lower than this but it is fluid, it needs more clay. If the weight is low, but the slip is very thick, it will need more sodium silicate to increase the fluidity. A deflocculant changes the electrostatic charges on the clay particles so that they repel each other and so the slip requires less water to flow in the mould.

Soda ash helps to deflocculate the clay, and is generally used in addition to sodium silicate. Soda ash used on its own will make the clay become tacky. If soda ash is not stored in an airtight container it can change into sodium bicarbonate which will act as a flocculant to thicken not a deflocculant to thin the slip.

Barium carbonate can also be used and neutralises the addition of sulphates in the clay and in the water. As casting moulds are made from plaster (calcium sulphate), there will be a build up of sulphates which have leached out from the moulds into the scrap clay, so barium carbonate might be useful in dispelling this.

After mixing the clay needs to hydrolyse, as it will change when the clay is mixed with water and each particle becomes saturated. Test the viscosity a day after mixing a batch as it will almost certainly change. If you adjust the viscosity with extra sodium silicate too soon after mixing the batch it is likely to be over saturated or over deflocculated.

Above: Slipcast clay trimmings. © Sue Pryke

RECLAIMING CLAY

Reclaiming your clay is a process which is a cost effective way of getting the most out of your material. It is fairly straightforward for ordinary clay recycling, but with slipcasting it is a little more tricky because of the addition of sodium silicate in the clay and also sodium silicate that will be transferred from the plaster moulds into the slip trimmings. This addition is enough to throw your weight calculations out.

The scraps and trimmings from the reservoir or spare when casting usually add up to quite generous amounts of clay. Keep these, either storing them in clay bags, drying them out (and they will take up less space) or putting them straight into a bucket with some water.

For reclaiming or recycling the slip start by adding all the dry clay into a bucket and add water to saturate the clay; this will make mixing easier to manage. At this point the amount of water does not matter, as excess water can be poured off when the clay settles. It is important to allow the clay to slake in the water, to soften all the harder pieces and allow for easier mixing.

When you are ready to reclaim, you can mix the clay and water by hand, with a drill and plaster mixer, a glaze mixer or even a larger blunger if you have one. I usually push the slurry through a few sieves as there are always unwanted pieces of debris that can be removed at this point.

The objective is to mix the clay until it resembles a smooth pouring slip. When the slurry has been sieved, the key is to determine the pint weight. Getting the right consistency using deflocculants comes into play once the right weight has been achieved.

Go through the same processes of adjusting slip as you would if you were making a fresh batch of clay. Add more clay if it is weighing too light. Add more deflocculant if the weight is correct but the slip is really thick.

You might find that the slip is much thicker but it weighs less than usual. It may become fluid when mixed but settle really quickly, so therefore the deflocculants need adjusting.

Most casting potters add a proportion of the casting slip trimmings back into a main batch, but limit this to 10-20% otherwise it will affect the whole batch and make it unstable.

I regularly use reclaim slip as I find that it accumulates too quickly to process into each fresh batch of clay. Certain items are unaffected by the reclaim which can be more difficult to cast with; it tends to be thicker, heavier, cast less smoothly and takes longer to dry. Vessels such as vases seem unaffected by using reclaim, but I would not use it for casting plates, which require the best quality slip that flows well without leaving any wreathing, or trails across the plate.

The way to set up your reclaim is similar to the way you would set up a new batch of clay. Find the pint weight and test the fluidity. The fluidity is usually determined by using a torsion viscometer, but you can test the thixotropy by more rudimentary means. By dipping a spoon, or even better your hand, into a mix you will get to feel how thick or watery the slip is. If it drips off your hand easily and looks very thin, it is not thick enough, so more clay should be added. If it does not move but the pint weight is correct the addition of more sodium silicate or Dispex (or Darvan), which is a ready prepared mix of sodium silicate and soda ash, will add fluidity back to the batch.

Beware of adding too much sodium silicate as this will cause the mix to be too thin, which results in a long casting time, an uneven surface in the cast and a dry, brittle body which doesn't trim very easily.

Too little sodium silicate will result in a flabby cast, which takes forever to dry, it will drain unevenly and leave wreathing or draining marks across each piece. It will also cast very quickly.

Note also that if far too much sodium silicate is added the solution can also have the reverse effect and produce a watery mix which can be brought back with the addition of Epsom salts. Initially try 20 g (0.7 oz) to 100ml (3.4 fl oz) water.

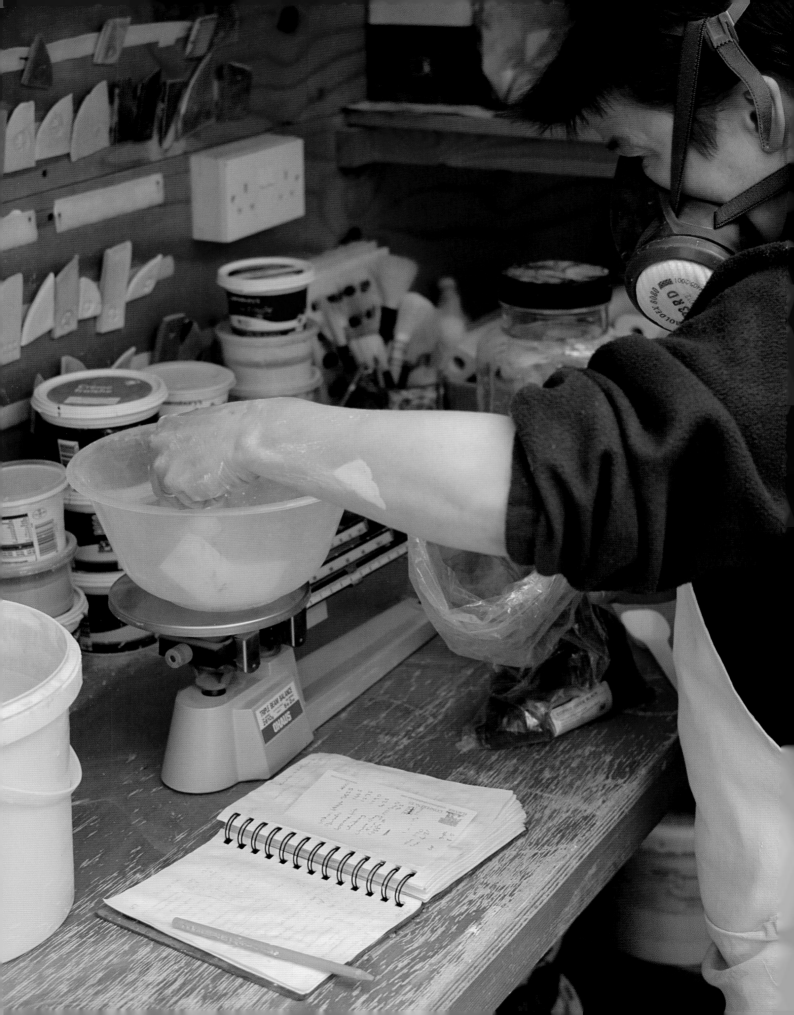

—

HEALTH AND SAFETY

LINDA BLOOMFIELD

It is important to look after your health in the pottery studio. The main cause for concern is exposure to dust. Silica dust is harmful to the lungs and can cause silicosis after many years of exposure. This used to happen to people who worked in industrial potteries, stone cutters and miners but nowadays more precautions are taken. It is really important to wear a respirator when making glazes and prevent dust accumulating by cleaning the studio. Silica is present not only in quartz and flint used for making glazes, but also in clay, feldspar, frits, talc, wollastonite and other silicate materials, which include ground-up igneous rocks such as granite and pumice. The best way to reduce dust is to clean work surfaces, batts and floors and wash towels, overalls and aprons frequently. Wet cleaning with a sponge or mop is best, or alternatively you can use a vacuum cleaner with a dust filter.

Opposite: Mixing a glaze wearing a respirator mask.

SOLUBLE MATERIALS

Glazes are made of materials that are not soluble in water, otherwise there would be problems with the glaze consistency in the bucket and absorption of soluble salts into the biscuit ware. If an alkaline material dissolves in water, it can cause the glaze to settle in a hard layer at the bottom. This sometimes happens with slightly soluble materials such as nepheline syenite, a rock related to feldspar. This can be remedied by digging out the hard layer, mixing with the water and adding a small amount of Epsom salts dissolved in water. If acid materials dissolve in water, they can cause the glaze to become thick and gel like, which can happen with gerstley borate or bone ash glazes. If this happens, it is best to add a deflocculant such as sodium silicate to counteract the acidity. Because most glaze materials are insoluble, they will not be absorbed by the skin, so most glazes are safe to stir by hand, with the exception of ash glazes, which contain soluble alkalis, which are caustic, and require rubber gloves to be worn.

TOXIC MATERIALS

Most clays and glaze materials are not toxic, with the exception of lead and barium carbonate. By law, glazes must not contain soluble, leachable lead or cadmium. It is best to avoid the use of these materials in functional tableware. However, many of the colouring oxides and carbonates are toxic, particularly nickel, chromium, vanadium and manganese. Most oxides do not dissolve in water, but should not be ingested or inhaled. Firing fumes from these metal oxides can also be toxic, so make sure the kiln is well ventilated and fire at night when you are not in the studio. Chromium oxide is particularly volatile and forms a vapour that wafts around the kiln. Soluble forms of these colouring oxides are very toxic as they can be absorbed easily; these are nitrates, chlorides and sulphates sometimes used in pottery to obtain watercolour effects. Once the glaze has been fired, the metal oxides will be locked up in the glaze structure, provided it is properly formulated with the correct proportions of silica, alumina, alkali metal (sodium, potassium, lithium) and alkaline earth (calcium, magnesium, strontium) oxides (see Chapter 8, Glazing). There can be a problem with adding too much copper oxide to a glaze as it acts as an alkali metal like sodium and can unbalance the glaze, causing alkali to leach out of the glaze when in contact with acid foods. To avoid this happening, don't add more than 3% copper oxide to a glaze; I usually add less than 1%. Many other colouring oxides (cobalt, manganese, iron) act as alkaline earths, which are more stabilising additions to glazes.

Stains and underglazes are made using colouring oxides that have been heated together with silica and ground to a powder, rendering them non-toxic. The disadvantage of stains and underglazes is that they don't dissolve in the glaze and so often lack depth. The advantage is that they are safer to use, particularly in pottery cafés and community studios.

STUDIO PRACTICE

It is most important to keep down clay dust in the pottery. Make sure you clean the studio regularly using a wet sponge or mop. Food and drink should not be consumed in the studio as dust could fall into it. If you have a home studio, change your shoes and overalls at the door so that you do not bring clay dust into the house.

Wear a respirator mask when weighing dry glaze materials. Wear rubber gloves if using ash glazes. Do not wash glaze colourants down the sink. Dry out and dispose of them in landfill, or mix your waste glazes together to use as an unrepeatable mystery glaze.

MATERIALS CONTAINING SILICA

Clay

Feldspar

Frit

Talc

Wollastonite

Zirconium silicate

Stains

TOXIC GLAZE MATERIALS

Lead

Cadmium

Barium carbonate

Vanadium pentoxide

Nickel oxide

Chromium oxide

Manganese dioxide

SLIGHTLY TOXIC MATERIALS

Cobalt oxide/carbonate

Copper oxide/carbonate

Zinc oxide

Lithium carbonate

Wood ash

Borax

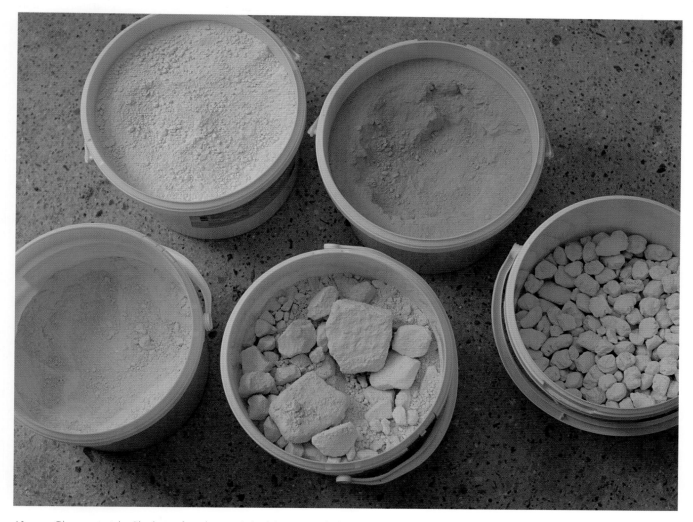

Above: Glaze materials. Clockwise from bottom left: dolomite, nepheline syenite, bentonite, bone ash and Cornish stone.

—

MAKING METHODS

LINDA BLOOMFIELD

HAND BUILDING

PINCH. COIL. SLAB. PRESS MOULD. EXTRUDE.

The simplest and oldest form of hand-built pottery is a pinch pot. These can be used to make bowls and cups. Pinch pots can be made larger by adding coils, scoring the rim of the pot and adding slip to attach each coil.

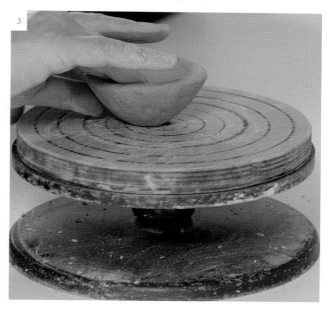

PINCH POT BY KERRY HASTINGS

1: Start with a ball of clay and push a thumb into the centre.
© Henry Bloomfield

2: Gradually rotate the pot in your palm while pinching gently between your thumb and finger. © Henry Bloomfield

3: Place on a flat surface to flatten the base of the pot.
© Henry Bloomfield

Opposite: Press moulded and textured square plate by Sarah Pike. © Sarah Pike

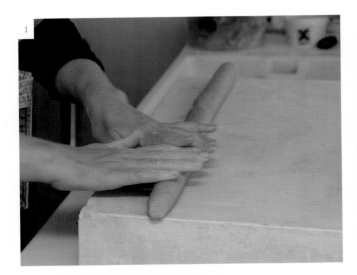

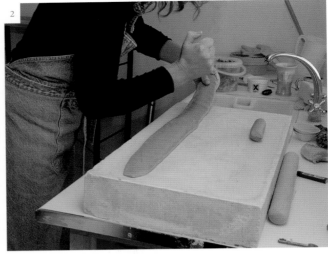

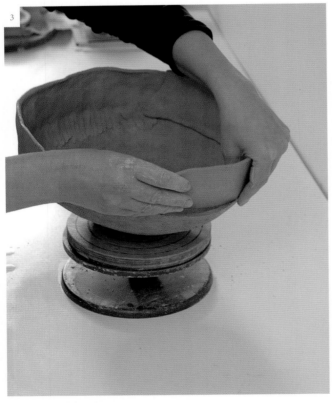

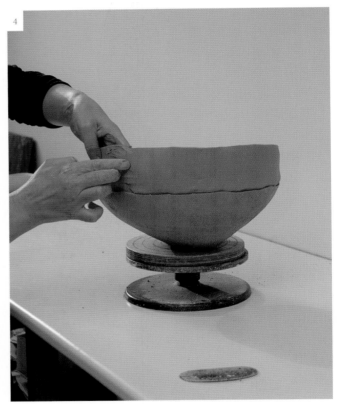

COILED POT BY KERRY HASTINGS

1: Rolling a coil on a plaster slab. © Henry Bloomfield

2: Flattening the coil with the side of the hand.
© Henry Bloomfield

3: Attaching the flattened coil to a bowl.
© Henry Bloomfield

4: Smoothing over the joins with a finger.
© Henry Bloomfield

5: Refining the inside profile of the bowl with a serrated metal kidney. © Henry Bloomfield

Coils and wider strips of clay can be formed by rolling and flattening. After the coils are joined together, the shape can be refined and smoothed using the fingers, a wooden tool or a serrated metal kidney. Coiling is not a very fast way to make pots and is more often used to make sculptural vessels than functional tableware. However, coils can be useful for making handles, lugs and flanges on lids.

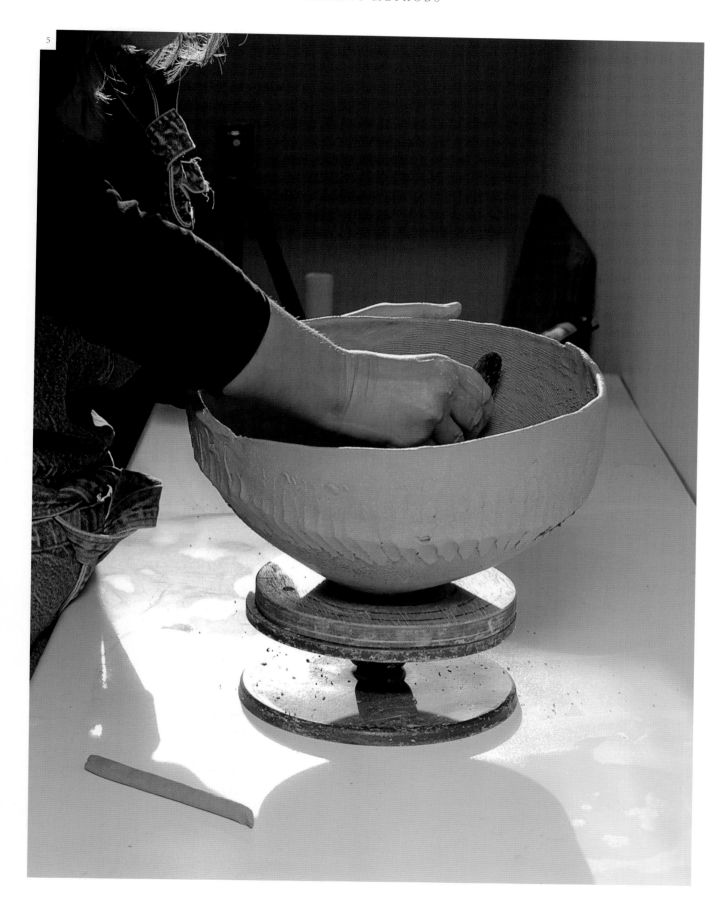

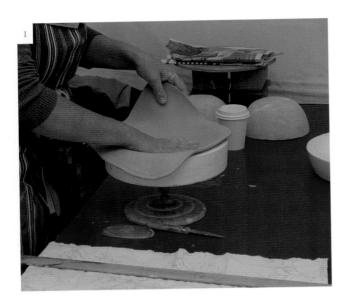

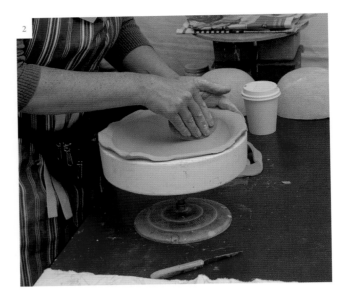

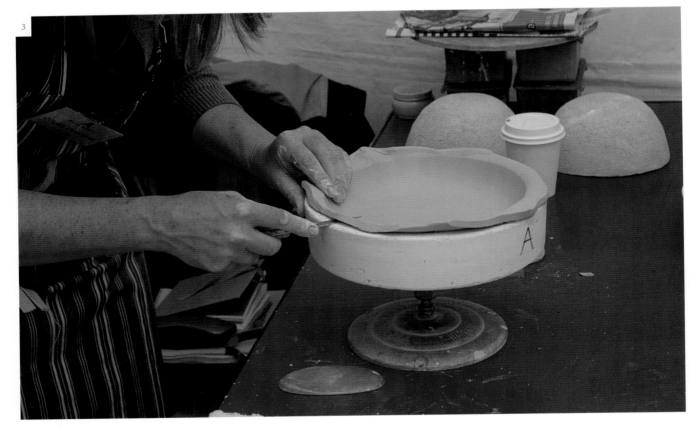

PRESS MOULDED BOWL BY JULIET WALTERS

1: Press-moulding a bowl from a soft slab. © Henry Bloomfield

2: Pressing the bowl into the mould using a rubber kidney.
© Henry Bloomfield

3: Trimming the excess clay at the edge of the bowl.
© Henry Bloomfield

Opposite top: Press moulded and slip-decorated earthenware dish by Patia Davis. © Patia Davis

Opposite bottom: Stoneware slab platter with indigo slip and matt white glaze by Yo Thom. Height 29 cm (11½ in). Length 38 cm (15 in). © Yo Thom

Slabs can be rolled out by hand using a rolling pin and a batten on either side as a thickness guide. These can then be cut to shape using a ruler or cardboard template. If the slabs are left to harden overnight, they will hold their shape better when joining. The edges must be scored and slipped, then pressed firmly together. A soft slab can be pressed into a plaster press mould or draped over a hump mould to make a plate or bowl (see the mould making section).

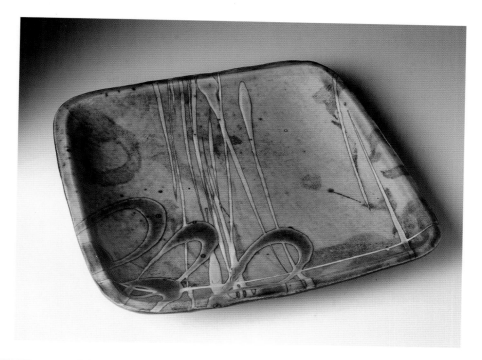

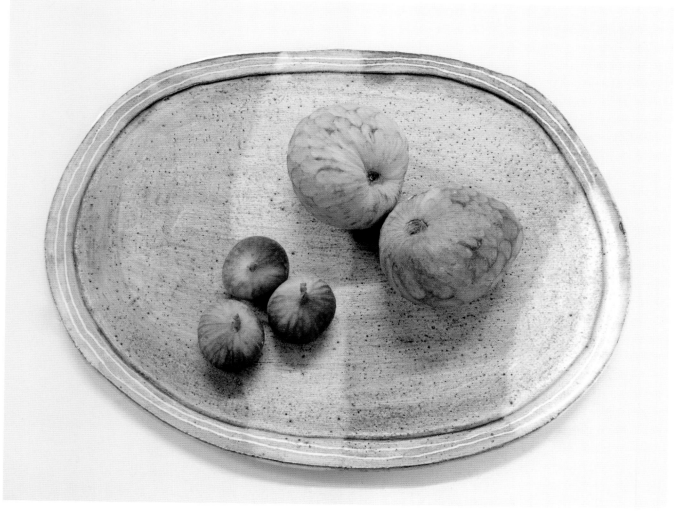

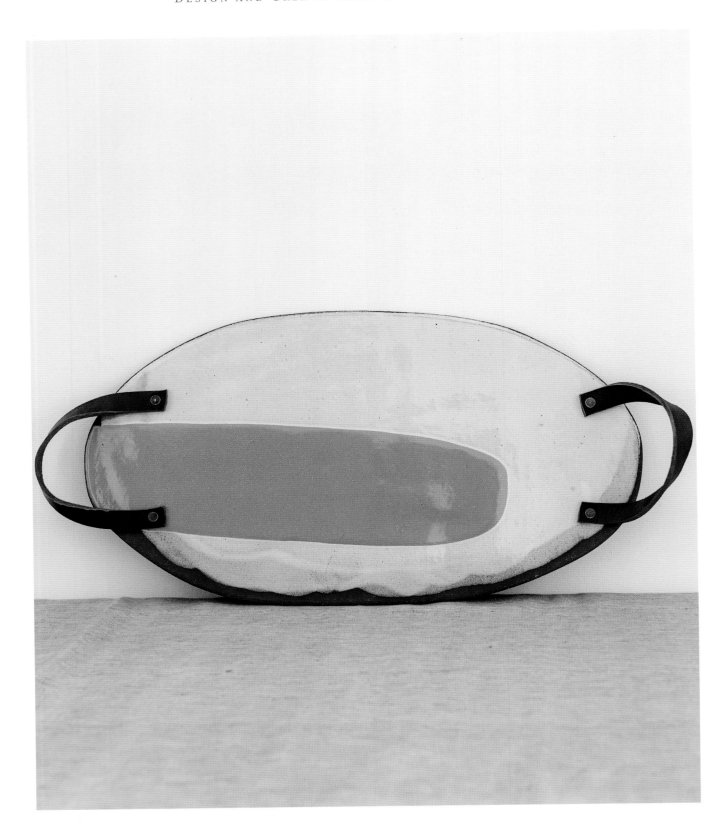

Above: Large slab-built platter with leather handles by Silvia K. © Silvia K Ceramics

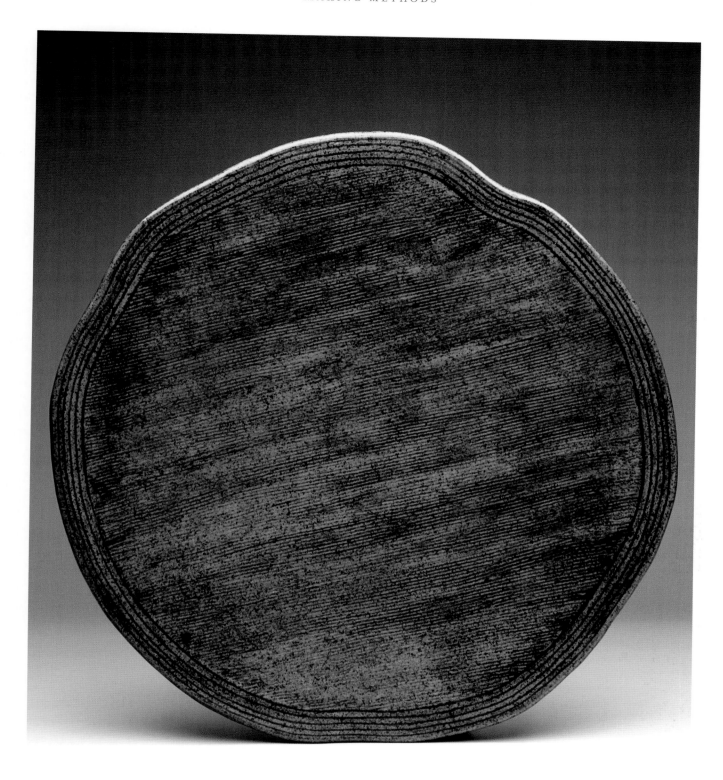

Above: Stoneware platter by Karen Bunting. Diameter 36 cm (14¼ in). © Karen Bunting

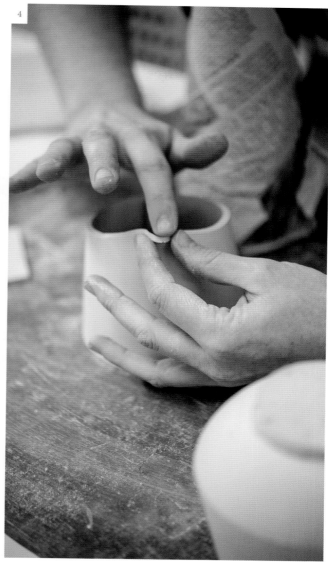

SLAB-BUILT MUG AND JUG BY JESSICA THORN.

1: Kneading porcelain clay in the studio. © Silkie Lloyd

2: Rolling out using a rolling pin between two battens of wood, used as a thickness guide. © Silkie Lloyd

3: Forming a tapered cylinder around a bottle covered in newspaper. © Ben Boswell

4: Forming a spout on a jug. © Ben Boswell

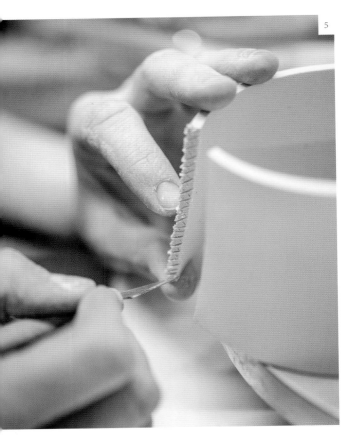

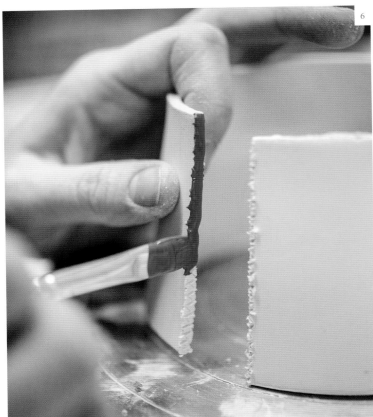

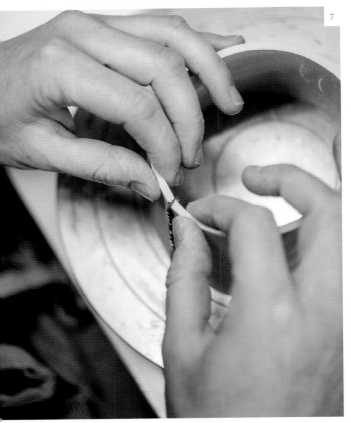

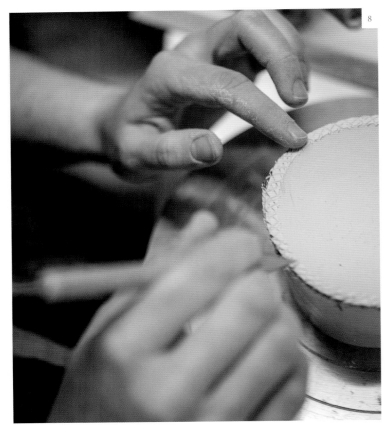

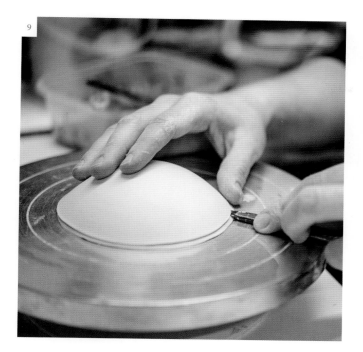

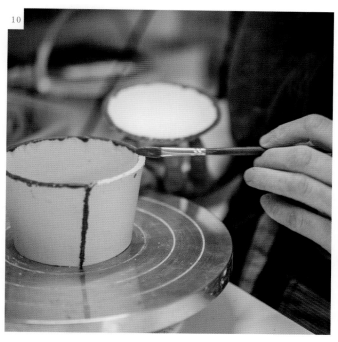

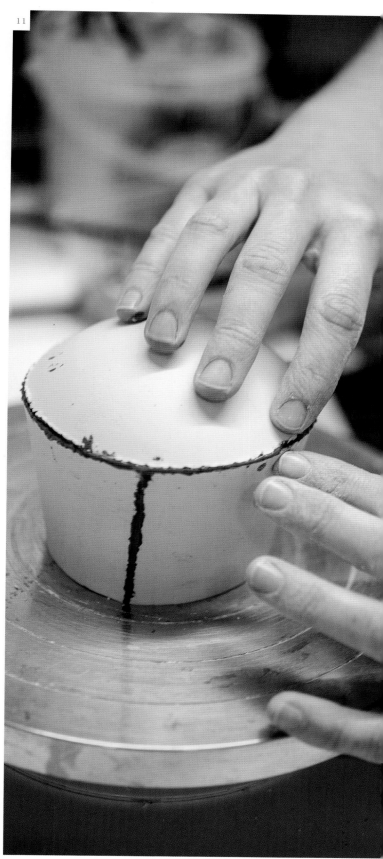

5: Scoring the edges of the slab. © Ben Boswell

6: Applying blue coloured slip. © Ben Boswell

7: Joining the edges together. © Ben Boswell

8: Scoring the edge of the base. © Ben Boswell

9: Trimming the domed base formed in a press mould. © Ben Boswell

10: Applying blue slip to the edge. © Ben Boswell

11: Attaching the base. © Ben Boswell

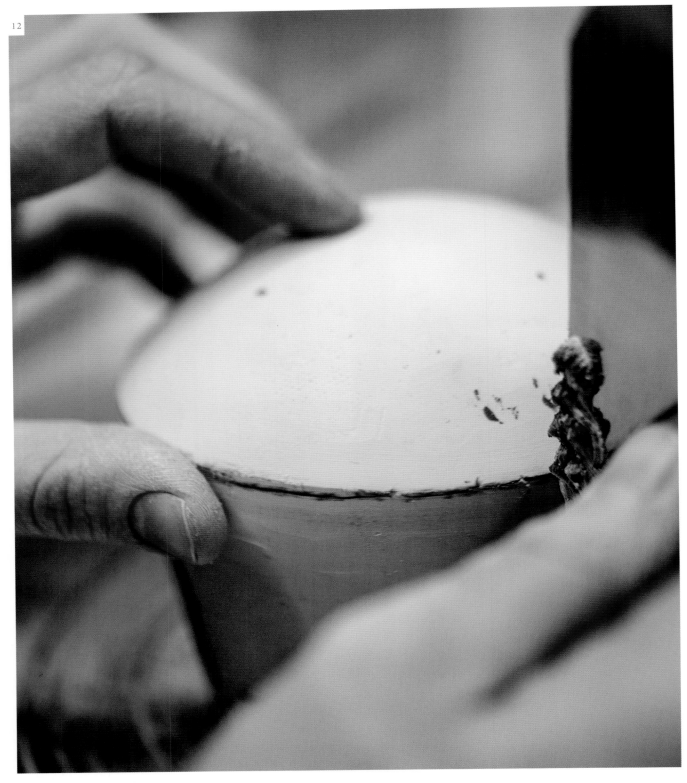

12: Scraping away excess slip using a metal kidney. © Ben Boswell

13: Finished mug by Jessica Thorn, slab-built porcelain with blue slip, glazed with a transparent glaze on the inside and diamond polished on the outside. © Jess Hand

Overleaf: Mugs and cup by Sarah Pike made from mid-range red stoneware and fired to cone 6. They are slab-built and textured with hand-carved stamps. © Sarah Pike

13

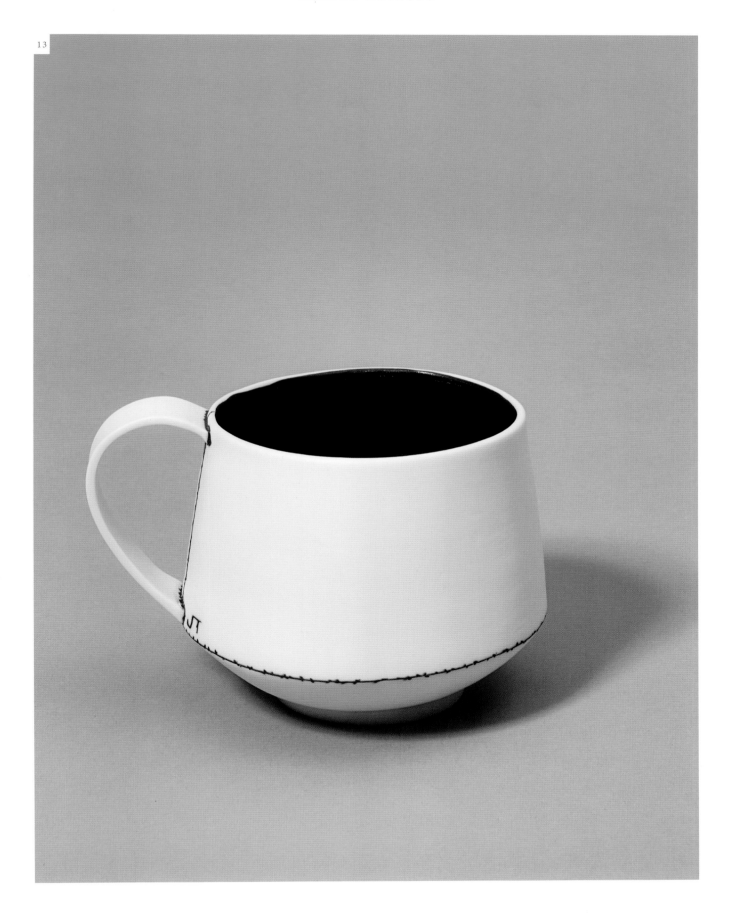

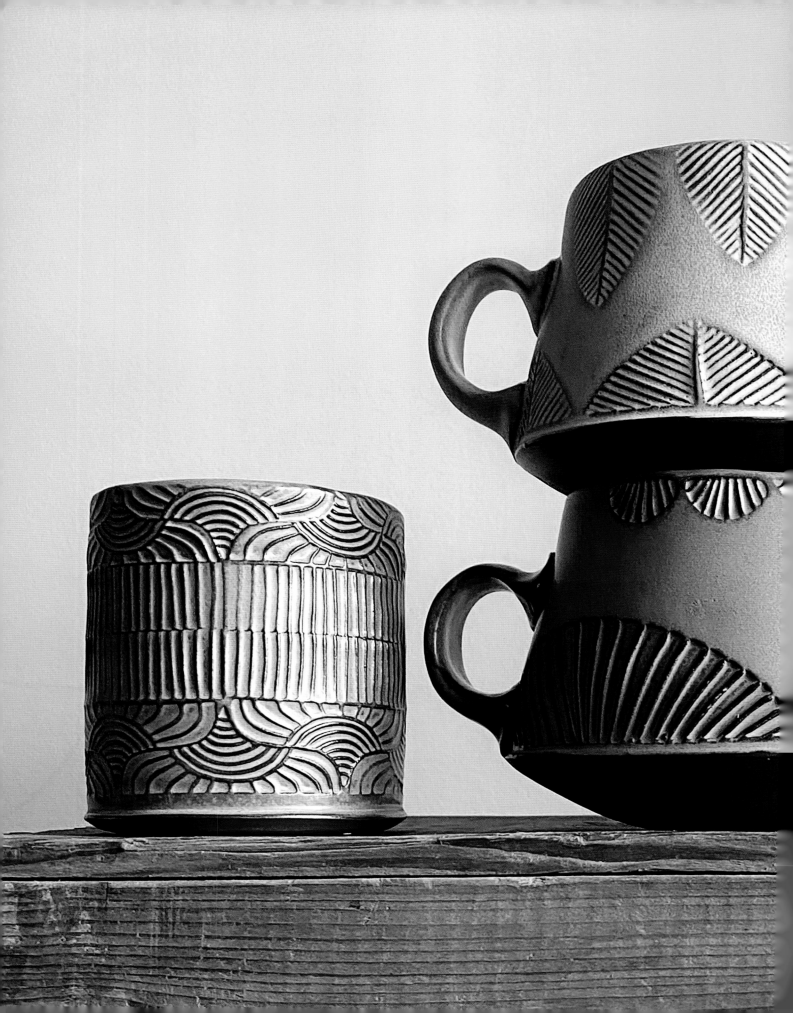

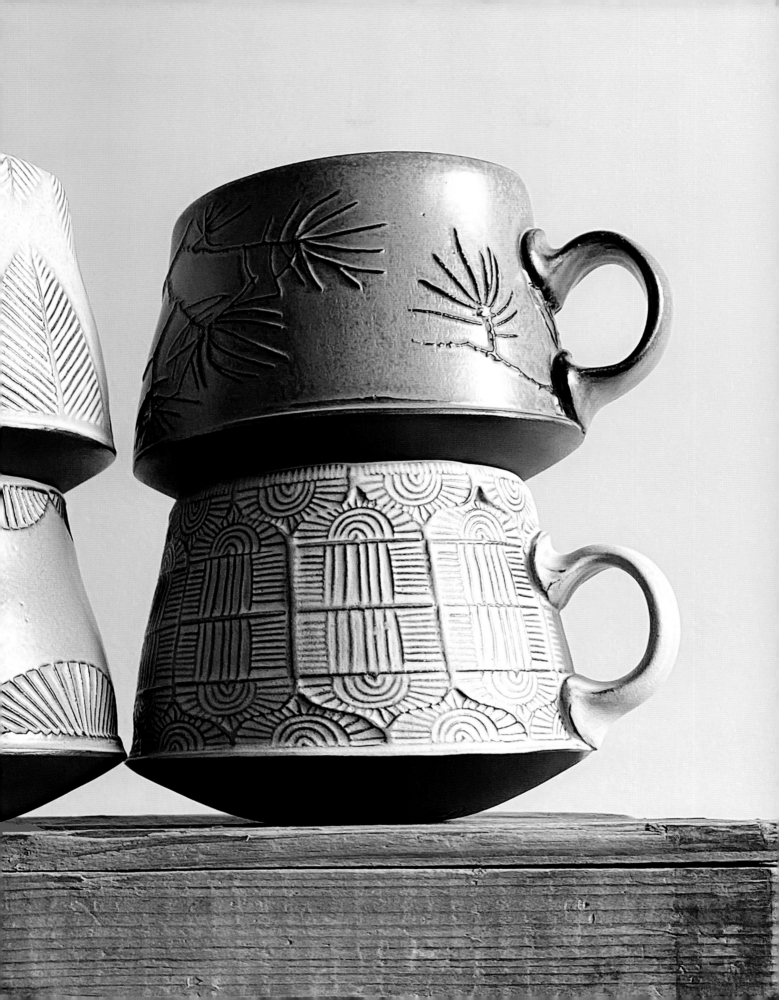

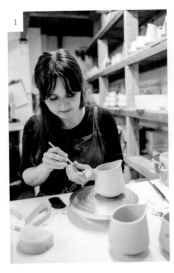
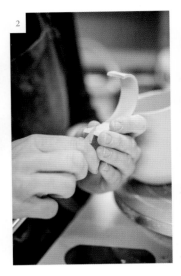
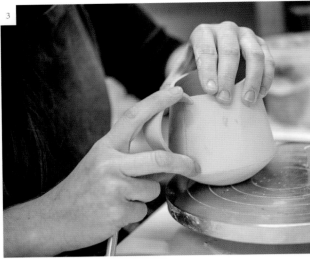

SLAB HANDLE BY JESSICA THORN

1: Cutting a slab handle to attach to her slab-built jug.
© Ben Boswell

2: Cutting the handle to the right size. © Ben Boswell

3: Positioning the handle onto the jug. © Ben Boswell

4: Scoring the jug at the marked positions where the handle will be attached. © Ben Boswell

5: Applying clay slip. Jessica uses coloured slip as a feature of her work, highlighting the joins. © Ben Boswell

6: Attaching the handle to the jug. © Ben Boswell

Opposite: Finished jug by Jessica Thorn, slab-built porcelain with blue slip on the inside, glazed with a transparent glaze on the inside and diamond polished on the outside. © Jess Hand

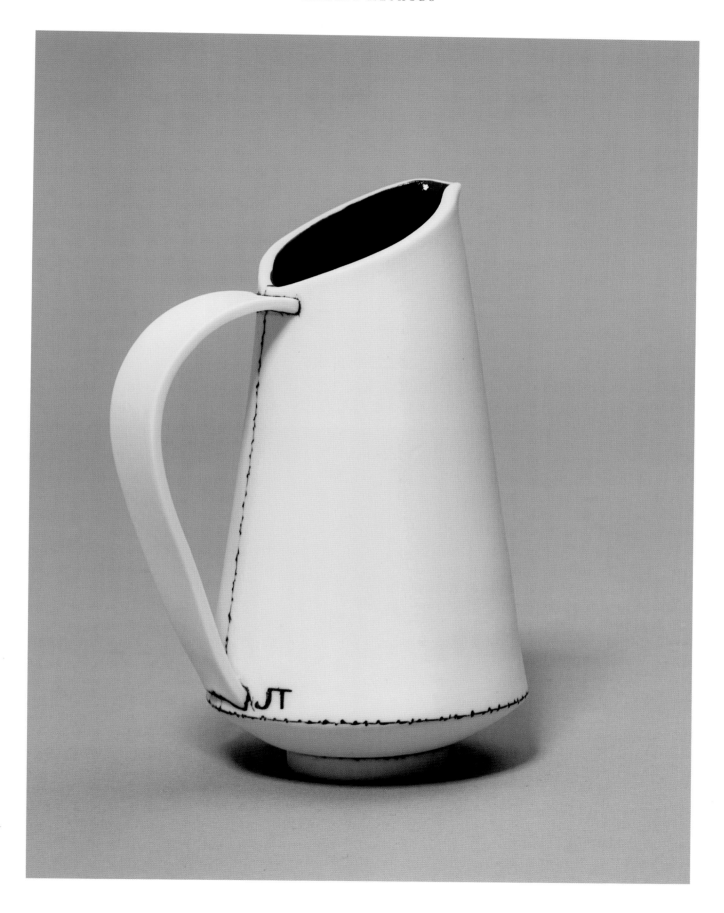

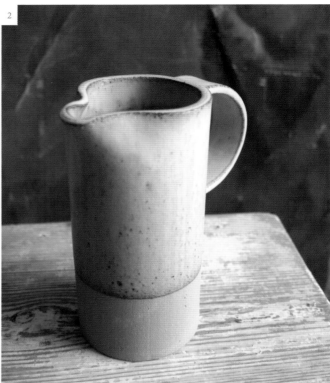

EXTRUDING

Forms can be extruded through a die that has been cut to the required shape. Extruding is a good way to make rectangular serving dishes. Some potters use an extruder to make uniform coils which can then be joined onto thrown pots. The jug shown here is made from an extruded cylinder, with a slab base and handle joined on.

1: Christine Hester Smith extruding red earthenware clay.
© Christine Hester Smith

2: Extruded stoneware jug by Tom Butcher.
© Rosie Brown

3: Extruded stoneware dishes by Tom Butcher.
© Tom Butcher

THROWING

Production potters who make multiple pieces need to have a well-organised workspace. Plenty of shelving is essential, as are ware boards placed near the wheel on which to place freshly thrown pots. The clay preparation table needs to be very stable so that it does not move during wedging and you will need a set of scales for weighing out balls of clay so that each piece in a batch is the same size. It is most efficient to make in batches of the same shape and to make just enough work to fill the kiln. For example, I know that 22 mugs will fill one kiln shelf and I can fit five shelves of mugs in my kiln. That way, once the making, firing, and glazing cycle has finished, you can start again with empty shelves. Orders can be pinned on a notice board in the studio or chalked on a blackboard.

WHEELS

There are several types of potter's wheel, either with a momentum wheel or foot treadle, or powered by electricity. Wheels usually have a removable tray to collect water or slip used for lubricating the clay. They are usually turned anticlockwise in the West and clockwise in the Far East and it is useful if the direction can be reversed.

Top: Electric wheel.

Bottom: Tools for throwing. From top right: chamois leather for smoothing rims, cutting wire, wooden ribs, pin, bevelling tool, throwing stick, sponge on a stick and measuring callipers.

Throwing involves shaping a pot on the wheel using the hands. A ball of clay is thrown down onto the dampened wheel so that it sticks, then centred on the spinning wheel using the hands lubricated with water, then a well is opened up using the thumbs or middle finger to form the base. Pressure is applied by the fingers to the clay wall which is pulled slowly up from the rotating wheel head, lifting and growing the pot. Often a finger is used on the inside and a knuckle on the outside. Some potters throw using a sponge or wooden rib. Several lifts are needed before the required height and wall thinness is reached, then the pot walls can be stretched and shaped outwards In this way, mugs, jugs, vases and bowls can be made relatively quickly.

Before you start throwing on the wheel, the clay needs to be prepared thoroughly by wedging and kneading (see Chapter 5, Clay Preparation). If the clay is too wet, it will be difficult to throw tall pots with thin walls; it can be left out of the bag overnight to firm up. Earthenware and stoneware clays are easier to throw than porcelain. More experienced potters will be able to throw taller and thinner pots with the same weight of clay.

Some potters complete the pot while throwing on the wheel, while others throw more thickly and spend more time turning when the pot is leather hard. Turning involves fixing the pot back onto the wheel and shaving off clay using sharp metal tools. When making large batches of pots, it is a good idea to design shapes that do not need too much turning, in order to improve efficiency.

THROWING WEIGHTS

Typical weights of clay to use for throwing, final dimensions after firing. Stoneware and porcelain clays shrink by 12-15%. Earthenware shrinks by 8-11% from wet to fired.

	Weight	Height	Diameter
Plate (Below)			
Small	450 g (1 lb)	-	20 cm (8 in)
Medium	900 g (2 lb)	-	25 cm (9¾ in)
Mug (1)			
Standard	340 g (12 oz)	11 cm (4¼ in)	7 cm (2¾ in)
Large	450 g (1 lb)	11 cm (4¼ in)	8 cm (3 in)
Cup (2)			
Standard	280 g (10 oz)	7 cm (2¾ in)	11 cm (4¼ in)
Saucer (3)			
Standard	400 g (14 oz)	3 cm (1¼ in)	17 cm (6¾ in)
Jug (4)			
Small	340 g (12 oz)	9 cm (3½ in)	-
Medium	450 g (1 lb)	12 cm (4¾ in)	-
Large	900 g (2 lb)	15 cm (6 in)	-
Bowl (5)			
Small	280 g (10 oz)	7 cm (2¾ in)	11 cm (4¼ in)
Medium	450 g (1 lb)	8 cm (3 in)	14 cm (5½ in)
Sugar pot (6)			
Small	340 g (12 oz)	11 cm (4¼ in)	-
Teapot (7)			
Medium	900 g (2 lb)	14 cm (5½ in)	-

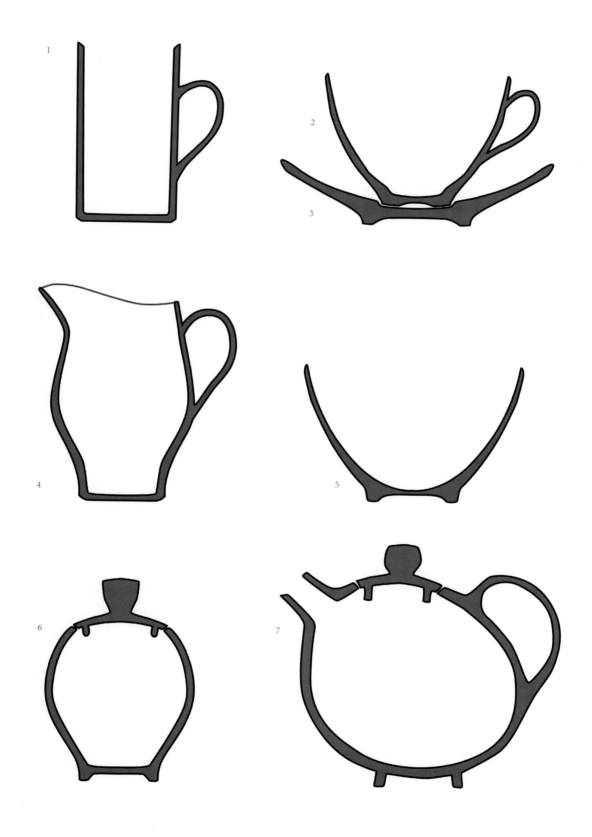

1

MUGS

Mugs are made by throwing a cylinder with a flat base. A ball of clay is slammed down onto the wheel, centred and flattened until it is the diameter required, before opening up a well in the centre. To check the thickness of the base, you can insert a pin. The inside base is widened by pulling the fingers gradually away from the centre. The wall can then be lifted using a finger on the inside and a knuckle on the outside to pull up the clay. The walls can be collared inwards between lifts to keep them from growing outwards. Several lifts will be needed to reach the maximum height. As the wall is lifted higher, less pressure will be required towards the top. The walls can be consolidated and straightened using a wooden rib on the outside and a finger on the inside. This also removes slurry and throwing lines. The base is finally bevelled at the edge using a wooden or metal tool and the mug is cut under with a wire and lifted off the wheel. A number of different shapes such as jugs, vases and teapots can be formed from an initial cylinder.

PORCELAIN MUG BY LINDA BLOOMFIELD

1: Forming a flat base using the middle fingers.

2: Pulling up the wall using the middle finger on the inside and the knuckle on the outside. The rim is compressed with the thumb at the same time. Note the well-defined inside corner. © Ben Boswell

3: Pulling up a ripple of clay using a finger on the inside and a knuckle on the outside. © Ben Boswell

4: Starting another lift from the base and moving up slowly. © Ben Boswell

5: Completing the lift by easing off the pressure near the rim. © Ben Boswell

6: Using a wooden rib to remove slurry and consolidate the outside profile. A metal tool has been used to clear away excess clay from around the base and bevel the edge. © Ben Boswell

7: Jaejun Lee turning a mug using a turning tool he made himself. © Ben Boswell

2

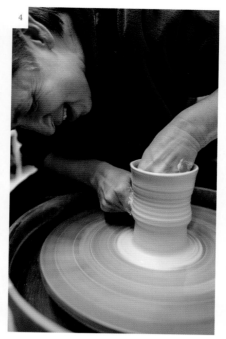

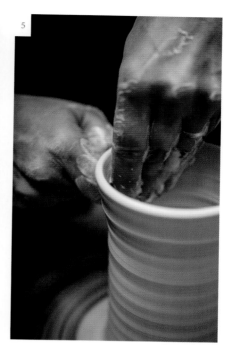

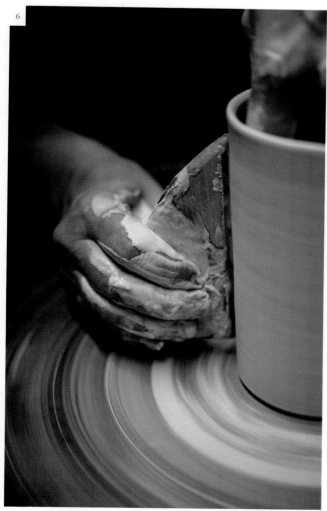

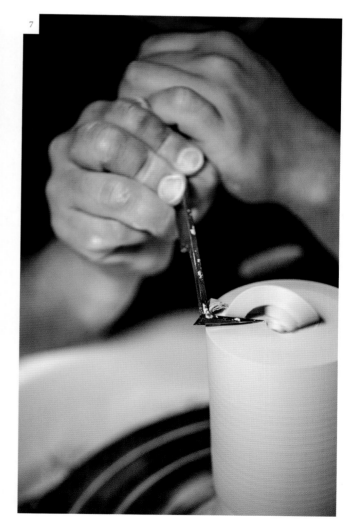

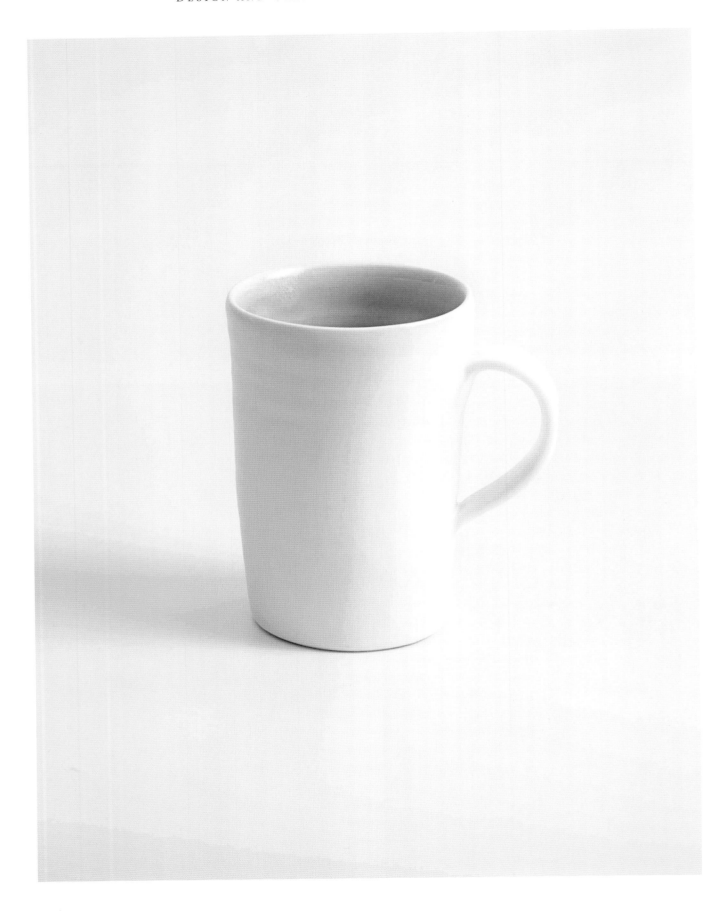

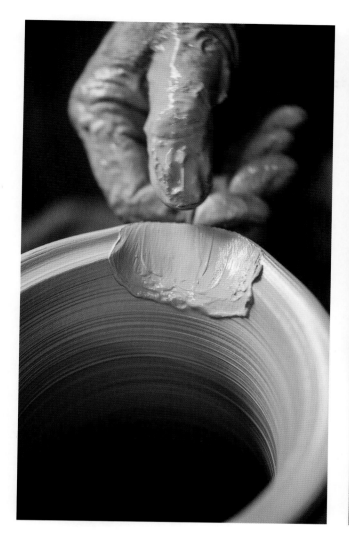

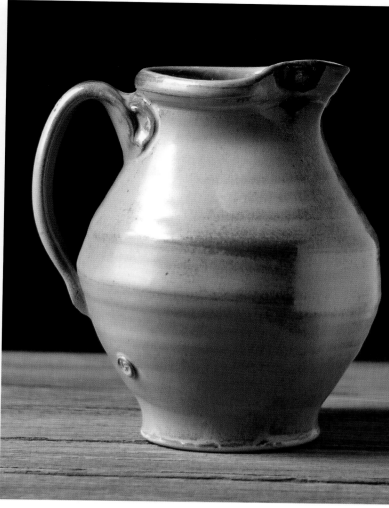

JUGS

Jugs are made in the same way as mugs and can be bellied out to form a rounded or baluster shape which increases the capacity. To make the pouring lip, an area of the rim is thinned and pulled up before forming into a lip between the finger and thumb of one hand and the finger of the other hand. The edge of the rim should be sharp enough to cut off the flow of liquid when you have finished pouring. The rim can be smoothed using a wetted strip of chamois leather.

Opposite: The finished mug.

Left: Joe Finch pulling a lip on a jug. © Ben Boswell

Right: Thrown stoneware jug with a wide-bellied form and pulled lip by Lucy Fagella. © Lucy Fagella

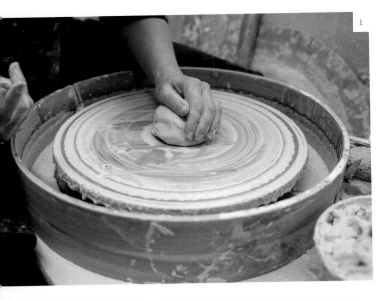

BOWLS

Bowls are made by first throwing a V shape on the wheel with slightly higher walls than needed in the finished bowl, and then stretching the rim wider using a curved rib and refining the shape of the inside curve. The base should not be too narrow to start with, otherwise the bowl walls may slump. In large bowls the base should be relatively wide and flat and the bowl can be thrown on a wooden batt to make it easier to remove from the wheel. The excess clay at the base helps to support the walls and can be turned away at the later stage.

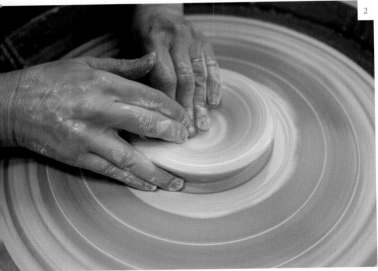

THROWN PORCELAIN BOWL
BY LINDA BLOOMFIELD

1: A ball of clay is firmly placed on the wheel. © Henry Bloomfield

2: Opening up using the middle fingers. The area of the base is small. © Henry Bloomfield

3: The walls are pulled up with the knuckle on the outside and the index finger on the inside. © Henry Bloomfield

4: Continuing to pull the walls upwards and outwards. © Henry Bloomfield

5: Each lift brings a ripple of clay from the base up to the rim. The outer knuckle is positioned just below the ripple. © Henry Bloomfield

6: The rim is stretched outwards, thinned and refined. © Henry Bloomfield

7: A curved wooden rib is used to shape the inside profile, with the fingers of the other hand pressing on the outside. © Henry Bloomfield

8: A metal tool is used to cut a bevel and remove slurry. © Henry Bloomfield

9: The bowl is wired underneath and lifted off the wheel. © Henry Bloomfield

Opposite bottom: The finished bowl.

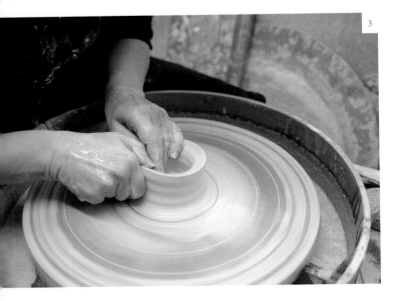

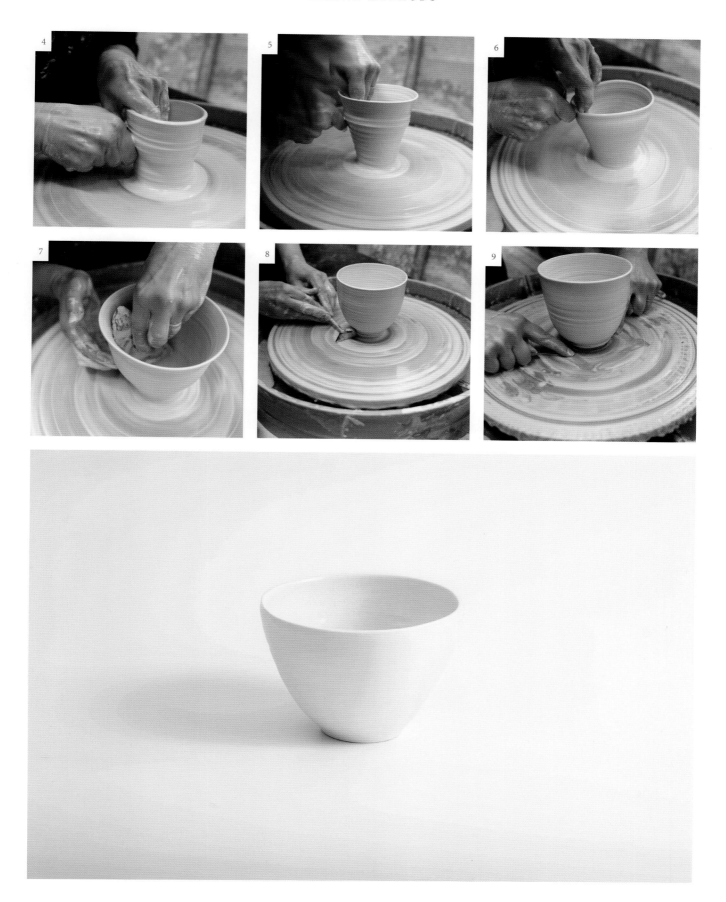

Turning involves placing the leather-hard bowl upside down on the wheel and fixing with three pads of clay or placing on a chuck. A chuck is a solid cylinder of clay onto which you place the upturned cup or bowl. (A chum is a hollow cylinder of clay into which you fit the upturned pot for turning.) Clay is shaved away using a metal bevelling tool or loop tool. The foot-ring can then be formed and excess clay turned away from the base and sides.

TURNED BOWL BY HENRY BLOOMFIELD

1: The bowl is fixed to the wheel using three pads of clay.

2: A foot-ring is marked out using a metal loop tool.

3: The centre of the foot-ring is hollowed out using the loop tool.

4: The inside edge of the foot-ring is completed.

5: The outside edge of the foot-ring is trimmed.

6: The flat surface of the foot-ring is trimmed.

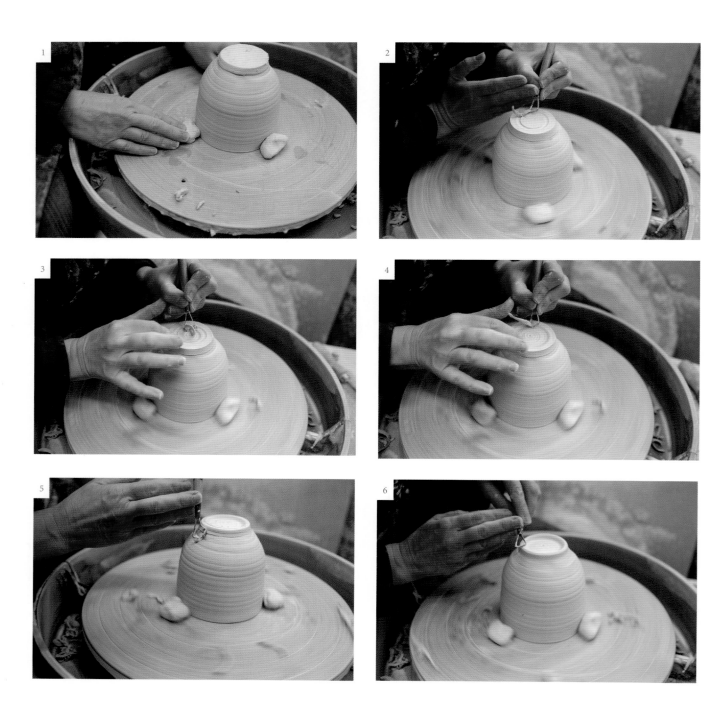

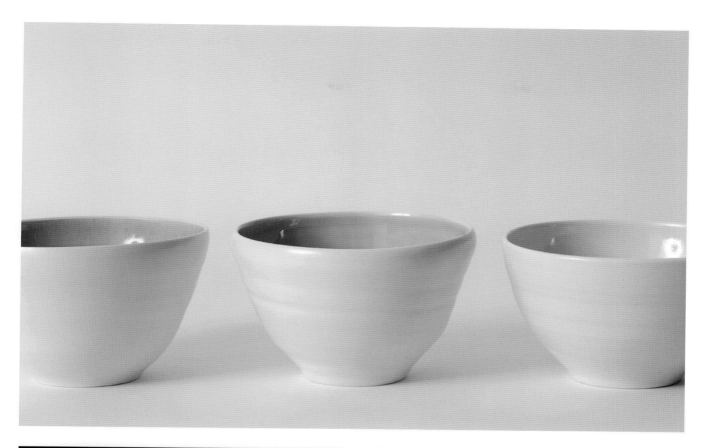

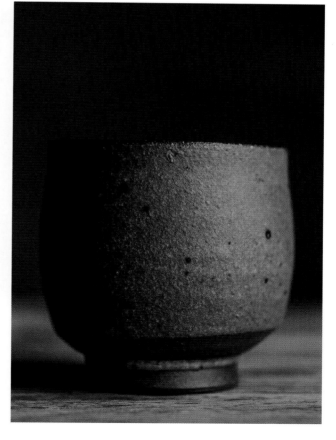

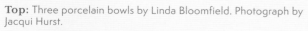

Top: Three porcelain bowls by Linda Bloomfield. Photograph by Jacqui Hurst.

Bottom left: A foot-ring elevates this turned stoneware tea bowl by Ali Herbert. © Matt Austin

Bottom right: The foot-ring of a stoneware tea bowl by Ali Herbert. © Matt Austin

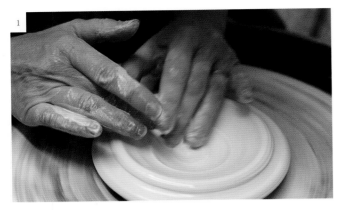

THROWN SAUCER BY LINDA BLOOMFIELD

1: Forming a well at the centre of the saucer which is slightly wider than the foot-ring of the cup. © Henry Bloomfield

2: Forming the wall of the saucer. © Henry Bloomfield

3: Lifting and thinning the wall. © Henry Bloomfield

4: Finishing the rim of the saucer. © Henry Bloomfield

5: Defining the edge of the well. © Henry Bloomfield

6: Bevelling the edge of the base. © Henry Bloomfield

7: Cutting under with a fine wire. The saucer is left on the batt overnight and turned the next day. © Henry Bloomfield

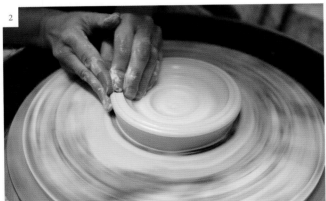

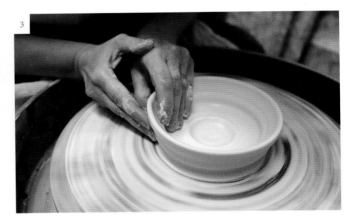

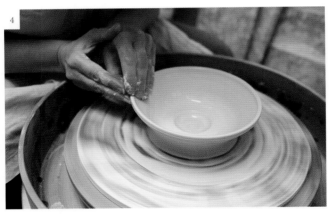

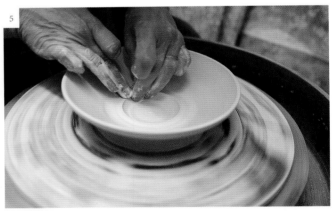

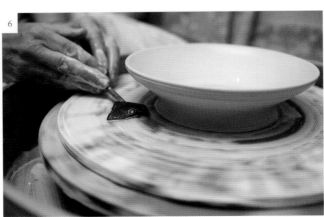

SAUCERS

Saucers are shallow bowls with a well in the centre that fits the foot-ring of the cup and prevents it from sliding around. They are thrown in the same way as a bowl, centring a flattened ball of clay, opening up a V shape, forming the well in the centre slightly larger than the foot-ring or base of the cup and pulling the walls upwards and outwards. The base needs to be thick enough to form both the well and the turned foot-ring below, so should start off double the thickness of the base of a bowl. Finally, a rib can be used to stretch, flatten and turn the wall outwards like the rim of a plate. The base should be left relatively wide to support the walls. The excess clay at the base can be turned away later.

TURNED SAUCER BY LINDA BLOOMFIELD

1: Turning the base of a saucer using a loop tool. Three pads of clay are used to fix the saucer to the wheel.
© Henry Bloomfield.

2: The excess clay at the edge of the base is turned away.
© Henry Bloomfield

3: The edge is bevelled so that the glaze can be wiped back neatly to this edge. © Henry Bloomfield

Below; The central well of the foot-ring has been turned. Very little clay has been removed from the central part where the well is. © Henry Bloomfield

Some potters make the well at the throwing stage, while others turn it later. The well should be slightly larger than the foot-ring of the cup. The foot-ring on the base of the saucer can be slightly larger than the central well. Be careful not to make the base too thin.

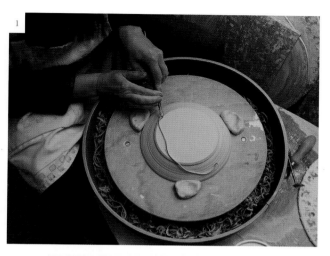

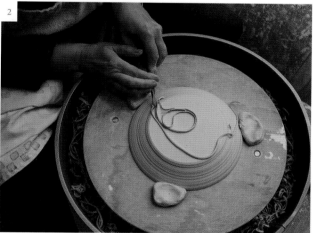

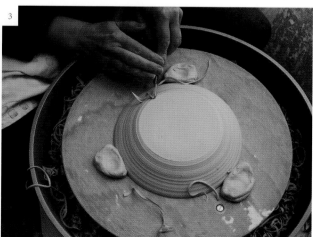

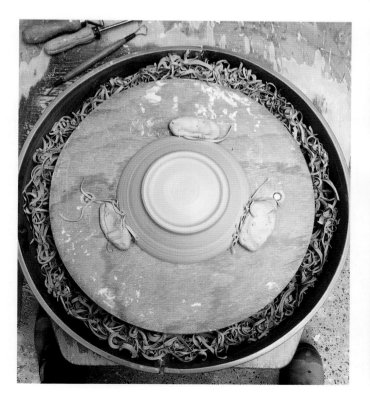

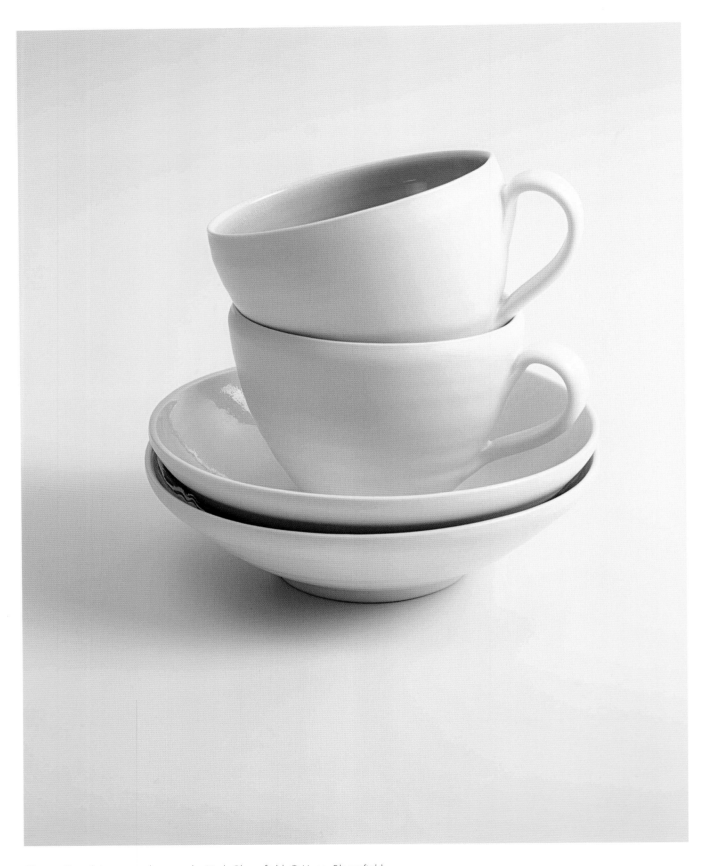

Above: Porcelain cups and saucers by Linda Bloomfield. © Henry Bloomfield

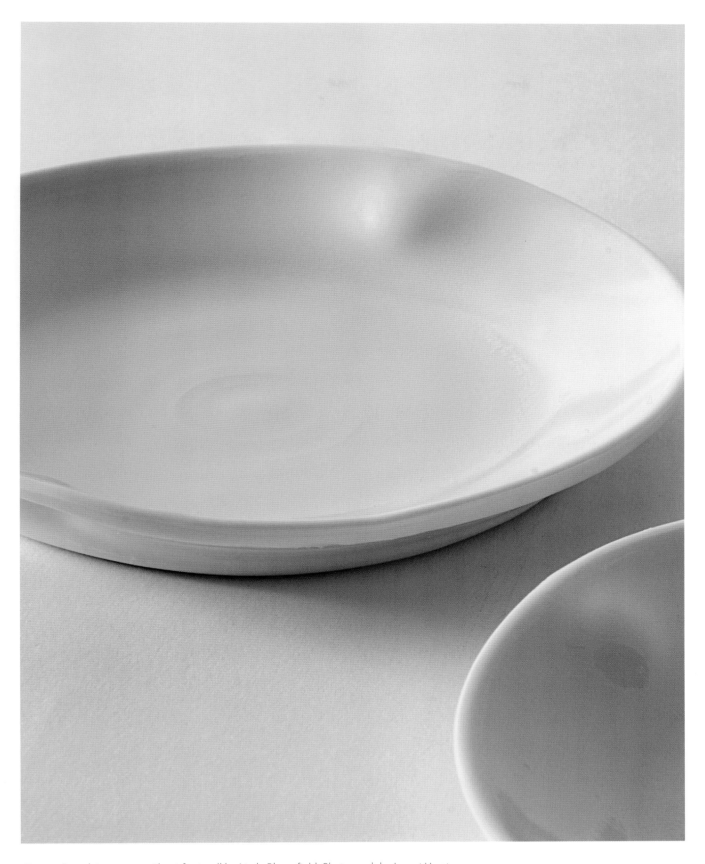

Above: Porcelain saucers without foot well by Linda Bloomfield. Photograph by Jacqui Hurst.

HANDLES

Handles can be made using a variety of methods. They can be hand built from coils or slabs, or pulled from a thick coil of clay using water as lubrication. Some potters attach a thick, pulled stub to the pot and then pull it further while joined to the pot before cutting off the excess and attaching the lower end. Others form the handle fully and leave it to dry slightly before attaching to the pot, scoring and using slip to get a firm join. Ideally, the handle and pot should be joined when they are at the same state of dryness, otherwise cracks may form as the handle dries and shrinks. Slipcasting in a mould is another way to make handles (see page 120, Handle Carving).

HANDLE BY LINDA BLOOMFIELD

1: Pulling a handle in porcelain, using a hand dipped in water and pulling the clay between two fingers. © Henry Bloomfield

2: Pulling the clay between thumb and finger until it reaches a suitable width and length. © Henry Bloomfield

3: Using a knife to score the cup. © Henry Bloomfield

4: Applying slip. © Henry Bloomfield

5: Cutting a length of handle. © Henry Bloomfield

6: Applying the handle to the cup. © Henry Bloomfield

7: Pressing the handle onto the cup. This style of handle is not pulled on the pot as the porcelain cup can distort. © Henry Bloomfield

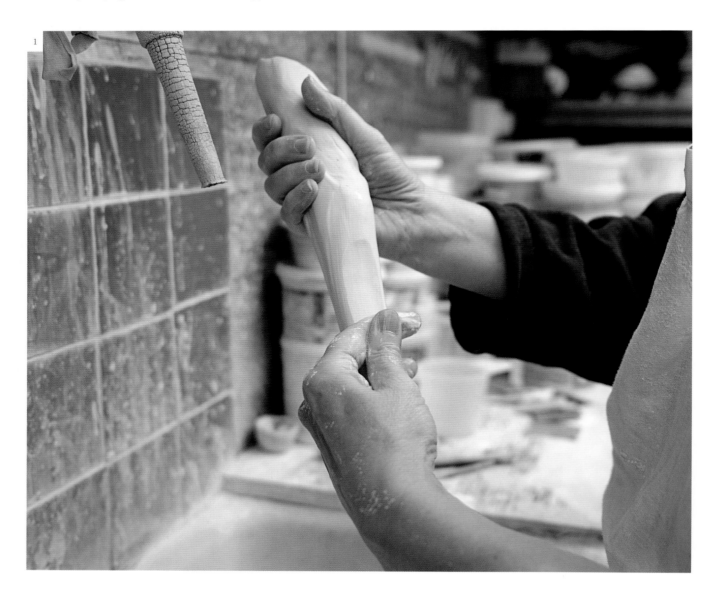

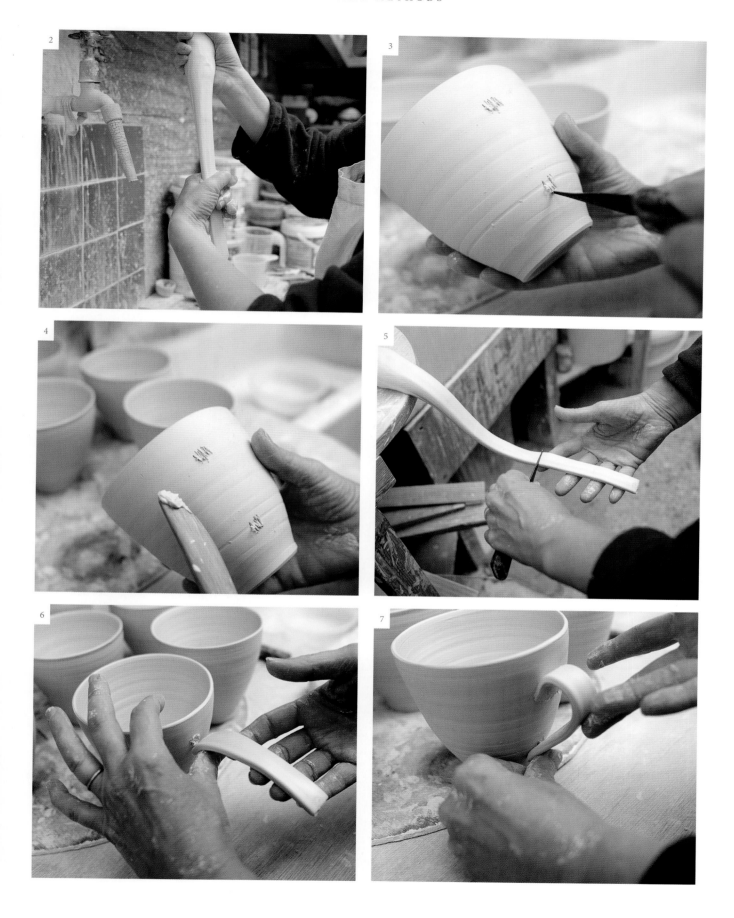

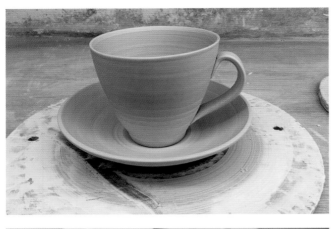
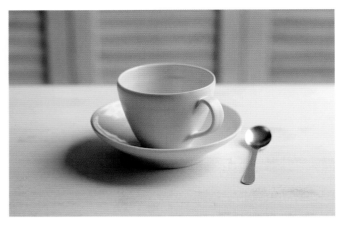

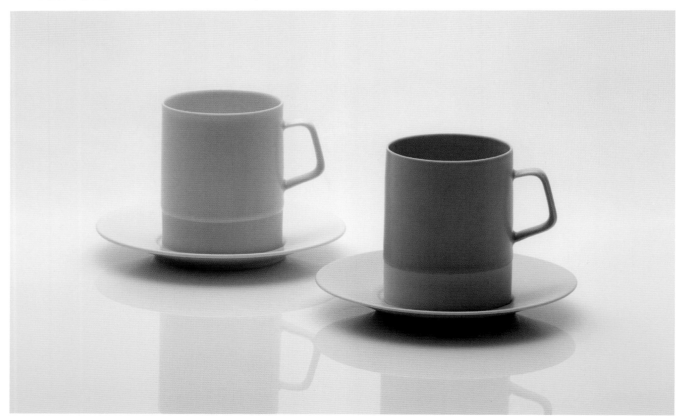

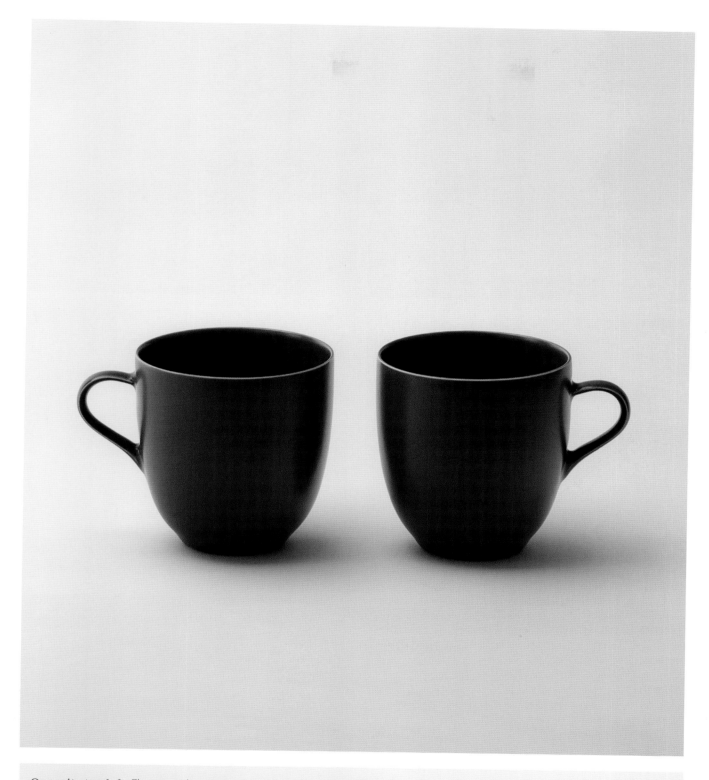

Opposite top left: The cup and saucer prior to firing. © Henry Bloomfield

Opposite top right: Finished cup and saucer by Linda Bloomfield. © Henry Bloomfield

Opposite middle left: Moulds for slipcasting handles by Jaejun Lee. © Ben Boswell

Opposite middle right: Jaejun Lee attaching a slipcast handle to a thrown and turned mug. © Ben Boswell

Opposite bottom and above: Porcelain mugs, thrown and turned with slipcast handles by Jaejun Lee. © Jaejun Lee

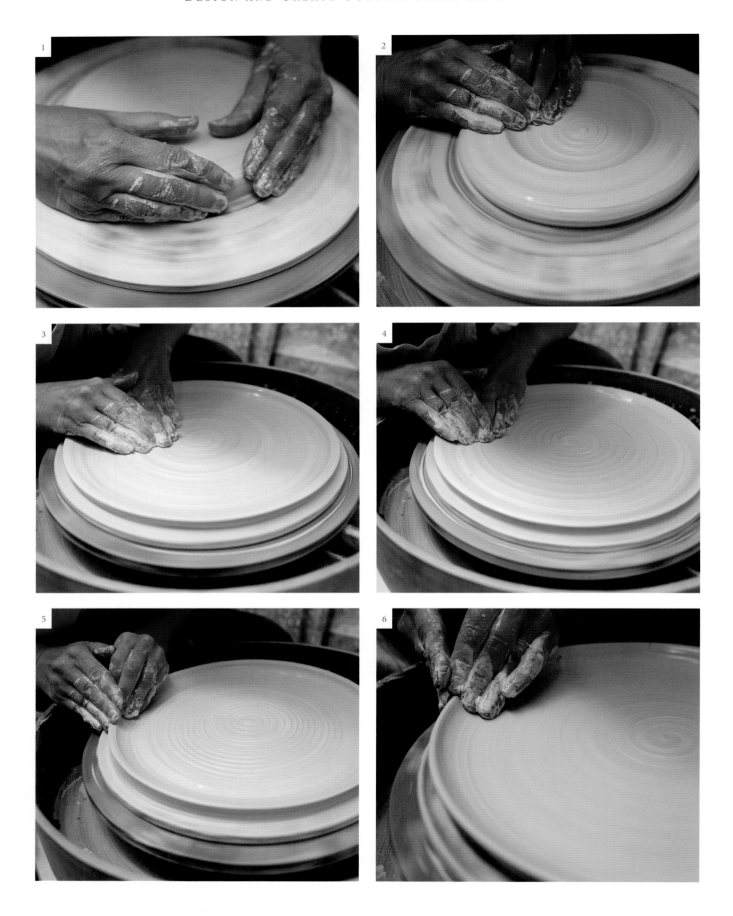

PLATES

Plates can be thrown on the wheel, with or without a flat rim. It is best to use a wooden batt so that the plate can be taken off the wheel without distorting. Clay preparation is important, as is making a smooth surface by patting the ball of clay before throwing on the wheel so that no air is trapped between the clay and the batt. A ball of clay is thrown onto the moistened batt, centred and flattened out, then opened up and pulled outwards towards the edge of the batt using the fingers or heel of the hand, leaving enough clay at the edge to form the rim. The base can be compressed using a rib to prevent cracking. The wall of the plate is then thrown upwards. If making a flat rim, use a rib to stretch, dry and turn the surface outwards and make sure that is the last thing you do when finishing off on the wheel, otherwise the rim may collapse. Flat plate rims often shrink and lift up during drying, sloping upwards higher than they were when first thrown. The plate is wired under using a fine wire then left on the batt overnight and turned the next day. If a foot-ring is needed, the base of the plate should be made relatively thick. Larger plates sometimes need two concentric foot-rings to prevent the centre slumping during firing. I prefer to make flat coupe plates without foot-rings as this makes them lighter.

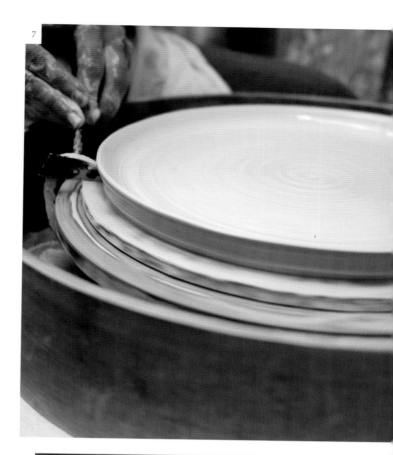

THROWN FLAT PLATES BY LINDA BLOOMFIELD

1: Centring a flat pad of clay onto the wheel. © Henry Bloomfield

2: Opening up the centre of the plate. © Henry Bloomfield

3: Pulling the clay out towards the edge of the batt, making sure not to trap air between the clay and the batt. © Henry Bloomfield

4: Compressing the base of the plate to prevent cracking. © Henry Bloomfield

5: Forming the rim of the plate. © Henry Bloomfield

6: Thinning and finishing the rim. © Henry Bloomfield

7: Bevelling the edge of the plate and removing slurry. © Henry Bloomfield

8: Wiring under the plate using a thin wire. The plate is left on the batt overnight and the base is trimmed the next day when the plate is leather hard. © Henry Bloomfield

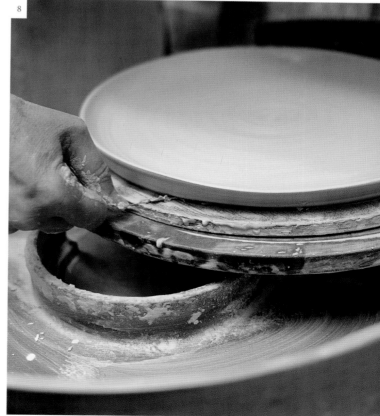

TURNING PLATES

These porcelain plates have a flat base. They are lifted off the batt the day after throwing. If the plates are stuck to the batts, they can be wired under again before turning over onto another batt and trimming. A fine, twisted wire helps prevent the plate from sticking back onto the batt after wiring. Compressing the underneath of the plate by trimming with a metal tool is an important step to prevent cracking. The edge of the plate is bevelled so that glaze can be wiped back to a straight edge.

1: Trimming the base to make it smooth and prevent cracking. © Ben Boswell

2: Cutting a bevelled edge with a loop tool. This makes it easier to sponge back the glaze to a neat edge. © Ben Boswell

3: Close-up of bevelled edge. © Ben Boswell

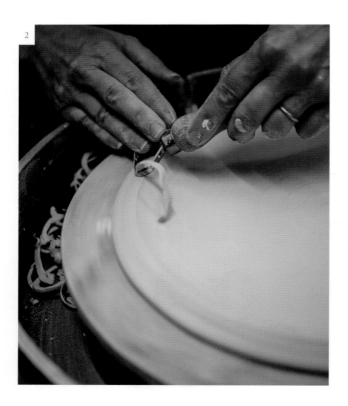

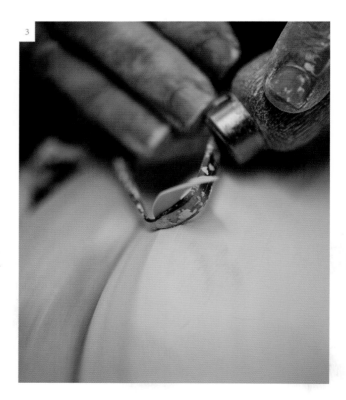

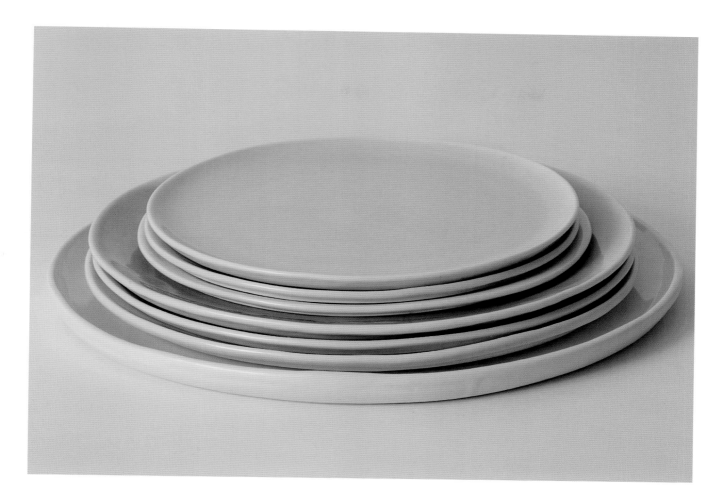

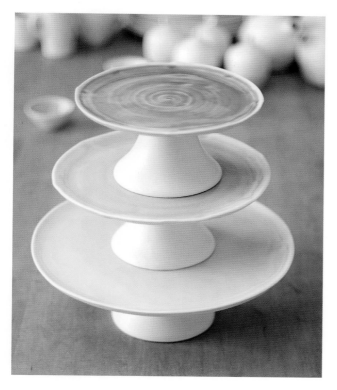

Tip: *Flat plates can be made into cake stands by adding a separately thrown foot. To avoid slumping, the plate and foot can be stuck together after firing using epoxy resin or tile adhesive. Another type of cake stand is shown on page 201 where the plates are stacked and joined by a central pole.*

Top: Porcelain plates with coloured glazes by Linda Bloomfield. Photograph by Jacqui Hurst.

Left: Porcelain cake stands by Linda Bloomfield. Each plate and foot are thrown separately and assembled after firing using tile adhesive.

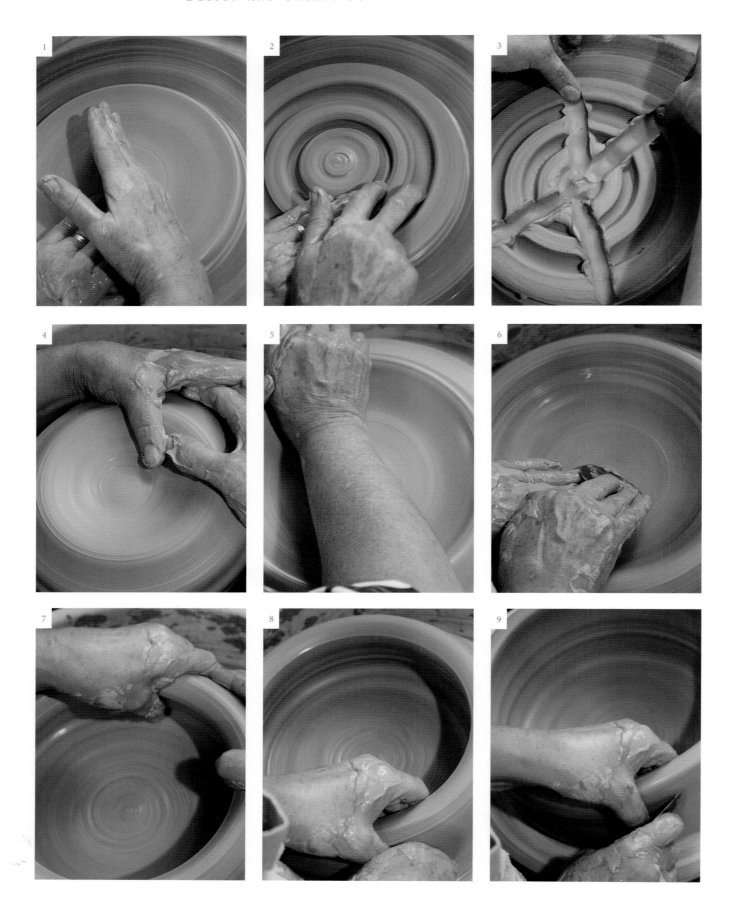

10

BAKING DISH BY ADRIANA CHRISTIANSON

1: Adriana Christianson throwing a pad of clay
on which to stick a wooden batt. © Adriana Christianson 2021

2: Making grooves in the pad of clay. © Adriana Christianson 2021

3: Making a cross so that the batt can be released easily.
© Adriana Christianson 2021

4: With a wooden batt now fixed to the wheel, the clay is centred
© Adriana Christianson 2021

5: The heel of the hand is used to form the base and push the clay
to the edge. © Adriana Christianson 2021

6: A rib is used to compress the base and avoid cracks.
© Adriana Christianson 2021

7: The rim is compressed and pulled upwards and inwards.
© Adriana Christianson 2021

8: The walls are lifted with one hand on the inside and the other
on the outside. © Adriana Christianson 2021

9: A rib is used to compress and smooth the outside wall.
© Adriana Christianson 2021

10: Oven-to-table baking dish by Adriana Christianson,
reduction-fired stoneware at 1280°C (2336°F) in Melbourne, Australia.
© Adriana Christianson 2021

Note: *Oval dishes and bowls are made by throwing a cylinder without a base, pressing into an oval and then attaching it to a separate slabbed or thrown base. It's important that your glaze fits well to your clay body, especially for ovenware. Read the chapter on Glazing, and in particular the information on shivering and dunting if you have any problems.*

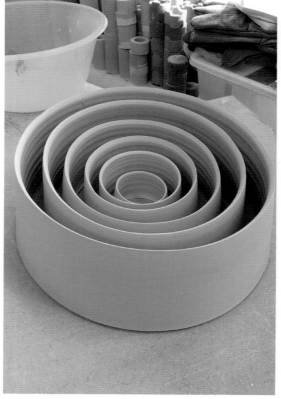

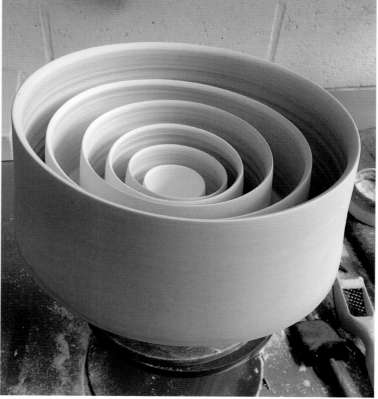

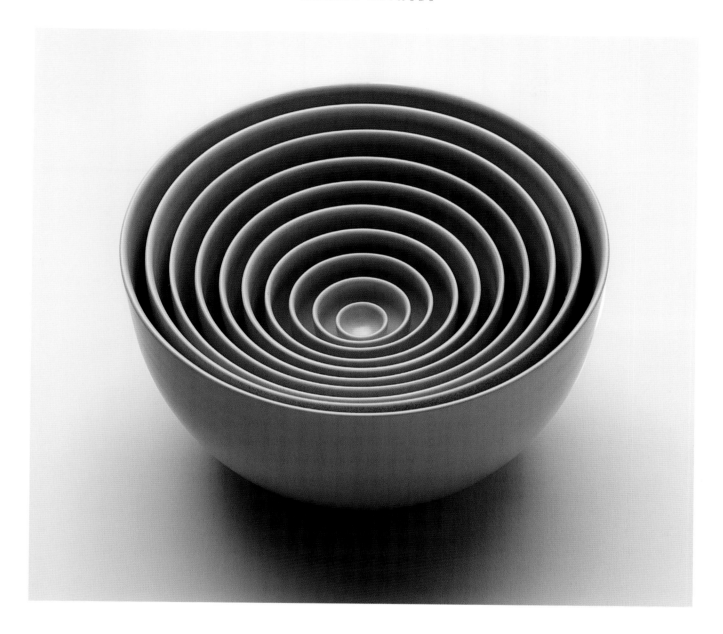

NESTING BOWLS

Each bowl within this nesting set (see opposite) is thrown in two separate parts; a top ring section (without a base), and a shallow bowl. The clay is weighed prior to throwing in order to produce the correct size bowl within the nest. When the sections are leather hard, the bowl is turned and trimmed, while the ring section is cut away from the batt and then lightly pressed to form an oval shape. The oval top is then joined to the bowl and the parts are sealed with slip. Once the slip has firmed, a surform tool is used to remove excess clay and shape the piece into a crisp oval bowl.

Opposite top: Sabine Nemet making an oval stoneware dish by distorting a thrown cylinder and attaching it to a slabbed base. © Ben Boswell

Opposite bottom left: Thrown nesting bowls by Louisa Taylor, before adding them to their bases. © Louisa Taylor

Opposite bottom right: Thrown nesting bowls by Louisa Taylor, now attached to their bases. © Louisa Taylor. Louisa's finished bowls can also be seen on page 24.

Above: Nesting porcelain bowls thrown and turned by Jaejun Lee. It requires a lot of skill to make ten pieces that fit snugly inside each other. © Jaejun Lee

TEAPOTS

Teapots are usually made in several sections; a body, lid, spout and handle. The thrown parts are usually left to dry until they are firm, then joined together the next day. The smaller pieces such as the spout and lid should be covered in plastic to make sure they don't dry out more than the body of the pot. The teapot body and lid may need to be turned. The lid can be placed upside down on a chuck or the gallery of the pot, which is attached to the wheel, and turned until it fits. The spout is cut at an angle and held up to the body to make sure the tip is higher than the rim of the body, then its position is marked. Holes are cut inside the area where the spout will be attached. This is then scored and slipped and the spout is joined on firmly. Finally, a handle is attached.

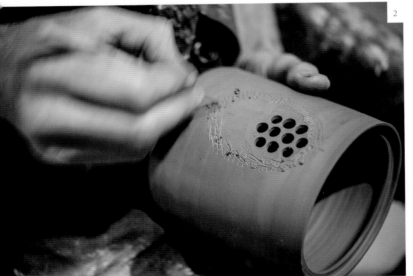

TEAPOT BY JAMES WATERS

1: James Waters thinning the wall around the strainer holes in the teapot body to avoid the holes clogging up with glaze. © Ben Boswell

2: Scoring ready for the spout attachment. © Ben Boswell

3: Slipping. © Ben Boswell

4: Attaching the spout. © Ben Boswell

5: Smoothing the join. © Ben Boswell

6: The finished teapot in the background, decorated by Tilla Waters. © Ben Boswell

7: Teapot spout being thrown by Keith Brymer Jones. © Ben Boswell

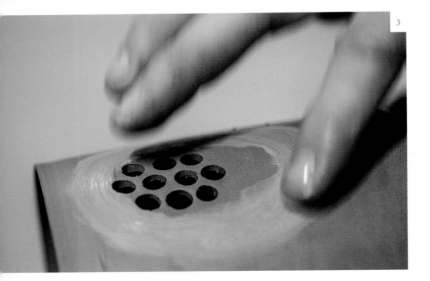

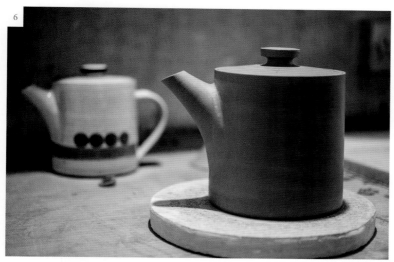

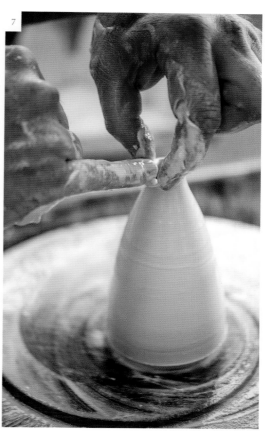

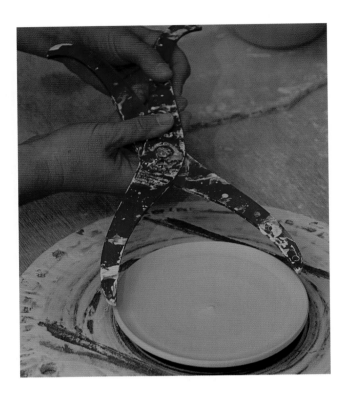

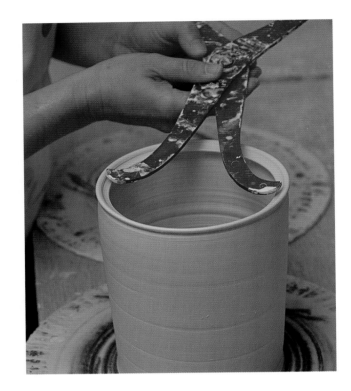

LIDS

Lids can be thrown on the wheel, either upside-down as a shallow bowl, or the right way up as a small dish with a thrown knob in the centre. The pot can have a gallery on which the lid sits, made by splitting the rim and flattening one half. The diameter of the pot needs to be measured carefully using callipers and the lid made to fit. The lid can be turned when leather hard so that it fits perfectly.

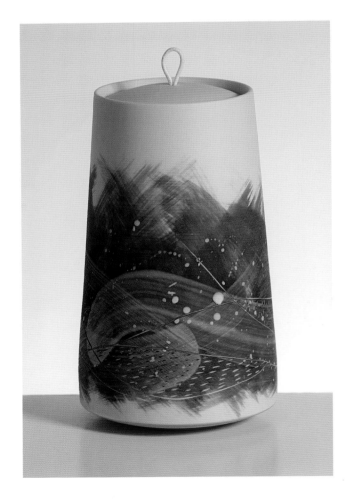

Above left: Measuring the diameter of a lid using callipers.

Above right: Measuring the inside diameter of a cylindrical pot with a gallery for the lid. This was made by splitting a thick rim and pushing down the inside half.

Right: Lidded jar by Juliet Macleod. Height 16.5 cm (6½ in). Diameter 9 cm (3½ in). Wheel-thrown and turned large lidded jar with a cord handle. Decorated with coloured slips using tools hand made from beachcombed wool and metal. Unglazed, polished exterior, glazed orange interior, and orange foot-ring. © Juliet Macleod

Opposite left: Stoneware honey pot by Alice Funge. The pot has a gallery on which the lid sits. The lid has a flange to prevent it falling off. © Alice Funge

Opposite right: Stoneware lidded jar by Pottery West. The lid is thrown as a flat dish with a flange and is slightly larger than the pot so that it can be picked up easily. © Pottery West

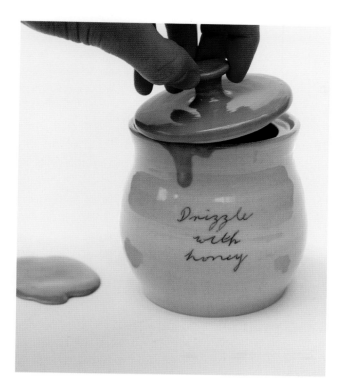

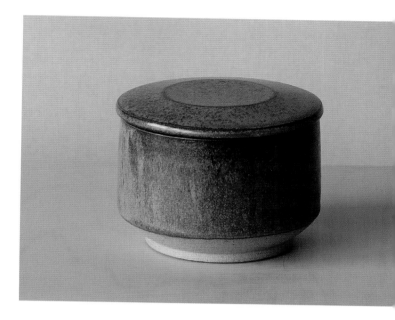

SUE PRYKE

MOULD AND
MODEL MAKING PROCESSES

Plaster model making is an industrial process for developing shapes for slipcasting or machine-made ceramics. This is a making method which can be used to scale up production in order to make larger (or faster) batches of work. It can be done at a high level and used for industry, or it can be simplified for the studio potter. The origination of a new shape is generally made in plaster of Paris and is called a model. A cast is taken from the new plaster shape, or the model which is called the mould.

The new shape (or model) is made in plaster either by turning on a lathe or a whirler, or by hand carving. A power whirler is similar to a potter's wheel which rotates on a vertical axis. The processes have remained unchanged until very recently when the introduction of 3D printing has taken over the majority of model and mould making at industry level.

At a craft level these skills are now listed by Heritage Crafts as an Endangered Craft. When I worked at

Wedgwood in the early 1990s there were 20 model-makers working there developing the concepts from the design team and producing exquisite models for the mould makers to cast and get the designs ready for the factory floor. By the mid 1990s the modellers were slowly replaced by rapid prototyping and 3D printing, depleting the need for the traditional craft skills.

There used to be a specialist HND course at Staffordshire College to train the model and mould makers ready for the industry, but with the decline of the industry in the UK and the increase of automated prototyping and mould making, the skills are no longer required to the same degree.

Developing models and moulds for tableware is very different than for sculptural work. As slipcasting relies on uniformity and repetition of form, it is important that the original model is as accurate to the initial design as possible. This requires that the original design is followed through in the model-making stage and precise moulds are made at the mould-making stage.

It's important to note that generally making and slipcasting should always be kept separate from plaster making. Plaster can contaminate the clay; if small pieces of plaster mix with clay it can lead to the plaster exploding in the clay piece whilst in the kiln firing. These processes should be kept in different rooms if possible.

The tableware caster needs moulds that cast very evenly to ensure consistency in cast thickness, which is probably not so important for sculptural work. Each mould will need to be of the same consistency in terms of plaster to water ratio when it is made; this ensures that the slip is cast at the same rate in each mould.

Models made on a lathe in plaster have a pristine surface which is ideal for replicating with mould making. For the studio potter, wood-turning lathes can also be used for turning plaster, and cup heads used on lathes can be converted to hold plaster for turning. Potter's wheels can also be converted to a plaster whirler, by adapting the pottery wheel-head and casting a plaster wheel-head on top to turn plaster models and moulds.

The seam lines are key to a neat finish and are important with tableware moulds; this is where two parts of a mould join. A good mould maker will be able to produce very tight fitting moulds where the seam lines are all but invisible when the mould is new. For instance, if you are making a round-bellied teapot it will have a seam line running around the curve where the moulds meet. As the moulds wear these seam lines become more visible, particularly so with coloured slip; the darker the colour the more apparent the lines are even on a new mould. The straighter the seam lines and the tighter they are when making, the neater the pot will look.

The model making process is a delight; potters and makers can easily replicate a shape by the use of plaster of Paris in order to make a mould for slipcasting or press moulding. For example you can take a seashell and pour plaster over it to make rudimentary mould for casting or pressing clay into. In this chapter are a few basics to help you understand the process and produce a set of moulds for realising your ideas.

LATHE TURNING

Lathe turning is a very satisfying way to make pristine models. It is similar to turning leather-hard clay on a wheel and similar tools are used too. There is a series of stages to ensure that the plaster is air bubble free and set enough to ensure a clean model.

Lathe turning is a way to make a symmetrical shape, in the same way that a wood turner would use a lathe on a horizontal axis. The advantage of using a lathe to make a form rather than a potter's wheel is that the surface of the plaster stays relatively dry and is easier to control than soft hollow clay. As the plaster dries it becomes a pristine shiny surface which makes following a drawing to attain an accurate model relatively straightforward.

1. The first stage is to prepare your drawing for the lathe. Sketch out the shape to scale either as a technical drawing by hand or with CAD, or you can just sketch it, as long as the dimensions are there to refer to. To make the process more efficient it's a good idea to have a drawing of your shape to hand. A cardboard template of the profile is useful as a guide which can be offered up to the model to check progress. You will need callipers and a ruler along with a pencil to mark off key dimensions such as height and widest diameter. An indelible or soft pencil is useful to provide clear markings.

1a

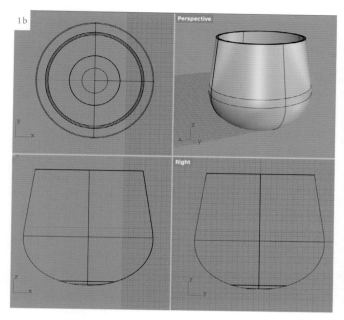

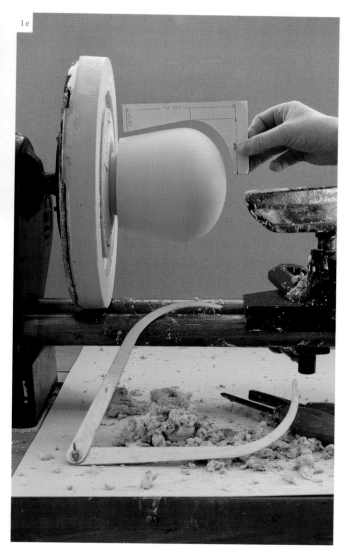

1a: Sketchbook. © Anna Thomson 2021

1b: Computer model. © Anna Thomson 2021

1c: Taking a profile template from a drawing.
© Ben Boswell

1d: Making a profile template.© Anna Thomson 2021

1e: Checking the dimensions with a card profile.
© Anna Thomson 2021

2. Plaster is usually turned with a series of sharp chisels, a metal kidney or modelling tools which can work as mini shaped chisels for small details such as foot-rings.

3. The lathe wheel-head or chuck needs cottling, which is the use of a piece of pliable plastic sheeting to wrap around the head to form a cylinder to contain the plaster.

Secure into place with a peg or bulldog clip at the top and string or tape at the base. There will be more force at the bottom of the cottle, so ensure this is tight. You can always add an extra roll of clay around the base to keep any drips contained.

4. Work out how much plaster you need to fill the cottle; a simple volumetric calculation will help to gauge the amount of plaster. (The volume of a cylinder is pi x radius squared x height). Plaster manufacturers will also provide a ratio of water to plaster to follow. Fill a bucket with the amount of water needed and add the dry plaster slowly to the water. Allow the plaster to steep, or soak into the water (this is often called quenching) which helps to reduce the amount of air bubbles in the plaster mix. The quality of the model is affected if there are too many air bubbles in the mix.

When all the water has been absorbed, stir slowly. You will find that the mix is thick until the plaster is fully dispersed. It should generally be milky. The thicker the mix, the harder the plaster will be and it will be difficult to turn. The thinner the mix, the weaker the plaster will be and it will take much longer to dry and control and result in a poorer surface quality.

2: Plaster tools for turning and measuring. © Ben Boswell

5a: Plaster ready for the lathe. © Sue Pryke

5b: Mapping out dimensions on plaster.
© Sasha Wardell

6a: Turning plaster. © Sasha Wardell

6b: When you get the consistency right, the plaster will just turn off in continuous ribbons. © Sasha Wardell

6c: Offering up a cardboard profile template to check the shape of the turned plaster. © Ben Boswell

5. When the plaster starts to warm up and thicken slightly, pour evenly into the cottle. If plaster is vigorously added into the cottle this will trap air bubbles which will be difficult to fill, making your model uneven on the surface.

You will feel the plaster heating up as it sets. For some techniques it makes sense to start the turning early, but it helps to keep the plaster in the cottle for longer so that it is firmer to handle.

Remove the cottle and attach to the lathe. Mark on the key dimensions; get the height marked off and the widest point and narrow points can be mapped out with a line.

6. If the plaster is still warm it will be wet to turn. If it has cooled slightly it should turn off in continuous ribbons. Quickly map out the height and diameter before it sets too hard as it makes it easier to work with.

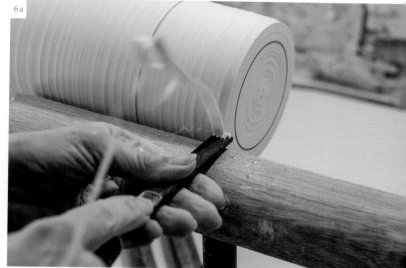

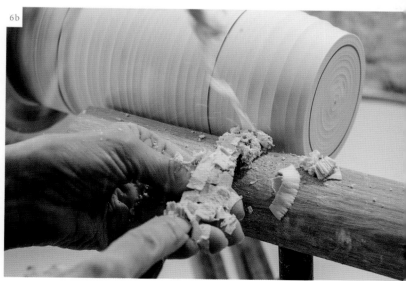

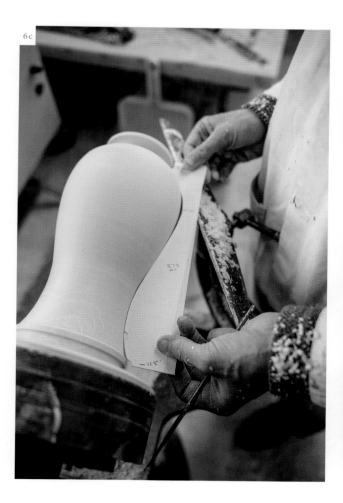

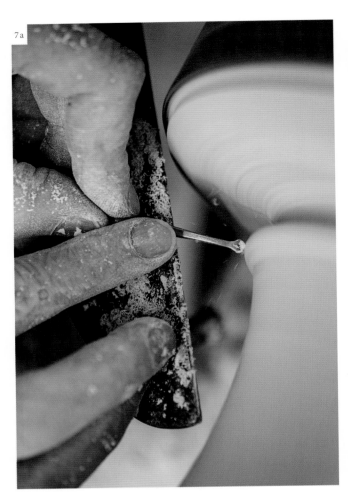

7a

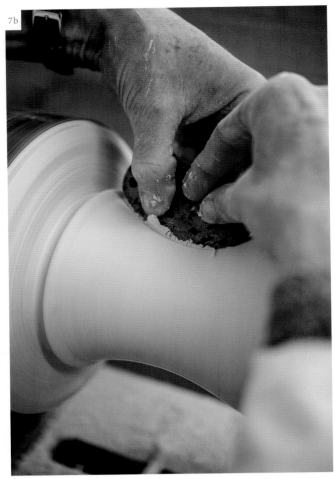

7b

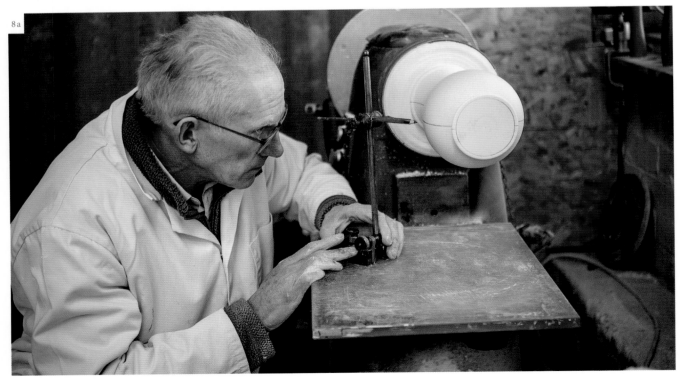

8a

7. As soon as the shape has been mapped out, the plaster should be cool enough to work into the fine details. Use a shaped steel kidney or a fine grade of wet-and-dry paper with water, 800 minimum to get the final detail into your model.

8. If you are making a curved shape or a shape such as a teapot or jug this is the time to add a centre line onto the model. A soft pencil or even a light indentation from a surface gauge will ensure that a line is visible when it comes to mould making.

Push away the tool rest and place a sheet of glass onto the lathe bed; this will give a flat and true surface for the surface gauge to run along. You can tie a pencil to the gauge with tape rather than scratching into the model with the point of the gauge. This will provide the guidance for the seams for mould making.

9. When your shape has been finalised the base needs to be turned to a minimum in order to tap off from the lathe. Make sure this final piece is not too thin for the weight of the model or it can fall off the lathe. Finally, make sure that the plaster sits on a clean bench so that any bits of plaster do not mark the pristine surface and the model is ready for mould making.

7a: Turning plaster with a small modelling tool. © Ben Boswell

7b: Turning with a steel kidney. © Ben Boswell

8a: Finding the centre line. © Ben Boswell

8b: Surface gauge, for finding the centre line. © Ben Boswell

9a: Finished cup before cutting off. © Sasha Wardell

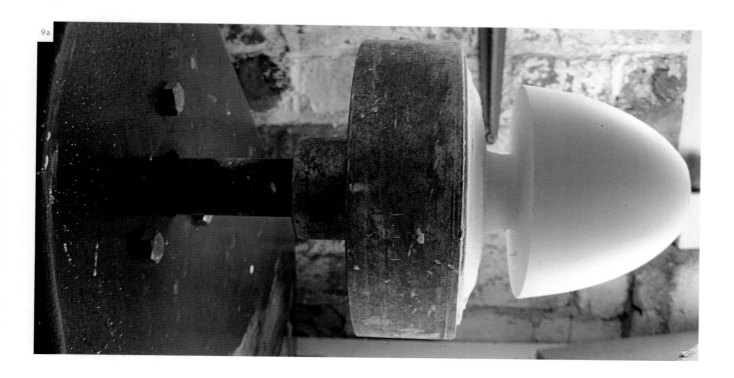

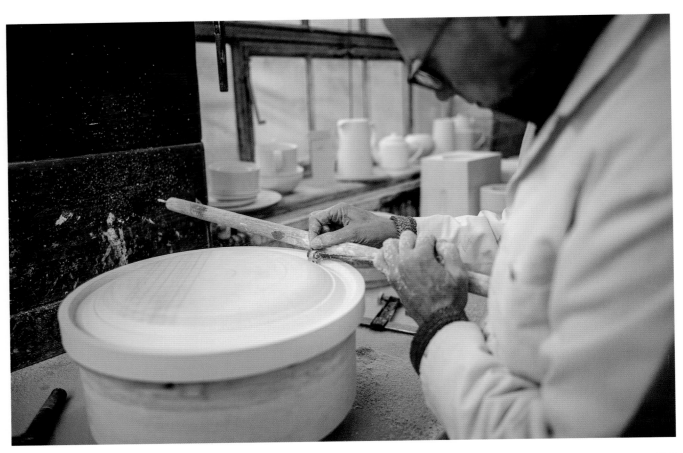

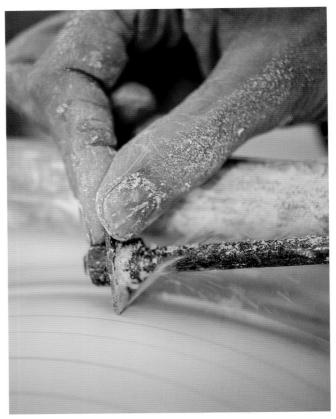

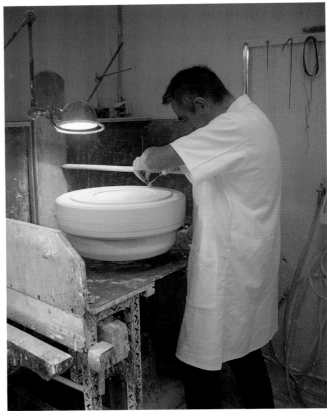

WHIRLER TURNING

Another method of turning pieces in plaster is the use of a power whirler. This is a similar set up to a potter's wheel. The wheel-head is made of plaster and tends to be used for making flatware pieces such as plates and bowls. It has other uses too, providing a flat and rotating surface for mould making.

The principles of turning a shape are similar to the lathe. The wheel-head is cottled up in the same way in order to make a shape but it is turned vertically using turning tools and a tool rest.

To make a bowl for slipcasting for instance, the outside shape will be turned in plaster upside down on the whirler, which enables another layer of plaster to be poured over the top which effectively makes the mould.

Opposite top: Whirler turning. © Ben Boswell

Opposite bottom left: Close-up of the whirler turning. © Ben Boswell

Opposite bottom right: Turning plate model. © Sasha Wardell

Above: Turning a plate on the whirler. © Ben Boswell

HANDLE CARVING

In order to make your handle to cast from there are various options. For industrial purposes it's easier to do everything in plaster so that the specialist mould makers only need use plaster. However, in a small pottery studio, it might be easier to make the handle and spout models from solid clay. Professional model-makers use plaster as it's far more precise, you have more control over a solid piece of plaster that has set and is firm to handle, unlike clay which moves and distorts when you try to model it or wipe it, for instance, with a sponge. A plaster model is pristine and can be carved and sanded to a super smooth finish, which will be translated ultimately into the mould which will be used again and again. In contrast, any small imperfections in a clay handle will be transferred and repeated with each cast. In a pottery studio setting however, where models can be made from a variety of materials, clay is easily accessible and often more than adequate, and in fact increasingly makers are using Styrofoam to carve shapes for model making. Making a handle or a spout from plaster for slipcasting or press moulding relies on precision and accuracy with measurements as well as craft skills. They are approached slightly differently but ideally they both need to be made in conjunction with the shape they are designed for as the fitting of the appendage is important for mould making purposes. If they are applied after making, the fit is important to ensure there are no issues with the making such as cracking and pulling away from the main body.

As with most plaster processes, it is best to begin with a drawing of the shape you are about to make along with a template to offer up to the model during the process which can act as a guide.

It is quite easy to distort the shape unwittingly if the measurements and templates are not to hand.

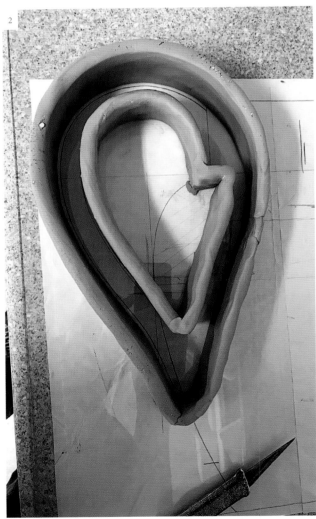

1: Drawing of a jug. © Ed Bentley

2: Cottling clay walls for casting the handle shape. © Ed Bentley. When the plaster is poured onto the glass, the plaster will pick up the pencil outline. Otherwise draw the shape into the top of the plaster when it has cooled off enough to carve.

3: Handle pouring. © Ed Bentley

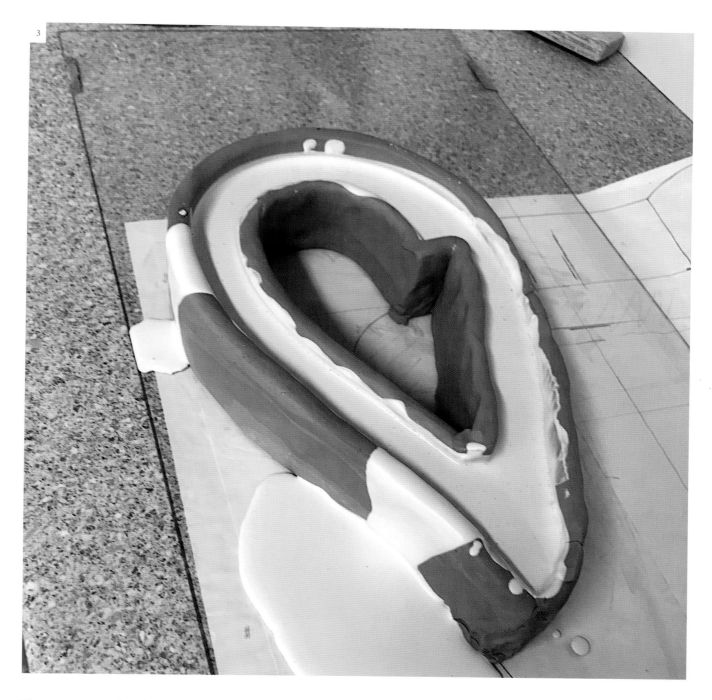

3

There are a couple of ways to make a handle in plaster, either casting plaster into a clay cottle or from a flat batt of plaster.

If you are carving from a batt, start with casting a flat batt of plaster, ideally to the thickness of your handle. Draw around the template and cut out the handle shape using a saw. Keep the sides square by using a steel set square. The centre line and dimensions can be marked out using a surface gauge and dividers.

If you are casting the shape of your handle, draw the shape of the handle, ideally, onto a sheet of glass (or a non-porous smooth surface such as a board); this ensures an accurate flat surface. Build clay walls around the shape, allowing a couple of millimetres higher on each side of the shape.

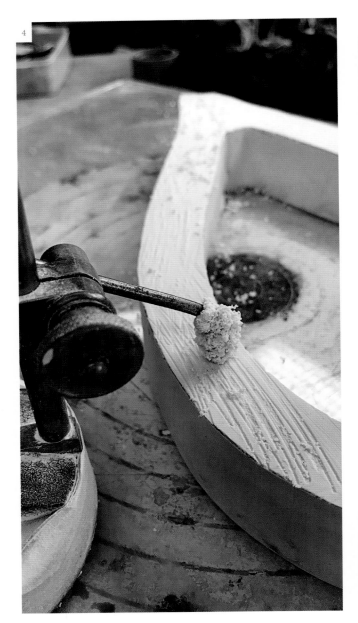

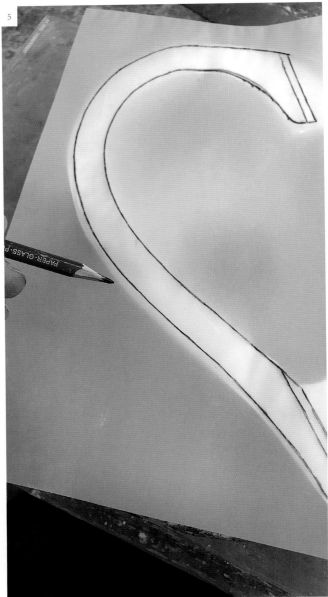

Where the plaster has been poured the top will need to be accurately levelled. You can do this by using a surface gauge and scratching across the top until the area is flat. If you don't have a surface gauge, you can use a spirit level, ruler and surform.

If you need to redraw the handle outline, use tracing paper or a cut-out of your shape, to transfer the outline to the plaster. Also add in the extra detail of the radius on the edges of the handle adding the dimensions from the top and bottom of the handle; this provides a continuous line to follow to keep your shape on track and symmetrical.

There are various plaster tools to use for handle carving, depending on size, such as rasps, serrated modelling tools and rifflers. The image is of a large traditional jug modelled by Ed Bentley for a project for Paul Smith. As the object is large, the handle is big enough to warrant a large surform to shape the outside.

For smaller shapes, it is just as important to keep measuring with callipers or a vernier gauge to keep the handle square.

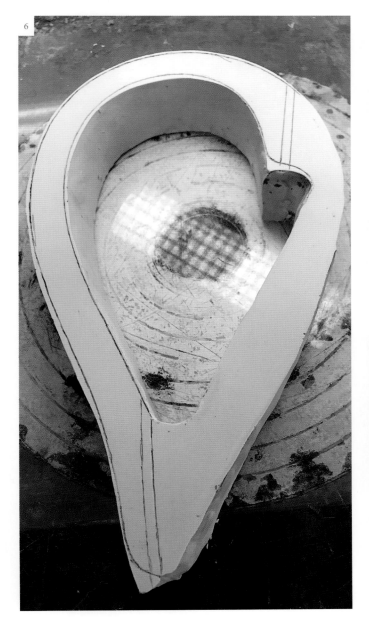

4: Handle surface gauging. © Ed Bentley

5: Transferring the handle drawing onto tracing paper.
© Ed Bentley

6: Handle drawing transferred onto plaster. © Ed Bentley

7: Surforming the handle into shape. © Ed Bentley

8: Using callipers to measure the handle dimensions.
© Ben Boswell

9: Surface gauge measuring. © Ben Boswell

Once the edges have all been squared off use a surface gauge to find the centre line; this ensures symmetry. If you do not have a surface gauge, you can use a pencil and clamp or use a pencil and ruler. Use forged steel rasps and serrated modelling tools to carve out the fine detail of radii on the handle and progress to a fine wet-and-dry paper with water to finish the shape, or even wrap around a pencil to reach into the curve.

Keeping the ends of the handles connected throughout the shape carving and refining helps to avoid snapping the handle whilst carving. This is easily done, especially with small delicate handles. The connector can be sawn off at the final stage.

The last stage is to fit the handle to the main pot to ensure that the curve at the ends of the handle are shaped to fit.

10: Sanding the handle. © Ed Bentley

11 and 12: Handle riffler modelling. © Ed Bentley

13: You can see that the same rifflers can be used on smaller-sized handles too. © Ben Boswell

14: Handle connector removal. © Ed Bentley

15: Fitting the handle. © Ben Boswell

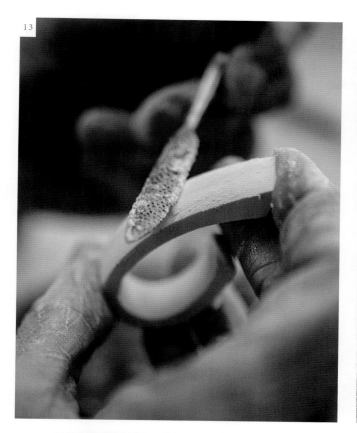

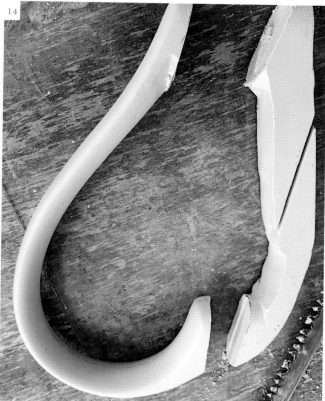

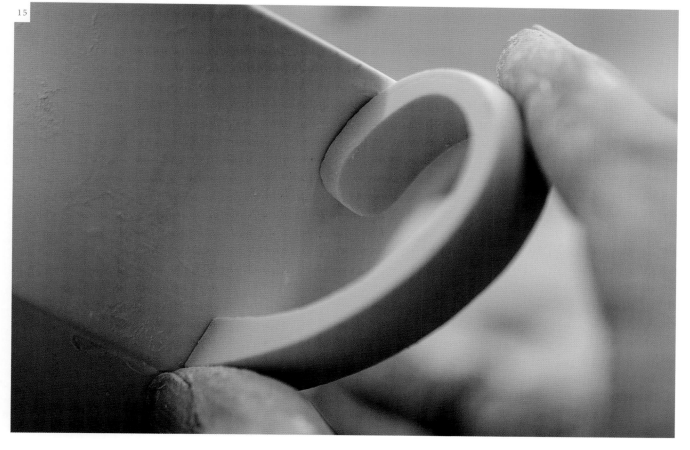

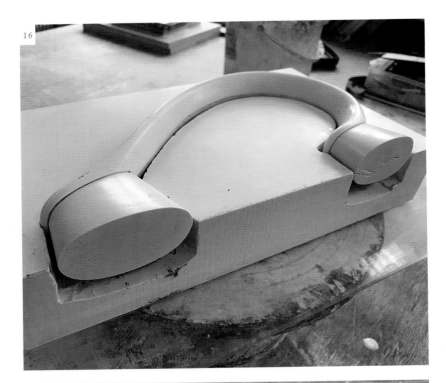

If the handles are cast onto the main piece, then they will need to fit into position accurately for mould making but even if they are fitted when cast, their shape at the end is really key to ensure that the handles stay in position and avoid cracking in the drying and firing stages. The handle is shown here with the oval-shaped 'spares' attached which allow space for pouring in the slip. Keep the centre line in position throughout the process as this will be needed for the mould making stage. For the next part in this process. See page 136 on how to finish the mould and cast the handle.

An alternative to making a plaster handle is to make a solid clay handle and then use that to create a mould, and cast from that.

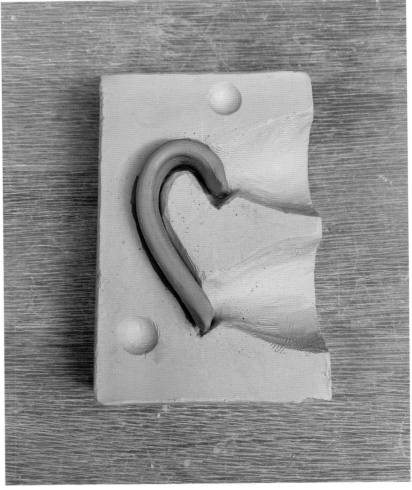

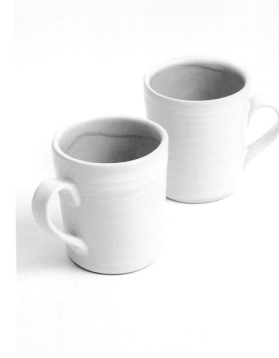

16: Handle and spares in set. © Ed Bentley

Left: Porcelain clay handle model in its carved plaster base. © Linda Bloomfield.

Above: Cast handle attached to an espresso cup. © Linda Bloomfield.

SPOUT CARVING

The approach to modelling a spout or a snip onto a jug or a teapot is slightly different from carving a handle, but a handle can also be modelled in the same way. A snip is a short spout, the sort you find on a jug, rather than a long spout found on a traditional teapot.

As a spout has a larger surface area in contact with the pot it is important to ensure that the spout follows the same shape, especially if it is to be joined onto the main piece during slipcasting or press moulding. Generally the plaster is cast onto the body and then carved into shape.

To start, find the centre line of the jug or teapot. Using your technical drawing, draw the outside shape of your spout onto the model; this will provide a guide as the cast spout will pick up the pencil outlines when it is cast onto the body.

Introduce a couple of natches using a curved modelling tool into the face of the body, generally on the centre line and one either side. A natch is a location marker and will provide indentations for a new spout to locate to the right place on a model. These natches will provide locator points for repositioning the spout. The plaster surface will need to be coated with a few layers of soft soap before casting on the spout so that it comes away easily for modelling. Depending on the shape of the vessel, the spout can be cast on whilst the shape is lying on the bench or standing upright.

Create a clay cottle. I find the neatest way to do this is to roll out clay to the height of your spout, use a ruler to measure the height and length needed and flatten the clay by drawing the flat of a ruler across it. This ensures a flat surface which will make your cast neater and create less plaster to surform away.

Top: Snip clay cottle. © Ed Bentley
Bottom: Spout set up. © Ed Bentley

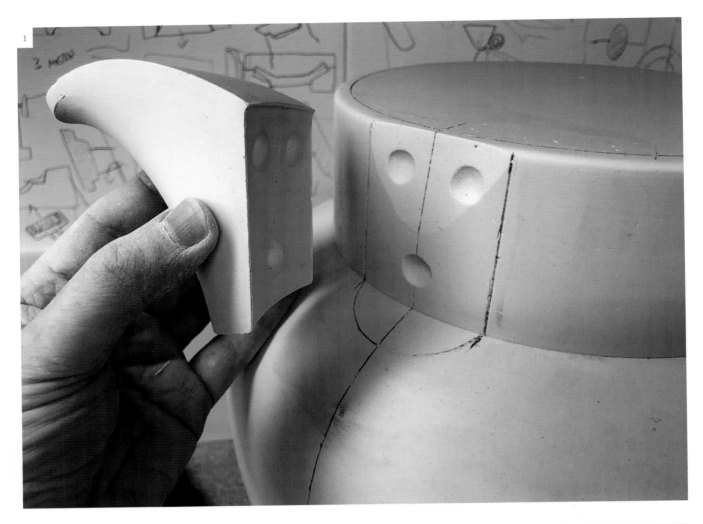

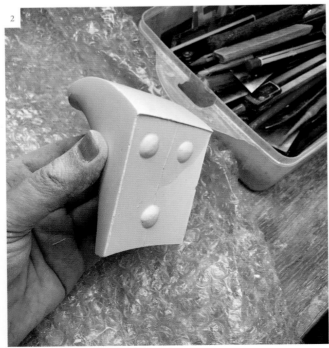

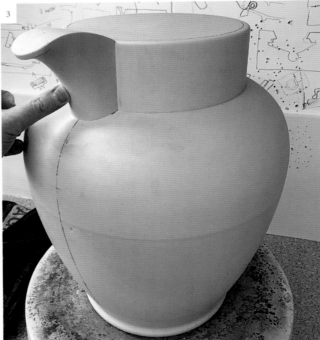

Pour plaster into the clay cottle and allow to set a little. It is much easier to carve when the plaster has the consistency of cottage cheese.

As with carving a handle, it is easier to map out your shape if you have all the dimension details to hand, including a template of the spout from the side and the top, all the details that are usually on a technical drawing. It will all help to keep the spout shape from twisting if you have measurements to refer to.

Aim towards shaping the sides and top of the spout quickly before the plaster sets. As it cools it should come away from the body easily allowing for carving to continue; it is easier to shape the detail when the plaster is firmer.

To check on your progress you can secure the modelled spout or snip to the teapot or jug body simply with an elastic band; it makes it easier to sit back and check on design details as well as progress.

When the shape has been formed with riffler tools, a smoother finish can be achieved by using fine wet-and-dry paper with water. Try to keep the centre line details on the spout as these will be needed for mould making.

1: Jug snip with locators. © Ed Bentley
2: Jug snip modelling. © Ed Bentley
3: Jug snip in place. © Ed Bentley
4: Spout fitting. © Sue Pryke
Top: Spout carving. © Sue Pryke
Bottom: Jug model complete. © Ed Bentley

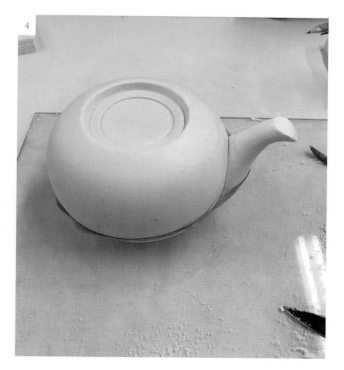

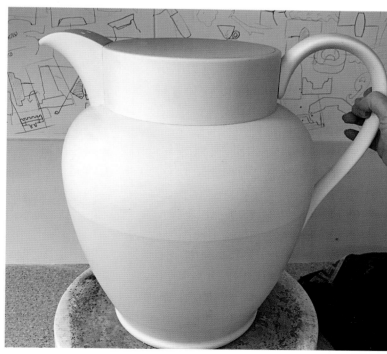

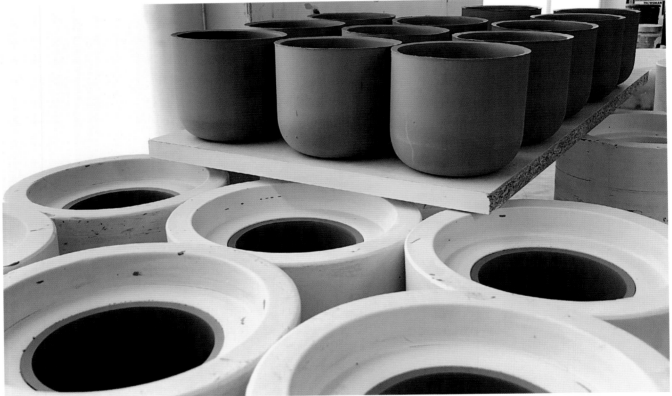

MOULD MAKING

DROP OUT MOULD

The simplest mould to make is a one-piece drop out mould. A drop out mould means it has no undercuts and is a simple straight-sided piece which will drop out of the mould after casting. My mug mould is a good example.

To achieve this the mould making process begins at the model making stage. The mug shape will be turned in plaster on the lathe, but at the base a step is required which will form the outside edge of the mould. The first step in the model is the edge of the reservoir, or spare. The second one in the image is the outside of the mould, which the cottle will be wrapped around to contain the plaster when making the mould.

The reservoir allows for a well in the top of the mould, so when the mould is filled with casting slip the top of the shape is covered and trimmed back when emptied to form a flat top rim in the shape.

The spare or reservoir is important as this is the overflow area in the top of the mould; it contains a reservoir of slip so when the casting slip is absorbed by the porous plaster mould the slip level will drop. The reservoir needs to be deep enough so that the slip does not drop below the line of the top of the model.

There are several approaches to making moulds. Some makers prefer not to have a spare or reservoir, although the drawback here is that the top edge is not so controlled and can be uneven.

Another method is to have a ring which is separate from the body of the piece. This shape is trimmed in a similar way, but I find this is an unnecessary extra piece of plaster to form and, as they tend to be quite thin, the spare is prone to breaking.

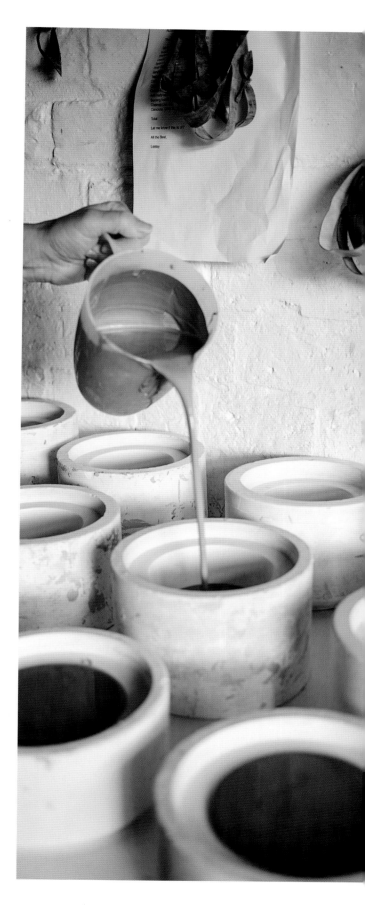

Top left: Mug on lathe with reservoir. © Sue Pryke
Top right: Mug model with reservoir. © Sue Pryke
Centre: Sue Pryke mug moulds. © Sue Pryke
Opposite bottom left: Slipcast bowls. © Sue Pryke
Opposite bottom right: Slipcast and trimmed bowls. © Sue Pryke
Right: Slipcasting mugs. © Sue Pryke

MULTIPART MOULD

For the majority of shapes a multipart mould will be necessary, even for simple curved vessels such as Anna Thomson's bowl. As the shape is curved it will need to be in two or three parts. The most obvious place to part the mould is on the widest point at the belly of the pot. Here Anna has set up her model with a ring of plaster or a batt of plaster which acts as a former giving a clean and flat base to cast the top half of her mould.

Again, the mould making part of the process begins when the model is made. The shape is turned on a lathe and the ring and spare are turned at the same time.

The model is set into clay, ensuring that the piece is held upright and evenly and supported by rolls of clay. The ring or batt which forms the size of the mould is placed on top. Use a small spirit level to make sure that this ring is even. It is always useful to make moulds on a flat and even table and a sheet of glass makes sure that the surface is flat.

Another important step to remember is that the moulds will need to have location marks so that they fit together. These can either be turned discs or plastic natches which you can buy from pottery suppliers. You can make your own natches by using a serrated curved tool which is rotated into the clay turning small circular shapes which will help to locate each section of the mould. A coin can also be used to turn into the plaster and used as a locator natch. Turn these into the plaster before soft soaping.

Here, blue plastic natches have been used. Place a small piece of clay in the inside of the natch, after soaping. If the clay is dampened it will stick to the plaster. When you pour the plaster it will cover the natches and you can add the second set of natches into the other side before pouring plaster over the top. It is usual to place two closer together so that it is obvious which part locates into which. If they are evenly spaced it will be difficult to tell them apart.

1: Model, spare and dividing batt.
© Anna Thomson

2: Mould making first set up. © Anna Thomson

3: Ready to cast the middle section.
© Anna Thomson

4: Ready to cast the spare.
© Anna Thomson

5: Finished mould. © Anna Thomson

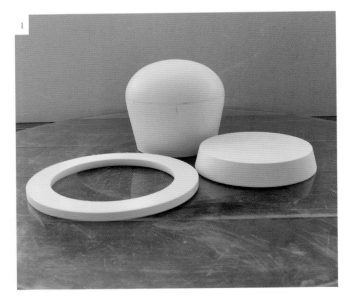

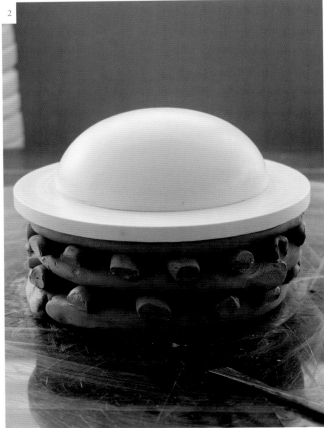

With all mould making, it is necessary to keep the model from drying out, so keep it wrapped up until ready to make the mould otherwise it will become too absorbent. As plaster is absorbent it is important to remember to use a few layers of soft soap or potter's size to coat the surface which will prevent the new layer of plaster from sticking to the model.

You can either use a soft brush or sponge to cover the plaster surface and another soft sponge to take the soft soap off the surface. I usually use three layers of size – the surface should look shiny. Try not to touch the model otherwise you will take the soft soap off. Make sure that all the excess soft soap has been removed otherwise the plaster will form soft crumbly areas which will lose definition.

Cottle up around your form and pour plaster over the top; make sure you measure the height needed. The aim is to keep all the plaster walls equally thick to ensure even casting when the mould is dry. If the wall thickness is 25 mm (1 in) make sure the height above the model is the same.

After casting the base, turn the model over and prepare the other side. As this is a three-part mould, the middle section will be cast flush to the top of the model. Soft soap each section. Even a quick coating over the mould is prudent in case of any spills, as you will find it will keep your mould looking neater and smoother for wrapping a cottle around.

Repeat the soaping and cottle up and run plaster to form the middle section. If you are using plastic natches put another natch over the top of each of those you positioned earlier and this will form the second part of the locator. The plaster will fill any natches you made by hand into the plaster.

After the plaster starts to set you can uncottle it and start the natch cutting and soft soaping again.

The spare that was made earlier can be placed centrally on the top of the model and this will provide the opening of the mould.

Cottle up again and pour plaster around the spare and the mould is complete. When the mould cools the cottle should come away easily. If you are impatient the cottle will tear the plaster if it is still warm. If you wait a little longer it should leave a nice sheen on the surface.

You can tease each section apart when the mould has completely cooled and take the model out. It will need a few days to dry before it is ready for slipcasting.

6: Finished mould. © Anna Thomson 2021

7: Finished mould parts. © Anna Thomson

8: Casting into the multi-part mould.
© Anna Thomson 2021

Opposite: Finished vessel. © Anna Thomson 2021

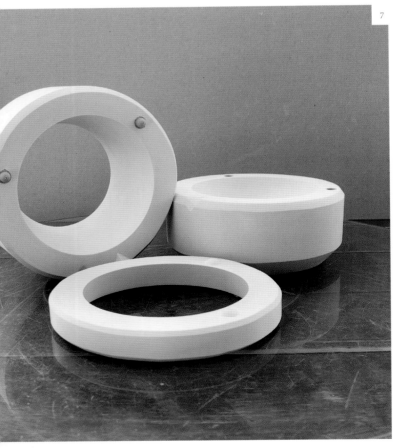

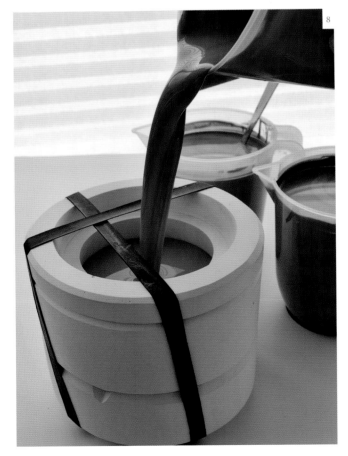

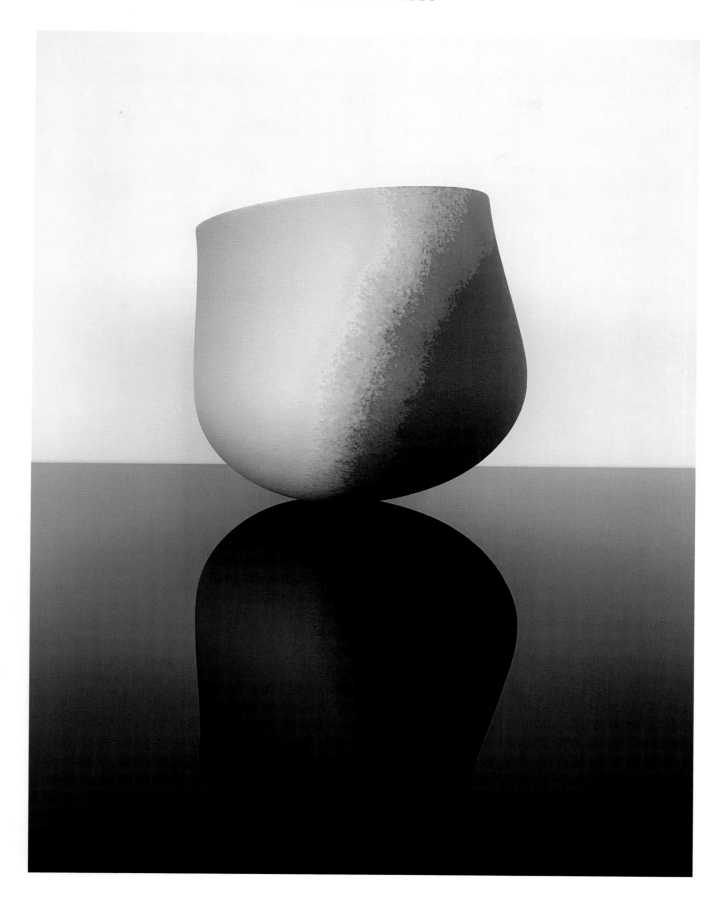

HANDLE MOULDS

For other shapes from handles to jugs or teapots you will need to make more complex plaster batts around your shapes.

These will provide a neat base for your mould and help to keep your shapes square but also flat. For handles, the plaster batt needs to follow the curve of the handle and fit snugly. Carve the shape from a flat batt of plaster, making it as close to your handle shape as possible and this will give a much more accurate mould. Any little gaps between the model and the batt can be filled with clay but be careful not to scratch the model.

The outside of the batt needs to be square as it will form the outside of the mould. You will also need to carve or turn a couple of 'spares' which will form the feed holes for your handle. These usually follow the shape of the ends of your handle and taper outwards

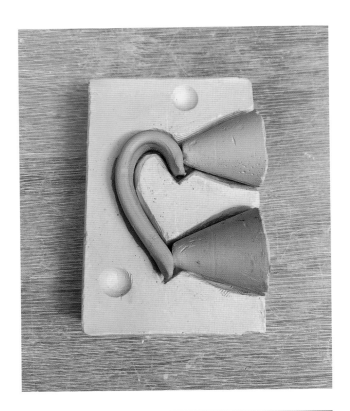

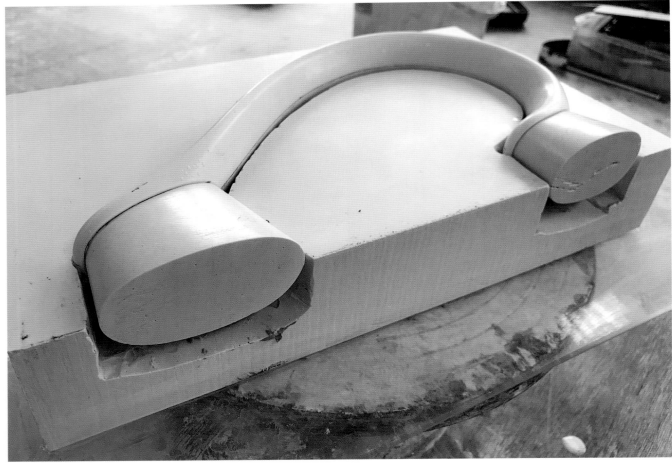

to provide a wider aperture to pour slip into. The spares can be seen in the photo as the large oval shapes attached to the handle.

Once the handle has been secured into place with clay, you can soft soap the batt and handle and affix your natches. To form the outside of the mould, use wooden boards. Keeping these square will ensure neat moulds too. Again, check that the area around the model is even so that you make an even mould and then pour plaster over the top.

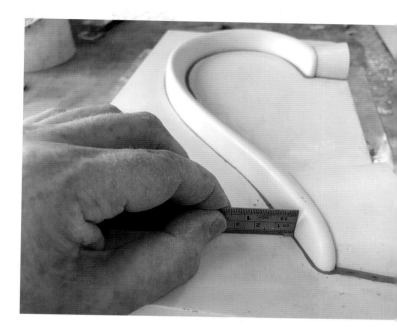

Once one side has been poured, turn over and prepare to make the second side. You might find that there is a little tidying to do where the clay was next to the handle. You will also need to add the second set of plastic natches if you used those. Soft soap and repeat the process.

To avoid chipping the mould, allow the plaster to cool before trying to prise the mould apart. Plaster swells as it sets so you will find that it may be difficult to remove your model without breaking it. There are a couple of tricks. When the plaster has set firmly, try tapping purposefully with a weight or similar. Do not apply too much pressure as you can easily break the mould, but sometimes the knock is enough to release the model.

If this method does not work, wait until the mould is dry and place it into cold water, and sometimes the handle floats out. This is a useful trick for many stuck models. The pressure caused by the air bubbles push the model out of the mould.

Generally speaking, handles are difficult to dislodge without destroying the model, but try to protect the mould from any damage.

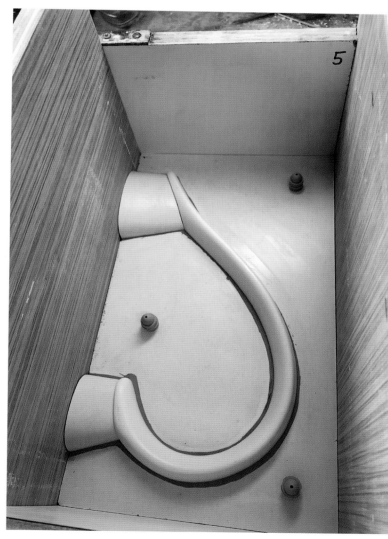

Opposite top: Clay handle model and plaster spares in a hand-carved plaster set.
Opposite bottom: Handle and spares in set. © Ed Bentley
Top: Handle clay filling. © Ed Bentley
Bottom: First half of the handle mould. © Ed Bentley

For shapes such as teapots and jugs, the principles are the same. Each side of the mould will need to be cut out of a plaster batt to fit the profile of the main shape. Spares will need to be introduced to create the reservoir for pouring slip into at the casting stage. Very often an extra spare is needed to form the foot on, such as on a teapot. So that the foot-ring is protected from chipping, these are recessed slightly into the mould.

The basic mould-making steps I have covered are based on the ceramic industry's approach to plaster work. Makers tend to be very resourceful and inventive when it comes to techniques especially with model and mould making. After all, not everyone has access to a lathe and whirler and these are not always appropriate.

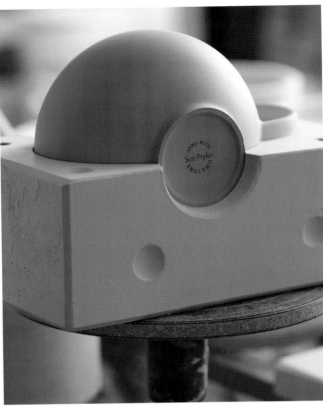

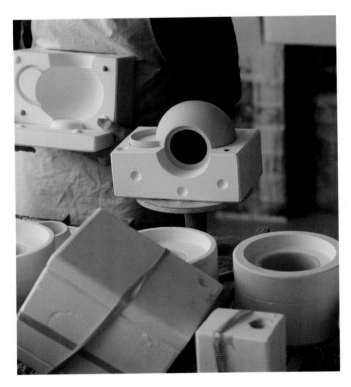

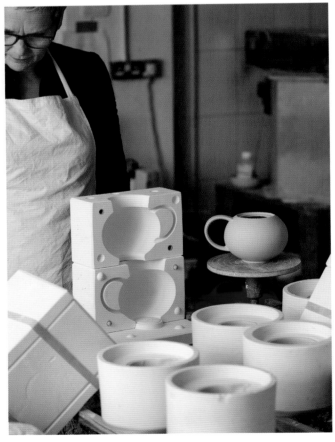

This page: Three views of Sue Pryke's teapot moulds.
© Sue Pryke

1 and 2: Monika Patuszyńska using a saw to model her moulds into shape. Photograph by Grzegorz Stadnik/Pracownia 2F, © Monika Patuszyńska

3-6: Arranging parts of the mould into place and securing with a staple gun. Photograph by Grzegorz Stadnik/Pracownia 2F, © Monika Patuszyńska

7: Final result of Monika Patuszyńska's model making process. Photograph by Grzegorz Stadnik/Pracownia 2F, © Monika Patuszyńska

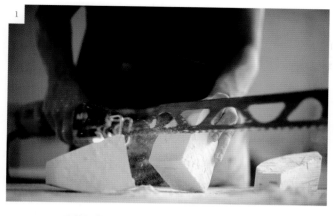

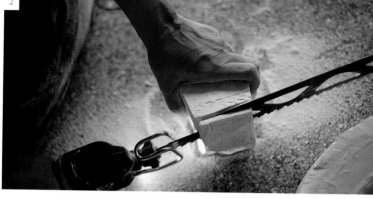

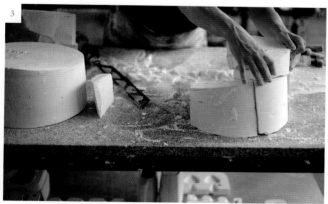

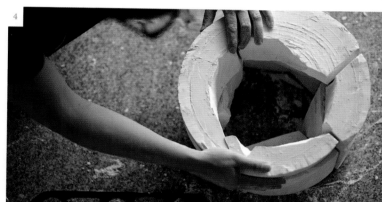

Some artists take a more creative approach to their use of moulds. Monika Patuszyńska works with solid blocks of plaster and a saw to manipulate the plaster to create her vessel shapes. She modifies old plaster moulds, breaking them into pieces to reassemble her forms, working from the outside inwards and embracing the imperfections of the process.

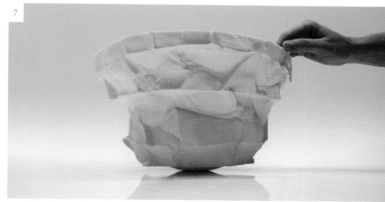

In contrast, Joris Link's work relies on precision assembling small and fragile pieces to create his shapes. Each form consists of hundreds of components to form a repeat pattern as well as providing the actual mould for slipcasting. The moulds are painstakingly constructed for each cast.

Mould making is a complex process and understanding the angles and draw of a shape in order to construct a mould are part of the intrigue for many. Anna Thomson's 'Multiplicity' light is made from a 38 part mould, partly modelled using 3D printing as well as traditional model and mould-making techniques. Her moulds are as precise and pristine as the final piece.

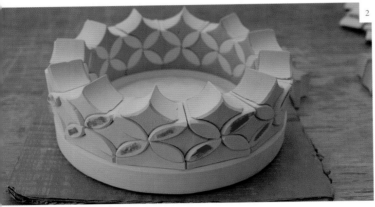

1: Joris Link's mould parts lined up for inserting into position, some pieces are coated with coloured slip, so that the slipcasting picks up the colour. © Joris Link

2: Assembling the mould. © Joris Link

3: The mould is secured by a strap and slip is poured into the mould. © Joris Link

4: When the piece is cast, the individual parts of the mould are taken out to reveal the slipcast piece. © Joris Link

5: Finished pieces. © Joris Link

Opposite top left: Porcelain 'Multiplicity' lighting vessel by Anna Thomson. © Anna Thomson 2021

Opposite centre: Close-up of the semi-porcelain 'Multiplicity' vessel by Anna Thomson. © Anna Thomson 2021

Opposite right: Semi-porcelain 'Multiplicity' vessel by Anna Thomson. © Anna Thomson 2021

Opposite bottom left: Liquid slip pouring into a mould. © Sue Pryke

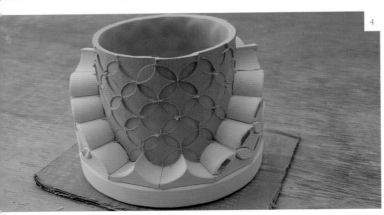

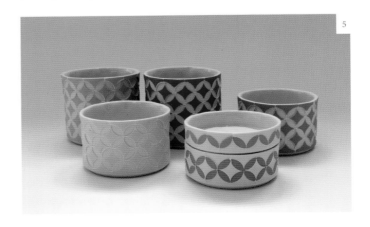

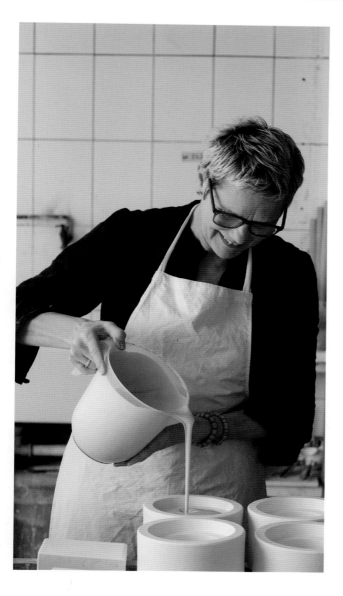

SUE PRYKE

SLIPCASTING

Slipcasting is the use of liquid clay being poured into a porous plaster mould. The clay needs to be kept in a liquid form so that it can be poured in and out of moulds. In order to keep the clay in a liquid state, the addition of deflocculants is needed in the form of sodium silicate to keep the particles of clay suspended and prevent the clay from settling (see Chapter 4, Materials).

Slipcasting for batch produced tableware has a slightly different emphasis on process than for sculptural work. Slipcasting is an industrial technique of making work in multiples. Each mould can be used 40 or 50 times before it needs to be replaced and you can have as many moulds as you have space for to reproduce a multitude of the same shape at a time. Generally the tableware maker is looking for consistency, the same wall thickness, the same radius on the rim. Most details are in the moulds, but the slip caster is in control of the thickness and the idiosyncrasies involved in the final flourishes of fettling and sponging. The sculptor is usually in pursuit of different attributes.

The liquid slip is poured into a porous mould and the clay form is cast using absorption which allows a layer of firm slip to form. The excess is then poured out of

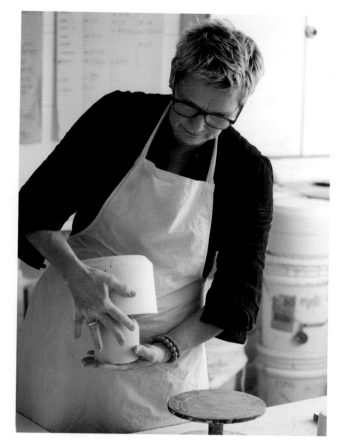

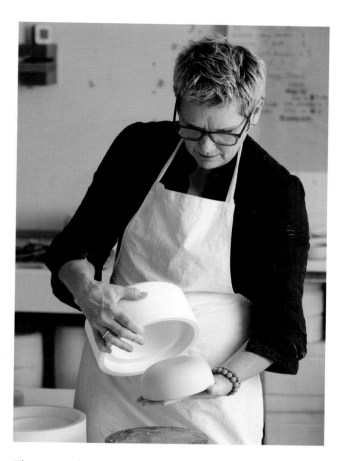

the mould and you are left with a shell, which is the cast piece. The thickness can be adjusted by changing the casting time, less for thinner pieces and more for a thicker cast.

Slipcasting is suited to more complex shapes, including forms that are not easily made on the wheel. In industry all teapots and the majority of jugs will be made by slipcasting as these cannot be made on a jigger jolley or an industrial roller machine.

Many potters choose to use casting in order to achieve uniformity and it is a great technique for batch production. Smaller factories and craft practices use this method of making but it is also used in mass production to make complex pieces that cannot be made in an automatic mould.

Opposite: Bowl from a drop out mould filled with walnuts. © Sue Pryke

Top left: Bowl dropping out of a mould. © Sue Pryke

Top right: Bowl from a drop out mould. © Sue Pryke

The way objects are cast depends on their shape. A straight-sided piece will probably be made from a one piece mould. When a piece is cast, the clay will shrink slightly as it dries, pulling away from the edge of the mould allowing the piece to drop out cleanly.

You can make more complex shapes in multi-part moulds and mugs can be made with the handle cast on which would require at least a two part mould. There are a lot of benefits to this. The handle is integral to the piece so it doesn't require extra fitting after casting which can lead to cracking and it is also less time-consuming in the production. The only drawback is that there are usually dimples where the handle shape joins the body of the mug in the casting. Very often if these are too deep they look unsightly and so are filled with a piece of clay so they do not fill with food or drink.

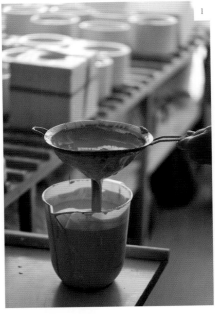

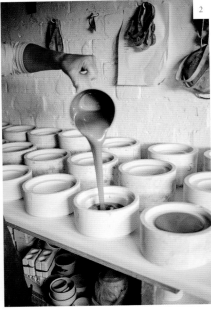

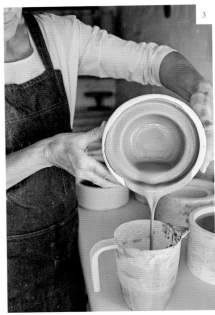

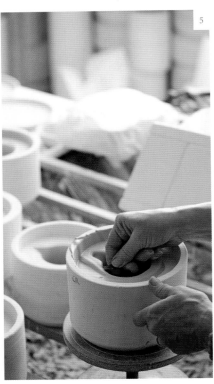

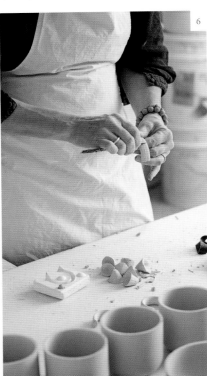

1: Sieving casting slip into a jug. © Sue Pryke

2: Pouring casting slip. © Sue Pryke

3: Emptying the casting slip. © Sue Pryke

4: Casts drying inside the moulds. © Sue Pryke

5: Trimming the spare from the cast. © Sue Pryke

6: Trimming seam lines off a handle. © Sue Pryke

7: Sticking the handle into place on a slipcast mug.© Sue Pryke

DROP OUT MOULD

A drop out mould is one of the easiest pieces to slipcast. The mugs that I have designed are all one piece moulds, and the handles are attached after the piece comes out of the mould. This is the most complex stage, where the handle and the adhering slip need to be at the correct consistency to allow the handle to stay in place and not crack as it dries.

Right: Sticking the handle into place on a slipcast mug.
© Sue Pryke

CASTING A MUG

It is best to practise casting and also test your slip on a small cast piece so that you can identify how long the cast needs to be in the mould. It is difficult to assess the thickness of a cast when your mould is full of slip. Try testing two or three smaller pieces at differing casting times first so you can deduce the most appropriate casting time.

1. Clean the mould, use a damp sponge to clean any dust or pieces of dry clay from inside.

2. Mix your slip until you achieve the correct pouring consistency. I recommend sieving the clay to prevent any congealed clumps of clay from going into the mould; these may form lumps on the inside of the cast, which should be smooth.

3. Pour slip into the mould with a steady consistent flow.

4. Time your casting. Set a timer to ensure consistency in casting time.

5. Empty the slip from the mould into a bucket or a casting trough and lean the mould at an angle for a clean drain. This will vary on each shape. Plates need to be more upright than mugs or bowls. Ideally leave at an angle of 45°. This will avoid draining marks on the inside of the cast or in the base. Leave to drain until the shine goes off the surface.

6. Turn the mould over. You can trim the top of the piece as soon as the surface looks dull; if it is still shiny it is probably too wet to trim and may distort easily. Use a sharp trimming tool flat against the reservoir in the top of the mould and with the mould on a turntable gently turn and cut off the spare or the reservoir. Try to keep this as flat as possible to avoid extra tidying later as this will create the top of the mug.

7. As soon as the cast mug starts to dry and shrink a little from the sides of the mould it can be emptied from the mould.

8. Take the handle from the mould. The ends where it has been cast will need trimming to the shape of the mug. There should be a slight curve so that it fits the profile of the mug.

9. Dip the ends of the handle into slip (this can be the same casting slip) and stick onto the side of the mug. I find that as long as the ends of the handle have the same shape to them as the mug it will keep in position and fire without pulling away from the pot. Ensure that the mug and handle are both at the same consistency.

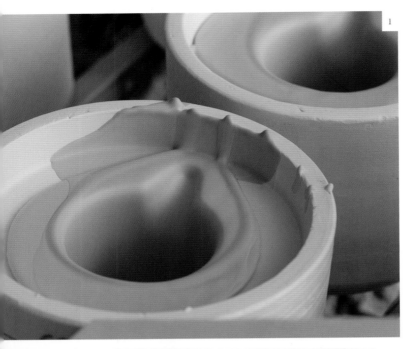

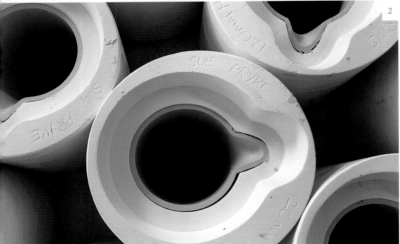

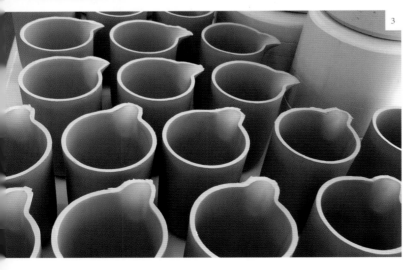

CASTING A JUG

Jugs are made the same way as a mug but the trimming is slightly different around the spout.

Depending on the design, they can be a little fiddly to trim in one go and very often the spout's final shape is determined by the sponging. A nice thin edge to the spout will help with a good pour.

CASTING A PLATE

Plates are not the easiest piece to get right. There is a larger and flatter area for any flaws in the slip to be visible. The casting follows the same steps as for any other object, but draining requires the plates to stand more upright, and is also dependent on the type of clay you have used. As always, test a few at differing angles to find what works best for your clay.

Tips on trimming: Dinner plates have a wide surface that needs to be kept pristine, so when trimming the edge on the reservoir be careful not to allow small soft pieces of clay to fall into the centre as this will spoil the flat cast area of the plate.

1: Jug casts drying inside the moulds. © Sue Pryke

2: Waiting for a jug cast to dry. © Sue Pryke

3: Trimmed jugs drying. © Sue Pryke

a: Casting a plate. © Sue Pryke

b: Emptying the plate mould.© Sue Pryke

c: Draining plate moulds. © Sue Pryke

d: Trimming the excess clay from the reservoir on the plate mould. A long scalpel blade is quite good for trimming tight angles or for getting a sharp finish. © Sue Pryke

e: Slipcast plates drying in the mould. © Sue Pryke

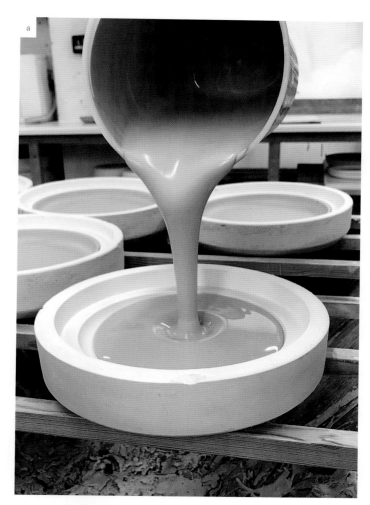

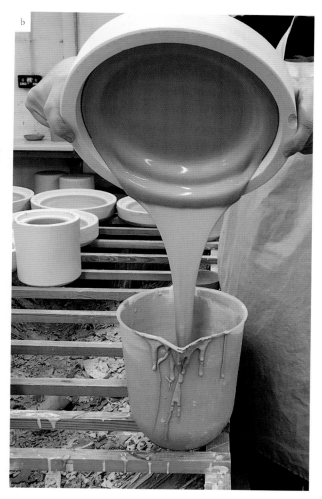

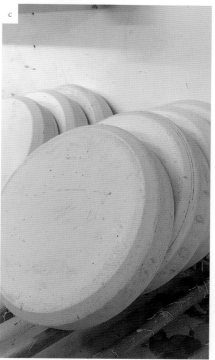

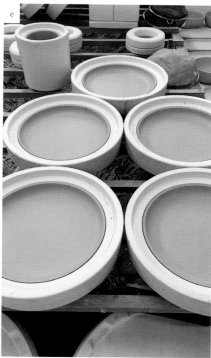

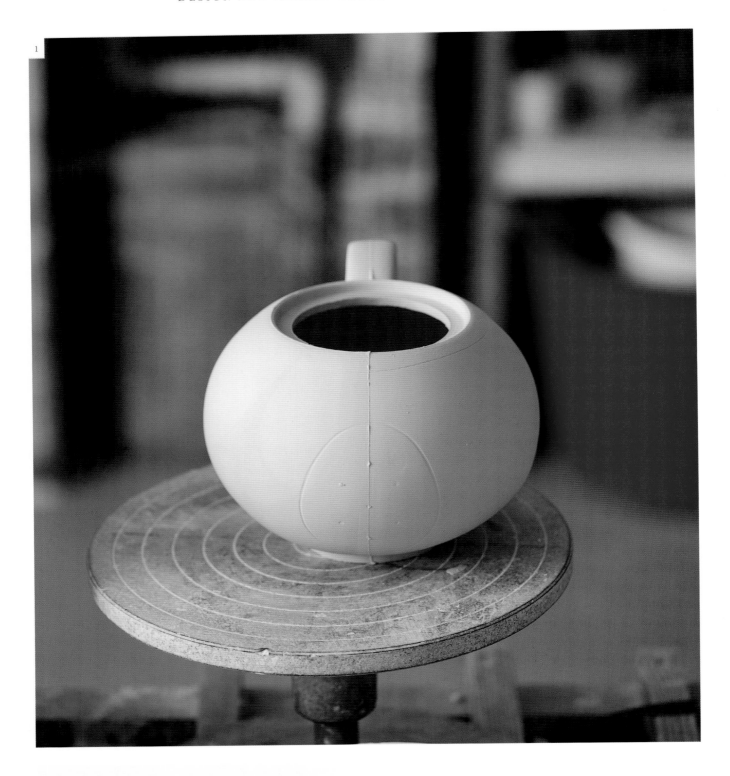

1: Spout position as marked by the mould. © Sue Pryke

2: Piercing the filter into the teapot. © Sue Pryke

3: Trimming the spout in the mould. © Sue Pryke

4: Applying slip to the teapot spout. © Sue Pryke

5: Positioning the spout onto the teapot body with slip.
© Sue Pryke

CASTING A TEAPOT IN A MULTIPART MOULD

Multipart moulds are necessary for complex pieces, such as teapots or simple curved shapes which have undercuts.

Very often with a teapot, the spout and handle are cast as an integral part of the piece and this simplifies the production process. The alternative is to cast the teapot body and cast the handle and spout separately and then join them after the pieces come out of the mould at the leather-hard stage. The advantage of this is that the teapot can have a filter pierced into the wall to make a strainer for the tea. It also allows for the possibility of changing the shape of the handle or spout at a later point.

Here the teapot is cast with the handle in the mould; the spout is cast separately. You can see that the spout position has been marked in the mould making it easier to locate after casting. The drill positions for piercing a filter in the clay body have also been marked out to make it easier to drill the holes in a fixed pattern. The spout is cast in a two-part mould; the base where it joins the pot will need to be trimmed by hand, but the shape is already outlined in the mould.

The edges of the spout will need a layer of slip to stick it to the teapot body. It is helpful to keep the seam lines visible on the teapot body to allow the two pieces to locate easily into position.

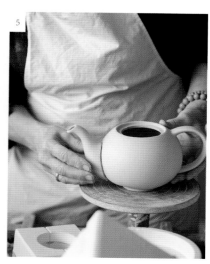

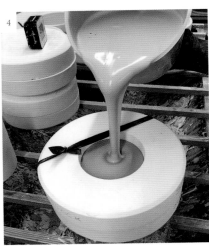
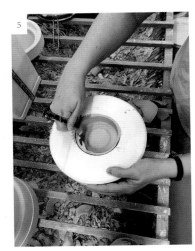

CASTING A SAUCER THROUGH THE FOOT

In order to cast a saucer with the footwell for the teacup, the saucer needs to be cast through the foot-ring on the back, otherwise a piece cast through the face or the front of the piece will not have a detailed outline of the foot well.

The process is quite lengthy from the model and mould making through to casting. Initially the model needs to be thick enough for the slip to run through when casting, as it needs to cast solid rather than being emptied after the usual casting time. If the model is too thin the slip will not run freely and fill the mould, leaving air pockets and not cast up fully.

1: Two-part saucer mould. © Sue Pryke

2: Two-part saucer mould placed together. © Sue Pryke

3: Saucer mould being cast. © Sue Pryke

4: Saucer mould being filled to the top of the reservoir. © Sue Pryke

5: Trimming the excess clay from the reservoir in the back of the saucer foot-ring. © Sue Pryke

6: Opening the saucer mould. © Sue Pryke

To cast, slip is poured through the opening on the back of the saucer. The saucer hollow is cast solid, allowing the excess slip to fill the reservoir. This is the extra bit which can be poured away and allows the piece to cast fully and capture the shape of the model.

The excess is drained after the casting time, leaving a suitable wall thickness for the saucer in the mould and an edge which will form the foot. The excess clay in the reservoir can be trimmed away and the mould opened to reveal the back of the saucer with the foot fully formed. The thickness of the underside of the saucer in the foot will be decided by the length of the casting time, but the rest of the shape will be formed in the mould, determined by the model.

SUE PRYKE

JIGGER AND JOLLEY

Jigger and jolleying are semi-automatic processes mainly used in industry which work with a spinning wheel-head, like a throwing wheel and a tapered tool which presses into the soft clay to form the inside or the back shape of the piece. These were developed in order to speed up the making process for high volumes of tableware. They can be adapted for studio potteries. Jolleying refers to making hollow-ware such as cups and bowls. The jigger is the production of flatware such as plates.

The jolley requires a plaster mould for the shape of the cup, and also a wooden or a steel profile to form the internal shape of the piece. The mould making for this process is quite specific as it has to fit to the metal back and ring plates which fit into the machinery of the jigger and jolley. Moulds need to be designed to fit tightly into these metal parts. Cups, bowls and hollow-ware are made this way. In a studio pottery set up, the jolley is semi-automatic and driven similarly to a wheel. The mould rotates.

JOLLEYING BY OWEN WALL

A ball of plastic clay is placed into the mug mould and batted into position.

As the jolley rotates the clay needs to be coaxed into position inside the mould.

A sponge and water are then used to manipulate the clay pulling it into the mould form; this ensures that the clay is pushed into position before the inside template is drawn down to start jolleying.

Once the clay has been pushed to form the bowl shape the jolley tool can be used to form the inside profile. The arm holding the internal shape is pulled down. Whilst the mould rotates, the arm and tool create the inside shape of the piece. The outer shape is formed by the plaster mould.

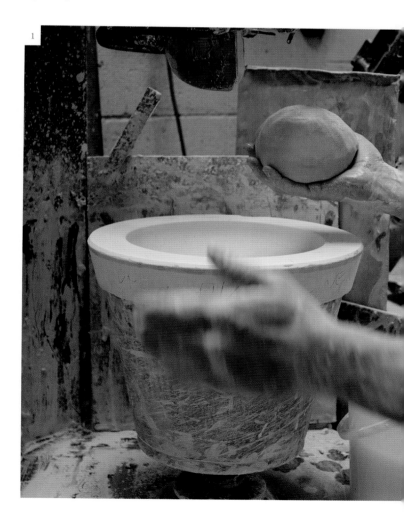

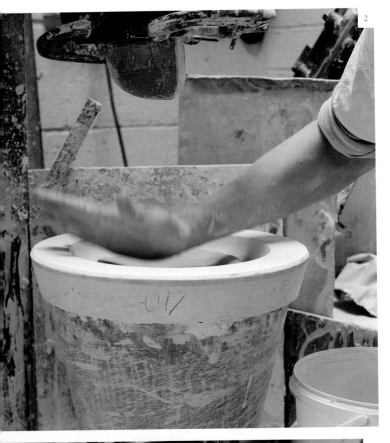

The top edge can be included in the tooling which ensures that there is less hand finishing needed. As with jiggering the tool rest will need to be used several times to ensure that the shape thickness has been achieved and the clay is evenly distributed. Excess clay will need to be cleaned away from the edge. The extra piece of clay can be cut off with a knife and the edge finished with a wet sponge.

Jolleying is a process which can be scaled up or down; in a studio setting it allows the potter to make batches of the same shape, creating uniformity. The plastic clay used for jolleying contains far less water than slipcasting and the forms can more easily be controlled during drying and firing without warping.

Semi-automatic plate and cup making in factories still relies on a skilled worker to place the clay on to the moulds from the pugged clay and to demould pieces ready for the next process at the end of making.

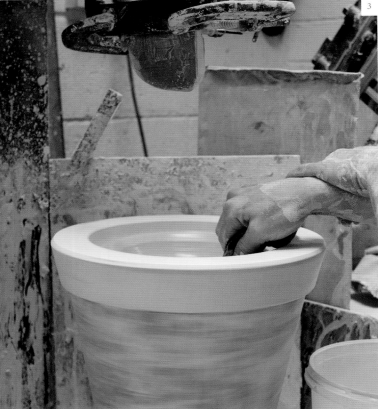

1 (previous page): A ball of clay thrown into a bowl mould. © Owen Wall

2: The ball of clay is batted out inside the bowl shape. © Owen Wall

3: Forming the bowl shape. © Owen Wall

4: Close-up of forming the bowl shape. © Owen Wall

5: Forming the inside of the jolley bowl with the tool. © Owen Wall

6: Notice the wall getting progressively thinner. © Owen Wall

7: Final shape with the potter's mark being impressed into the soft clay. © Owen Wall

8: Final fired bowl by Owen Wall. © Owen Wall

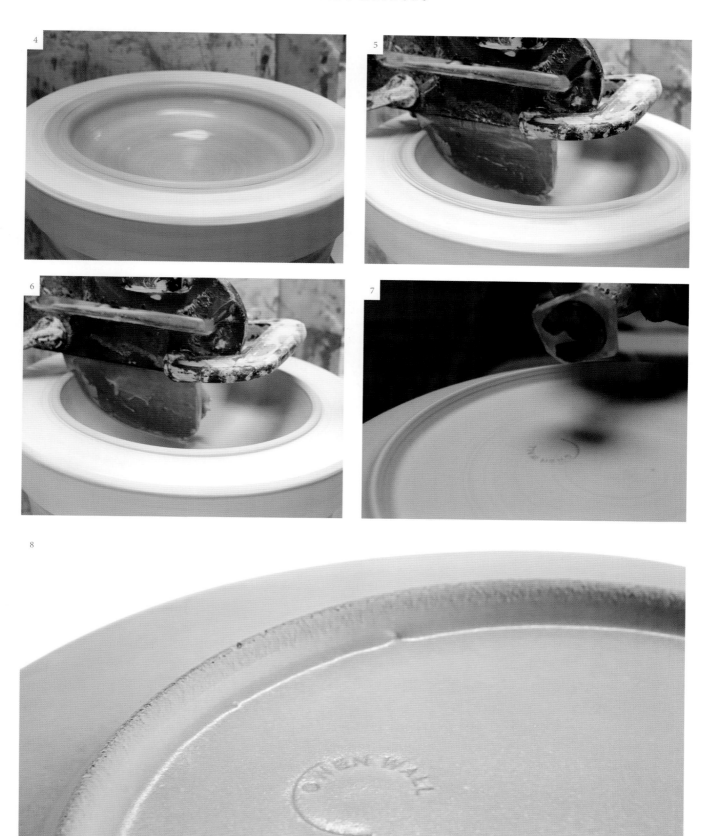

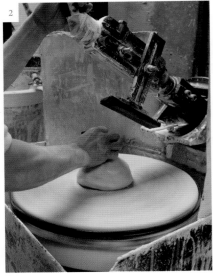

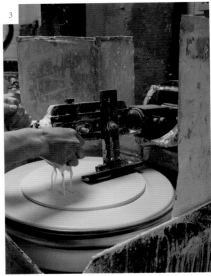

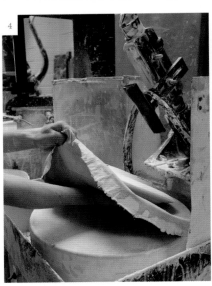

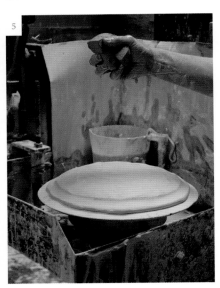

JIGGERING

Jiggering is the production of flat ware. Clay balls are formed to the same weight and size to ensure uniformity with each shape. The clay is then 'batted out' on a rotating jigger using a flat tool head; this ensures that the clay slabs are even in thickness. It is best to use a layer of fabric on the batt so that the clay can be moved once it has been batted out. The slabs of clay are lifted onto a convex plate form, i.e. a negative of the plate, before the shape is formed.

The clay is lowered onto the dome of the plate and this will form the face of the plate.

The clay needs to be kept watery on the surface to allow the clay to move over the plate head and help the tooling to glide over the surface.

The arm holding the tooling will create the profile for the back of the plate, forming the foot-ring.

When the shape has been formed, there will be some trimming of excess clay at the edge where the clay has been squeezed out from the tool; this can be removed with a knife and the edge smoothed over with a sponge. Plates will take time to dry before they can be removed from the hump mould.

Similarly to jolleying, the moulds created for each shape need to be modelled to fit into the stainless steel backs and rings for the jigger machine.

1: Jigger cup head.

2: A weighed ball of clay being batted out on the jolley ready to go onto the jigger.

3: Batting out the clay.

4: Lifting the clay slab onto the jigger head.

5: Sponging water onto the surface to help the tool glide.

6: Shaping the clay plate.

7 and 8: Shaping and trimming the back of the plate.

9: Final plate. All images © Owen Wall

Bottom: Final fired plate by Owen Wall.

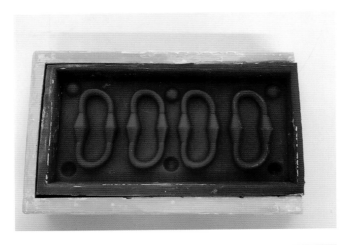

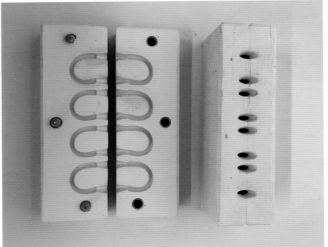

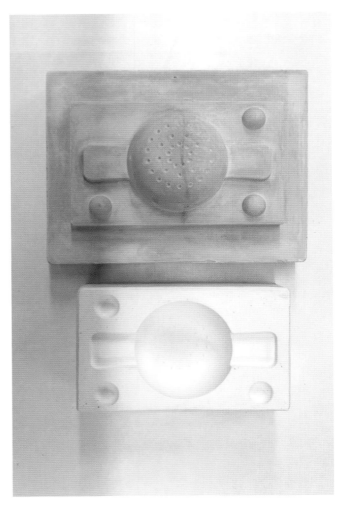

SUE PRYKE

3D PRINTING

Some of the moulds I use in the workshop have been made using digital technology. The initial models have been 3D printed in wax or a resin and the plaster master moulds have been taken from these printed versions. There are a number of benefits to working this way. One of the moulds is for a handle, but instead of having one mould per handle, there are several handles in the same mould. This makes it more efficient when it comes to slipcasting, and a huge time saving when it comes to mould making. To make this four-handle mould by hand would involve making four casts of the same handle and setting them up side by side in a mould.

The other mould which was 3D printed is the tea strainer. Making it this way is more efficient on model making time; it's a relatively easy task to make the piercing location marks in the model from a CAD drawing. The structure of the tea strainer, with the lugs or handles on each side, makes it tricky to get out of the mould without breaking when model making; a printed version is more robust and therefore saves on time and cost. It's easy to see why industry has embraced such advances in technology.

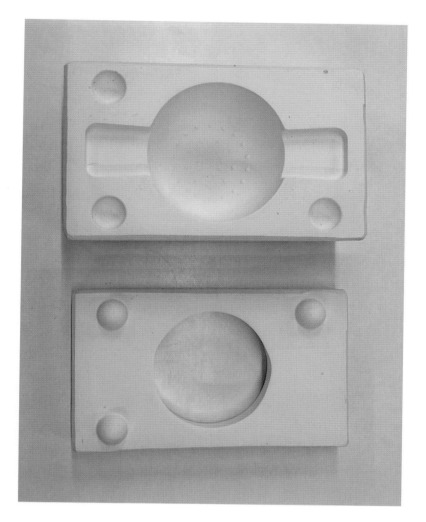

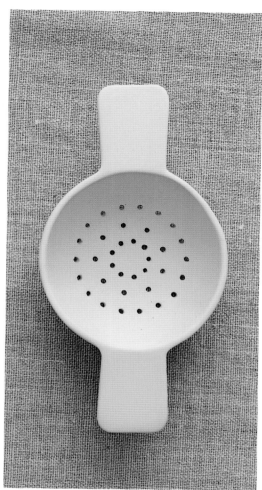

New technologies with model and mould making are the norm within industry to translate the concepts from the design team into models and moulds ready for the factory floor. Engineers have been utilising digital technology's capabilities for the best part of 20 years, if not longer. It is interesting to see how the craft sector are working with digital technology to create 3D printed artefacts for the home and the gallery.

Opposite top left: Rubber master mould made from a 3D print file. © Sue Pryke

Opposite bottom left: Slipcast handle mould made from a printed master mould. © Sue Pryke

Opposite right: Tea strainer mould made from a 3D printed model. © Sue Pryke

Top left: Tea strainer slipcast mould. © Sue Pryke

Top right: Finished slipcast tea strainer. © Sue Pryke

3D PRINTING BY KEELEY TRAAE

Keeley Traae worked within the ceramics industry for more than 25 years designing the world's most coveted dinnerware for Wedgwood. She is now going it alone and is using 3D printing to create a collection of functional vessels which are made using eco PLA materials (Polylactic Acid), which are plant-based materials made from renewable sources (usually corn starch) meaning its eco credentials are sound too as it is fully compostable and renewable.

Her process starts with sketches, followed by a digitally crafted 3D file. What is interesting is that Keeley is utilising the technology to print complex models, which would be time consuming to make with traditional methods of model and mould making, involving hand skills and plaster.

The printing process works though building layers in a CAD programme, the data is stored in an STL file and sent to slicing software. This software slices the information and creates a G-Code which is printed through a 3D printer. G-Code is the most common descriptor for CNC (computer numerical controlled) machining and mainly used in computer-aided manufacture. It is a complex set of instructions telling the machine where to move.

Keeley uses PLA materials to print and form her shapes, but there are makers who are printing directly with clay.

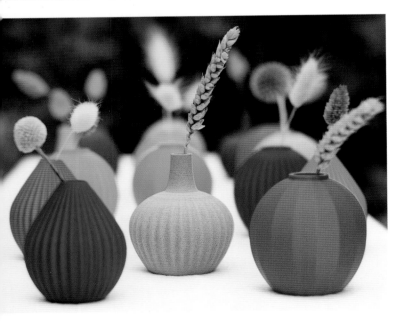

Top: Sketches. © Keeley Traae Design 2022

Middle: 3D surface building in CAD.
© Keeley Traae Design 2022

Bottom: 3D printed vases. © Keeley Traae Design 2022

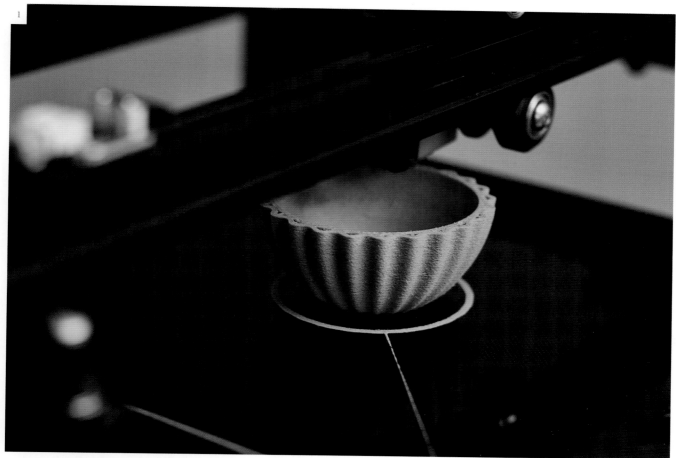

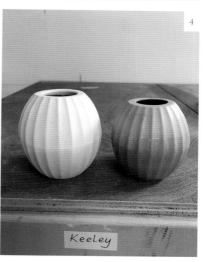

1: 3D printing in willow wood. © Keeley Traae Design 2022

2: Plaster moulds made from 3D printed models. © Keeley Traae Design 2022

3: Hand building two-part press moulds. © Keeley Traae Design 2022

4: Final fired vases, press moulded from 3D printed models. © Keeley Traae Design 2022

CAD DESIGN BY RYAN BARRETT

Ryan Barrett is a maker who digitally coils his CAD based forms. His shapes are monumental and are mathematically complex and it would be extremely difficult and time consuming to make forms like this by hand. He works with a porcelain which has added grogs for strength and plasticisers to keep the clay supple enough to print. The printer head extrudes in 1mm coils. It is a slow process and can take up to 18 hours to complete a piece. Ryan uses a programme called Gravity Sketch where he uses virtual reality to be able to create designs and manipulate forms before going into the stages of printing. For some of the final pieces he adds oxides into the clay body to create layers of colour and fires to 1300°C (2372°F).

His forms are fired and glazed using traditional firing techniques and glazes.

Below: Four printed forms by Ryan Barratt. © Ryan Barrett

Opposite: Final detail of a printed form piece by Ryan Barrett. © Ryan Barrett

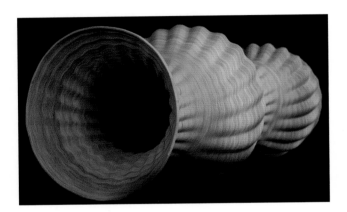

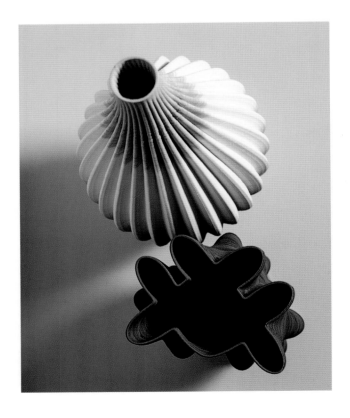

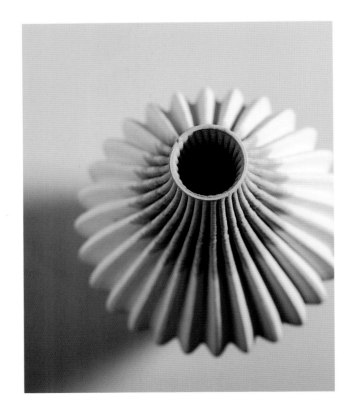

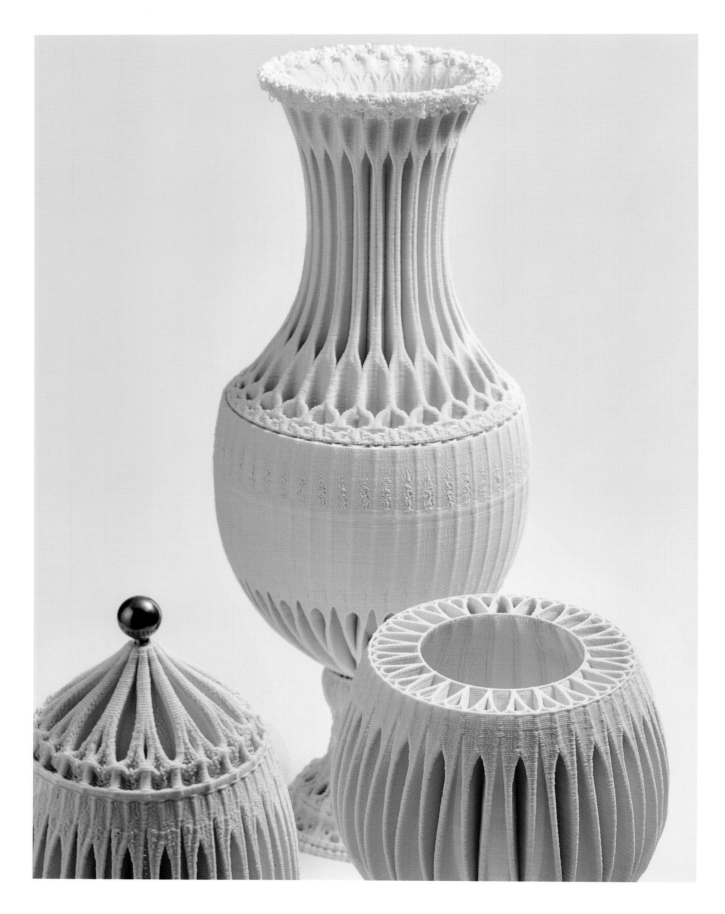

3D PRINTING BY NICO CONTI

Ceramic artist Nico Conti discovered 3D printing during his masters at the Royal College of Art. His shapes are highly complex forms, reminiscent of pieces of intricate lace and filigree or details from gothic architecture, but influenced by the craftsmen he grew up with in Malta. He spent time developing formulas and clay recipes to find a porcelain body suitable for 3D printing his fine sculptural forms. The manipulation of the forms range from glitches in the programme to shaping the strings of porcelain by hand as it is extruded from the printer.

Opposite: Final pieces by Nico Conti. © Cheongju Craft Biennale Organizing Committee

Top: Detail of 'Of Lace and Porcelain: Congruous Vase' by Nico Conti, 3D printed porcelain. Length 28 cm (11 in). Width 20 cm (8 in). Height 18 cm (7 in). © Nico Conti

Bottom: Detail of 'Of Lace and Porcelain: Bulbous Vase' by Nico Conti, 3D printed porcelain. Length 28cm (11 in). Width 20 cm (8 in). Height 18 cm (7 in). © Nico Conti

—

GLAZING

LINDA BLOOMFIELD
MAKING GLAZES

Glazes can be daunting, but making glazes is actually a straightforward process. Potters usually follow glaze recipes they find in books or online. The ingredients come as white powders; ground quartz, whiting, feldspar and clay. The powdered materials are weighed out carefully and added to a container half full of water, then left to slake, until the water has completely wetted the powder. The glaze can then be sieved through an 80 mesh potter's sieve (meaning it has 80 holes per linear inch). Once the water has been adjusted until the glaze consistency is somewhere between milk and single cream (either by adding water or leaving overnight to settle and then removing water) then it is ready to use.

It is not difficult to make a simple glaze without much knowledge. It is important to measure the glaze ingredients very carefully with accurate scales and to make a note of the recipe and number the corresponding test tile. However, if you gain an understanding of the science behind glazes, you will have much more control over what comes out of the kiln. This is particularly important for tableware which has to be safe to use, durable and easy to clean. The following chapter will cover glaze chemistry and explain what each glaze ingredient contributes.

GLAZE MATERIALS

The main material used in glazes is silica, in the form of ground flint or quartz. This is pure silicon dioxide (also known as silica) and is a glass former. The melting point of silica is too high to melt in a kiln, so fluxes are added to reduce the melting temperature. The main flux in stoneware glazes is feldspar, which contains sodium and potassium oxides. These are alkali metal oxides, which react with the acidic silica and break it down, helping it to melt. However, a simple mixture of sodium and silica, sodium silicate, would make a glaze which was soluble in water and likely to wash off in the dishwasher, so a second flux is added to make the fired glaze insoluble. This secondary flux is whiting, calcium carbonate, found in chalk and limestone. It helps to strengthen the glaze and makes it chemically stable. The resulting glaze would be very runny, so clay is added to make it more viscous in the melt. Clay contains aluminium oxide (also known as alumina) and silica. China clay, ball clay or a small amount of bentonite can be used as glaze materials that supply alumina. Clay also helps to suspend the heavier ingredients in water in the glaze bucket, preventing them from settling at the bottom.

Silica (flint, quartz)	Glassformer
Flux (feldspar, whiting)	Melter
Alumina (clay)	Stiffener

GLAZE RECIPES

Glaze recipes are written as a list of materials by weight percent, so if you want to make 100g glaze test, you can use the numbers in grams to add up to a total of 100g. If you want to make up a bigger batch of 1kg or 10kg, you can multiply by 10 or 100.

Stoneware glaze recipe, transparent glossy cone 9, 1280°C (2336°F)

Potash feldspar	27
Whiting	21
Quartz	32
China clay	20

Earthenware glaze recipe, transparent glossy cone 04, 1070°C (1960°F)

Borax frit	50
Soda feldspar	35
Whiting	5
Quartz	6
China clay	4

In the earthenware glaze recipe above, frit has been added. This is a kind of manmade feldspar, containing fluxes such as sodium and boron oxides, as well as silica. The reason for making frits is that some glaze materials such as borax are water soluble, eventually forming crystals in the glaze bucket that will not dissolve back into the glaze. A frit combines soluble materials with silica, which prevents them from dissolving in water. The more frit that is added to a glaze, the lower the firing temperature will be. Mid-range glazes (between stoneware and earthenware firing temperatures) can contain between 10% and 30% frit, while earthenware and raku glazes can contain up to 90% frit.

Looking at the glaze recipes given, the differences between stoneware and earthenware glaze recipes can clearly be seen. The earthenware glaze has less clay, quartz and whiting. Potash feldspar has been replaced by soda feldspar and borax frit has been added to decrease the firing temperature. Soda feldspar gives a more fluid melt than potash feldspar, but the glaze will be slightly softer and will scratch more easily. In general, the higher the firing temperature, the harder and more scratch resistant the glaze will be and the harder and stronger the fired clay body becomes.

GLAZE PROPERTIES

To make a shiny glaze, the glaze materials are combined together in a eutectic mixture. This is the lowest melting combination of materials. For silica and alumina, the eutectic ratio is 1:9 alumina to silica; a mixture with this molecular ratio melts at a lower temperature than either of the pure materials. Alumina is found in clay, together with silica (a clay molecule is a ratio of 1:2 alumina to silica and two water molecules). Alumina is also present in feldspar (1:6 alumina to silica and one soda molecule). Glazes with a ratio of 1:9 alumina to silica (plus enough fluxes to melt them) will be shiny and transparent at stoneware temperatures.

ALTERING THE GLAZE

To make the glaze more matt, the silica can be reduced or more clay can be added until the ratio of silica to alumina is 1:5.

Another way to make a matt glaze is to add more calcium or magnesium in the form of dolomite. However, these dolomite matt glazes may have subdued colour.

To make brightly coloured matt glazes, add strontium carbonate. This will give bright turquoise with copper oxide or lime green with chromium oxide.

To make the glaze more shiny, more silica, feldspar or frit can be added.

To make the glaze melt at a lower temperature, the clay in the recipe can be reduced or frit can be added.

Satin matt translucent glaze cone 8, 1270°C (2316°F)

Potash feldspar	31
Dolomite	24
Quartz	27
China clay	15
Zinc oxide	3

Satin matt glaze cone 6, 1240°C (2264°F)

Soda feldspar	44
Dolomite	23
Whiting	3
China clay	6
Quartz	23

COLOURING GLAZES

Glazes can be coloured by adding commercial stains or colouring oxides. Stains and underglaze colours have been mixed with stabilisers and opacifiers and have already been fired, so their colour will not change further during firing. However, colouring oxides are more likely to change colour during firing as they dissolve and react with the materials in the glaze, giving transparency and depth. The colouring oxides include cobalt, copper, chromium, iron, manganese, nickel, rutile and vanadium. Oxides can be brushed directly on to biscuit-fired ware and covered with a clear glaze, or mixed in with the glaze to give more uniform colour. When they are added to a base glaze recipe, they are usually added as an extra percentage by weight. For example, if a recipe has 2% copper oxide, you will need to add 2 g to 100 g (0.07 oz to 3.5 oz) dry weight of base glaze. Once mixed with water, the glaze will need to be sieved several times using an 80 to 100 mesh sieve. If speckles still remain, you may need to sieve again through a 120 mesh sieve. Many of the colouring oxides are toxic, so a mask must be worn when weighing the dry ingredients and firing fumes should be avoided.

In ceramics, the colours blue, green and brown can easily be made using cobalt, chromium, copper or iron oxides. The colouring oxides change colour when fired in a glaze; for example, cobalt oxide changes from black to blue. The warm colours – yellow, orange and red – are more difficult to make, involving toxic cadmium and selenium compounds, and are usually bought as commercially prepared stains, which are less toxic to use. These stains do not change colour on firing but are less concentrated than colouring oxides, so more is needed to colour a glaze (5-10%). Small amounts of colouring oxides (0.5-3%) dissolve in the glaze to give transparent coloured glazes. Combinations of colouring oxides do not always give predictable colours; for example, cobalt and chromium oxides combine to give an opaque teal. Make sure you test your glazes on a tile before using them on your pots. Commercially prepared stains tend to be stabilised using zirconium silicate, so they make the glaze opaque (zirconium silicate on its own gives an opaque white). Around 5-10% stain can be added to a glaze. Mixing stains is more predictable, like mixing pigments or paints; for example, combining red and yellow stains to make orange. When designing a range of glazes to go together, it is a good idea to choose either colouring oxides or commercial stains.

When using colouring oxides, the fluxes in the base glaze will have an effect on the colour developed during firing. For example, magnesium-based glazes will make green with copper oxide, while strontium-based glazes will be turquoise, particularly if the clay content is low. The kiln atmosphere will also affect the colour; restricting the oxygen intake during reduction firing will cause copper oxide to turn oxblood red and iron oxide to turn celadon green. Dolomite (calcium/ magnesium) matt glazes tend to have subdued colour, while barium and strontium matts can have bright colours including turquoise from copper, lime green from chromium, blue and purple from nickel oxide. Barium carbonate is toxic, so it may be preferable to substitute with non-toxic strontium carbonate for use on tableware. A small addition of lithium carbonate can also brighten the colours obtained from oxides.

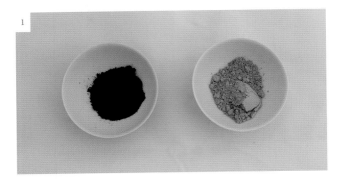

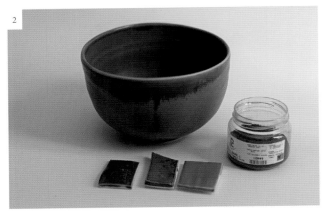

In general, small amounts of colouring oxide will dissolve in the glaze, resulting in a transparent coloured glaze. Larger amounts will remain as undissolved particles and the glaze will be opaque. In matt glazes, the matt surface is often made of tiny crystals, which will be coloured by oxides. Crystal growth can be encouraged by adding rutile or titanium dioxide.

COBALT

Cobalt is toxic and is found in minerals such as smaltite in combination with arsenic. In glazes, cobalt oxide or carbonate gives a strong blue colour. The carbonate is a weaker form and 1.5 times the amount of oxide is needed to gives the same strength of colour. Amounts of 0.5-2% cobalt oxide will give a strong blue in glazes, which can be subdued by adding iron and manganese oxides. Black glazes can be made using 2% each of cobalt, manganese, iron and 1% nickel oxide. Matt glazes containing dolomite or talc will turn cobalt a lavender blue colour.

COPPER

Copper oxide will give green in magnesium-based glazes and turquoise in strontium or barium-based glazes fired in oxidation, or oxblood red when fired in reduction. The carbonate is a weaker form and can be substituted for copper oxide but 1.5 times is needed. 1-3% copper oxide will give a strong colour, but more than this will produce a black, metallic effect.

CHROMIUM

Chromium oxide gives a range of colours in glazes. The usual colour from chromium is bright green, but a small amount (0.1-0.5%) will give a pink colour with tin oxide (5%), known as chrome tin pink. Chromium usually turns pinkish brown in the presence of zinc oxide. Chromium oxide is toxic.

1: Cobalt oxide and carbonate.

2: Blue bowl glazed with a dolomite matt glaze containing cobalt oxide.

3: Copper oxide.

4: Chromium oxide.

IRON

Iron oxide is used in many traditional glazes including honey yellow, celadon green, tenmoku brown black and kaki red brown. 0.5-15% iron oxide can be added to glazes, larger amounts giving stronger colours. Iron oxide is present in rust and red earthenware clay. Iron oxide pigments used by potters include red iron oxide, black iron oxide and yellow ochre.

RUTILE

Rutile is a mineral containing titanium dioxide and up to 15% iron oxide. A similar mineral containing 50:50 titanium and iron oxide is called ilmenite. 2-10% rutile can be used to give streaked and mottled effects in glazes.

NICKEL

Nickel oxide can be used to make grey glazes, together with cobalt. It will produce green and mustard colours with titanium dioxide or pink, purple and steel blue in barium and zinc glazes. 0.1-3% is needed in a glaze. Nickel oxide is toxic.

MANGANESE

Manganese dioxide will produce a dark brown in quantities of 1-15%. It will give a pinkish brown in barium glazes and purple when combined with a small amount of cobalt.

VANADIUM

Vanadium pentoxide can be used in dry matt glazes to give a mottled yellow colour. 2-8% is needed in the glaze. Vanadium is toxic.

OPACIFIERS

White glazes are made by adding tin oxide or zirconium silicate to a clear glaze. Amounts of 5% tin oxide or 10% zirconium oxide are needed to opacify the glaze. Black and grey glazes can be made using various combinations of iron, manganese, nickel and cobalt oxides.

1: Red iron oxide.

2: Rutile.

3: Manganese dioxide.

4: Tin glaze on red earthenware and tin oxide.

STAINS AND UNDERGLAZE COLOURS

Commercial stains are made by heating colouring oxides together with silica and opacifiers. Many stains contain zirconium silicate, which makes the glaze opaque. If you want to make a bright yellow, orange or red glaze, you will need to buy stains, as those colours cannot be made easily using oxides. Red and orange inclusion stains, where the pigment is encapsulated in a matrix of zirconium silicate, are stable up to high temperatures. If you want blue, green or brown it is better to use oxides, which give more interesting depth of colour than stains. Underglaze colours are stains mixed with clay, frit and CMC (carboxy methyl cellulose) gum to make them easier to apply.

If you use a white stoneware or porcelain clay, your glaze colours will be brighter than if you use a darker stoneware or red earthenware clay. Some potters apply a white slip or opaque white glaze to give a brighter ground for decoration. Slip can also be trailed to make a raised decoration or scratched through to reveal the clay body beneath.

White Slip (Patia Davis)

HVAR Ball clay	75
China clay	20
Quartz	5

Bottom left: Slip-decorated porcelain dish with yew ash glaze by Patia Davis. © Patia Davis

Bottom right: 'Under the Gulmohar Tree' plate in terracotta clay with brushed white slip and sgraffito decoration by Vallari Harshwal. © Vallari M Harshwal

GLAZE MIXING AND APPLICATION: BRUSHING, POURING, DIPPING

Once you have tested a few glaze recipes and found one that gives the fired result you want, you will need to mix up a larger batch of glaze so that you can start applying it to your pots. The simplest application methods are pouring, dipping and brushing.

In order to dip the pots in the glaze, you will need to mix up at least 5 l to 10 l (1.1 gal to 2.2 gal). I usually mix 7.5 kg (16.5 lb) of glaze in a 10 l (2.2 gal) bucket with a lid. The glaze recipes shown are multiplied by 75 to give the batch weight in grams. Start by half filling the bucket with water, then carefully weigh out the glaze ingredients and tick them off the list one by one. It is best to add the china clay or ball clay first, as this helps to suspend the heavier ingredients in the water. If you add the feldspar first, it is likely to settle in a hard mass at the bottom of the bucket. Then leave all the ingredients to slake in the water for a few hours before mixing and sieving three times through an 80 mesh sieve. You may need to add water to help flush the glaze through the sieve. If it ends up too thin, you will need to leave to settle overnight and remove water from the top, so if possible, make the glaze the day before you need to use it. The consistency should be between milk and single cream, but some glazes such as ash glazes need to be thicker. I stir by hand and if it is the correct thickness, I can just see the skin on the back of my hand through the glaze coating. However, ash glazes are caustic, so always wear rubber gloves when mixing those. When the consistency is right, mark

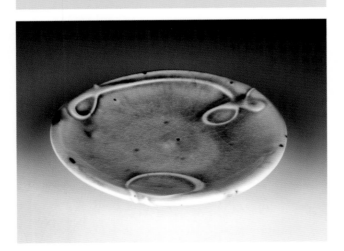

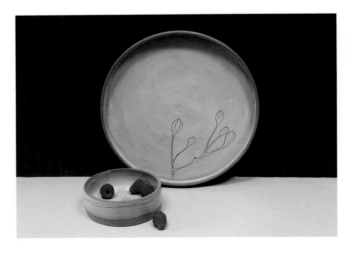

the level on the glaze bucket and use the same level every time you make a new batch of that glaze. Alternatively, you can weigh 500 ml or 1 pt of glaze and record the weight, then make sure the pint weight is the same each time you mix a new batch. Some potters prefer to use a hydrometer to gauge the glaze consistency. In general, glazes need to be applied more thickly on stoneware than on porcelain. The glaze thickness on the pot can be anywhere between 1mm and 3 mm (up to $^1/_{10}$ in).

When making production ware, it is particularly important to keep a note of the glaze recipe, the quantities of each material and the amount of water used so that your glazes can be repeated from batch to batch. Fire a test tile of each new glaze batch before applying it to a kiln-load of pots.

Earthenware glaze recipe, transparent glossy cone 04, 1070°C (1960°F)

Borax frit	50
Soda feldspar	35
Whiting	5
China clay	4
Flint	6

Stoneware transparent glossy glaze recipe cone 8, 1270°C (2320°F)

Potash feldspar	34
Borax frit	14
Whiting	11
China clay	13
Quartz	23
Dolomite	5

Left: Adding dry ingredients to water.

Top right: Sieving glaze through an 80-mesh sieve.

Centre right: Using a rubber spatula to push the glaze through the sieve.

Bottom right: Stirring the glaze.

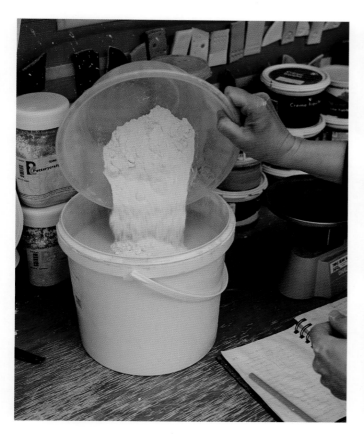

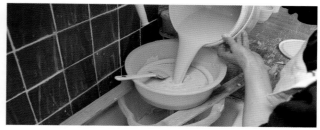

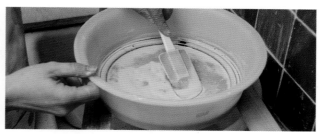

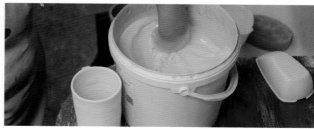

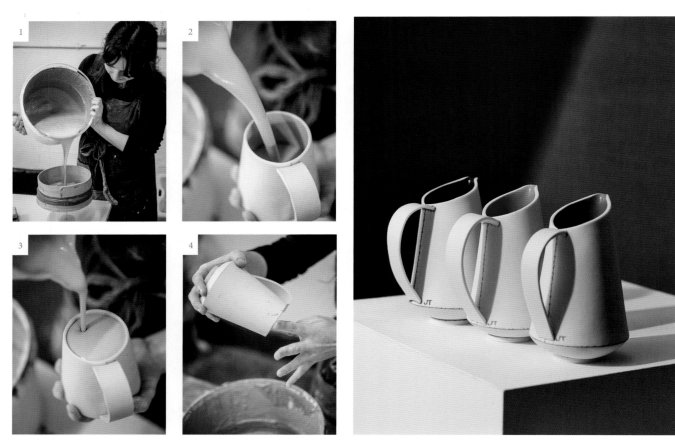

PREPARATION FOR GLAZING

You will need biscuit-fired pots, fired to around 990°C (1814°F) for stoneware or 1060°C (1940°F) for earthenware. Some potters raw glaze unfired pots, but biscuit firing allows you to wash off the glaze, leave to dry and start again if anything goes wrong. If you apply glaze straight after the biscuit firing, it should not be necessary to wash the pots. If they have been lying around for some time in the studio, any dust should be sponged off and the pots left to dry before applying glaze.

POURING

Pouring is the best application method for the inside of pots, or if you need to glaze a pot which is too large to dip. The glaze should be stirred very thoroughly, and stirred again between glazing multiple pots, otherwise it may start to settle in the bucket. Scoop up a measuring cup full of glaze and pour carefully into your pot, swill around and pour out. You may need to use a funnel to glaze the inside of narrow-necked pots. If you want a different glaze on the outside, wipe any glaze drips from the outside using a sponge and leave to dry. Very thin-walled pots will also need to be glazed on the inside first, then left to dry before glazing the outside. Very large pots can be placed on a whirler or wheel and rotated slowly while glaze is poured over the outside and collected in the wheel tray.

POURING SLIP BY JESSICA THORN

1: Jessica Thorn sieving a coloured slip.
© Ben Boswell

2: Pouring coloured slip into a jug. Slip is usually applied to leather-hard pots before biscuit firing. © Ben Boswell

3: Filling the jug to the rim. © Ben Boswell

4: Pouring out the slip and wiping the rim. © Ben Boswell

Opposite top right: Jugs by Jessica Thorn with coloured slips on the inside and used to assemble the component parts. © Jess Hand

Opposite bottom: Earthenware platters by Silvia K decorated by pouring white and coloured glazes. © Silvia K Ceramics

a: Dipping a mug in glaze.

b: Sponging the bottom of a mug. The glaze was first scraped off using an old credit card.

DIPPING

Dipping is a good way to apply glazes when you need a very even application.

Hold the pot sideways by the rim and foot, between finger and thumb, or using glazing tongs. Dip it swiftly into the glaze and out again, pouring out all the glaze from the inside of the pot. If you are only glazing the outside, hold the pot by pressing your fingers against the inner sides of the pot and dip up to just below the rim. Place on a clean surface and do not touch the pot again until the glaze has dried. You can finish by dipping the rim upside down or brushing glaze on to the rim. Any drips should be cut flat with a sharp knife. Any finger marks or bare patches can be touched up using a brush although some potters like to leave finger marks.

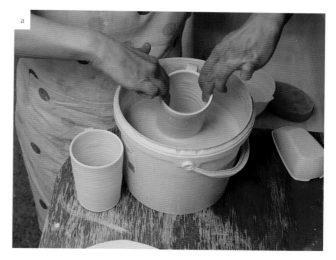

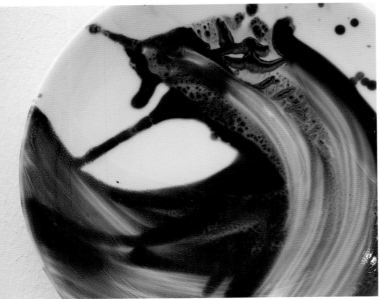

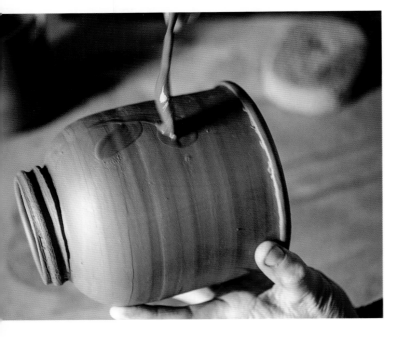

BRUSHING

To make the glaze easier to brush on, you can add CMC (carboxy methyl cellulose) or gum arabic to the glaze. Two or three coats of glaze will be needed to get an even coverage. I usually apply brush strokes round the pot, then go round a second time, starting each brush stroke in between the previous brush strokes. Once a glaze has been made into a brush-on glaze, it can't be used for dipping, so only make small batches. Potters often use Chinese calligraphy brushes or wide Japanese hake brushes for covering larger areas.

You can mask areas you do not want glazed by applying wax resist, latex or masking tape. However, I find it easier to scrape glaze off the base using an old credit card and then carefully sponge the base. When throwing pots on the wheel, I always bevel the edge of the base to make a neat line to sponge back to. This also prevents the glaze from sticking onto the kiln shelf.

SPRAYING

The advantage of spraying is that you do not need to mix up a large batch of glaze. The draw-back is that you need a lot of equipment: a spray booth, spray gun and compressor. A respirator mask should also be worn while spray glazing. The pot is placed on a whirler and rotated while spraying glaze on in several thin coats.

Top left: Selection of brushes for glazing.

Centre: Close-up of the bone china 'Wave' plate by Reiko Kaneko with brushed glaze decoration. © Reiko Kaneko

Bottom: Patia Davis brushing slip decoration onto her screw-threaded jar before biscuit firing. © Ben Boswell

Opposite: Solomia Zoumaras spraying glaze in a spray booth. Some areas are masked using masking tape.

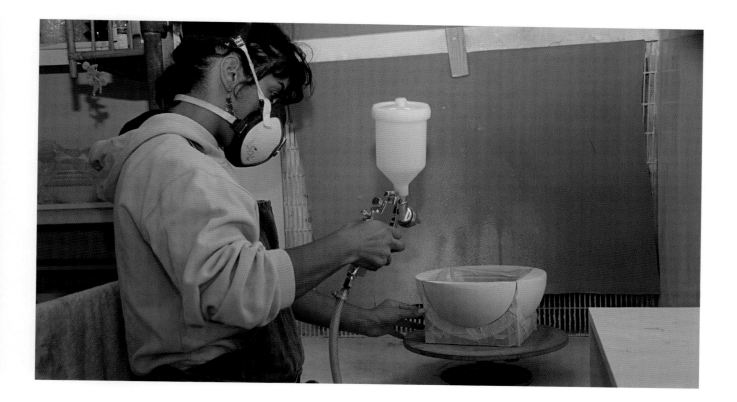

LAYERING GLAZES

Underglaze colours, slips or oxides can be brushed on before applying the glaze. Rich effects can be obtained by applying several layers of different glazes, for example a white glaze over a darker glaze or a runny glaze over a matt glaze. The glazes often react, producing interesting effects.

However, not all glazes are compatible with other glazes so always test on a tile first.

It is important to consider whether to use one glaze all over, or different glazes on the inside and outside of pots. Before using more than one glaze, test to make sure they are compatible. They should fire to the same temperature as the clay body and have the same expansion as the clay body to avoid crazing or shivering, either of which may occur if the glaze does not fit the clay body. If the glaze has a slightly different expansion from the clay body, the stress will be more balanced if the glaze is applied all over the pot. However, if the glaze is applied only to the inside of the pot, the stress will be unbalanced and the pot

may crack. This can also happen if there is a different glaze on the outside, such as when functional ware potters use a non-food-safe glaze on the outside and a food-safe liner glaze on the inside. To minimise the stress, make sure you do not apply the glaze too thickly.

When layering two glazes, make sure both glazes mature at the same temperature. If the underlying glaze matures early, then any gases given off may be trapped in the more viscous, overlying glaze and may form blisters. However, layering glazes can result in rich effects, so it is a good idea to test combinations of pairs of glazes layered one over the other. There are some glaze ingredients that destroy certain colours; chrome tin pinks are particularly sensitive, and are affected by certain glaze materials such as zinc oxide. For example, if you overlap a chrome-tin pink glaze with a second glaze containing zinc oxide, the pink colour will disappear. If you fire a chrome-tin pink glaze too high (above 1250°C or 2282°F) then the colour may also disappear, even if the pink is in the form of a commercial stain. Chrome green glazes are also incompatible with zinc oxide glazes, turning into brown zinc chromate where they overlap.

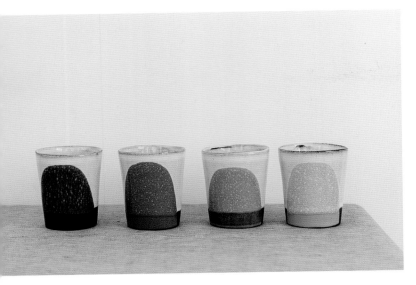

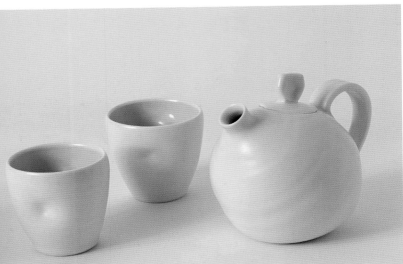

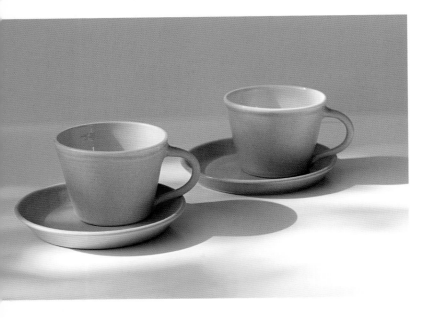

Think about where the glazes will overlap and how they will meet at the rim. Some glazes run or react with other glazes to form drips. It might be a good idea to leave a band of unglazed clay on the outside near the base of the pot to allow for drips to run down without sticking to the kiln shelf.

GLAZE PROBLEMS

There are many problems that can occur with glazes, both in the glaze bucket and after firing. Here I will explain the most common problems and what you can do to correct them. It is better if you make your own glazes as then you will know what is in them and will be more able to determine what might be causing problems.

PROBLEMS IN THE GLAZE BUCKET

There are several problems that can occur when glazes have been mixed and then left for several months. Some glazes settle in a hard layer at the bottom of the glaze bucket. This is caused by slightly soluble alkalis in the glaze materials leaching into the water. Particular materials that cause this problem are nepheline syenite and soda feldspar. The dissolved sodium causes the water to become alkaline and the clay particles are no longer attracted together and sink to the bottom of the bucket. To overcome this problem, the glaze needs to be flocculated, so that the clay particles attract each other and clump together, remaining suspended in the water. Epsom salts (magnesium sulphate) can be used as a flocculant to counteract the alkalinity of the water and affect the charge on the clay particles. The edges of the clay particles have a positive charge and are attracted to the negatively charged faces of other clay particles, building a structure like a house of cards and helping to suspend the other materials in the glaze. The glaze will seem thicker in consistency than before flocculation. It will also form fewer drips when applying by dipping and pouring.

To correct a settled glaze, first pour off the water, dig out the hard layer of glaze, mix the water back in and add a small amount (a teaspoon) of Epsom salts dissolved in water. This may need to be done every few months to keep the glaze suspended.

In glazes with very little clay content, the addition of 2% bentonite will also help suspension. Bentonite is a very plastic clay that can be mixed with the other dry glaze materials before adding to water. If added later to prevent settling in an already mixed glaze, mix the bentonite into a paste with a little water before adding to the glaze.

If the glaze contains bone ash (calcium phosphate), leaching of the phosphate into the glaze water can cause the glaze to become very thick, like a gel. When applied to a pot, it may form cracks and fall off. Adding water to the glaze does not correct the cracking problem; the glaze needs to be deflocculated. In this case the water has become acidic and can be balanced by adding sodium silicate or Dispex (a sodium-based polymer). Only a few drops of deflocculant need to be added to reduce the viscosity of the glaze. This may

need to be done every few months to keep the glaze from thickening again.

To determine whether the glaze has the correct amount of water, you can measure its specific gravity, by weighing 100 ml (3.5 fl oz) of glaze in a measuring cup. You can calculate the specific gravity by weighing any volume of glaze and dividing the weight in grams by the volume in millilitres. For example, if 100 ml glaze weighs 140g, the specific gravity is 1.4. In the potteries in Stoke-on-Trent this was known as the pint weight (measured using Imperial units). Most glazes have a specific gravity between 1.4 and 1.5. Once you get the glaze to the consistency you want (I prefer it to be between milk and single cream), record the specific gravity so that you can adjust the water content in the future if needed.

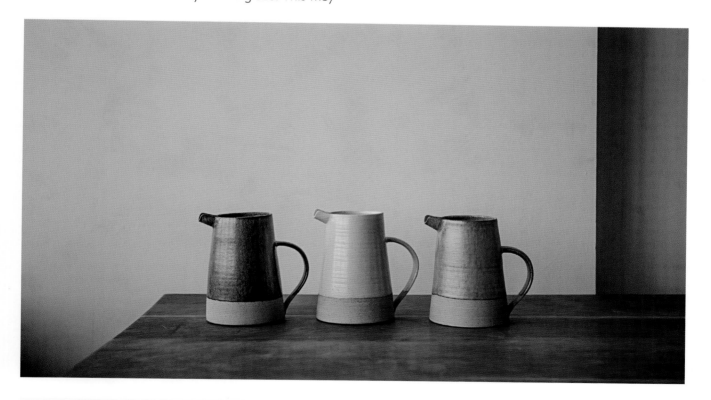

Opposite top: Terracotta beakers with layered tin-white and coloured glazes by Silvia K. The tin glaze breaks through with white speckles on the coloured glazes. © Silvia K Ceramics

Opposite centre: Teapot and cups with pink glaze on the inside and satin matt white on the outside and rim by Linda Bloomfield. This requires careful application so that the white glaze does not overlap the pink.

Opposite bottom: Cups and saucers with coloured glazes on the outside by Sue Ure. The transparent glaze on the inside also covers the rim and meets the coloured glaze in a line on the outside. © Sue Ure Ceramics

Above: Jugs with unglazed bands at the base by Pottery West. Photograph by Helena Dolby. © Pottery West

PROBLEMS AFTER FIRING

There are several glaze problems that do not appear until after firing. Crawling occurs when the glaze shrinks and cracks on drying. During firing, the glaze melts and the cracks widen, leaving bare patches. This can happen if the glaze has been applied too thickly, or if the clay content is high (more than 15% clay in the glaze recipe). In glazes with high clay content, some of the clay can be calcined (biscuit fired before adding to the glaze). This prevents the clay shrinking and cracking. Other materials that can cause crawling are zinc oxide and light magnesium carbonate.

Some cases of crawling are caused by firing too quickly, before the glaze has had time to dry out. Water in the glaze turns to steam and blows off sections of the glaze. To prevent this happening, make sure the glazed ware is completely dry before firing. Dusty or greasy biscuit ware can also cause crawling and can be sponged before glazing to prevent this.

When making tableware, the glaze has to fit the clay body very closely, otherwise there may be problems such as chipping, cracking and crazing. These are all caused by stresses between the glaze and clay body, each having different thermal expansions.

A common problem is cracking, also known as dunting, when a pot cracks during or after firing. This is often caused by poor glaze fit, particularly when the pot is glazed only on the inside, or if it has a liner glaze and a different glaze on the outside. If the liner glaze has a lower expansion than the clay body, the fired glaze will be too big for the pot and the resulting stresses will eventually cause the glaze to chip or the pot to crack. This often happens to large pieces such as plates, particularly if they are glazed only on one side. To correct the glaze fit, a high expansion material such as nepheline syenite or high alkaline frit can be added to the glaze in increments of 2% (dry weight). To calculate the dry weight of a glaze that is already mixed with water, a rough estimate is that the glaze is roughly half dry powder and half water by weight, so 200g (7 oz) of glaze will contain roughly 100 g (3.5 oz) dry powder and 100 ml (3.4 fl oz) water. Glaze the inside of a cylindrical pot and test by pouring in boiling water to see if it cracks.

Other glaze problems include crazing (also known as crackle), where the glaze is too small for the clay body. To correct crazing, reduce the sodium in the glaze (soda feldspar, nepheline syenite or high alkaline frit) or add a low expansion material such as silica (quartz), talc (magnesium silicate) or low expansion (calcium borate) frit in 2% increments (see next section for more details). While some potters see crazing as a problem, other potters use it as a special effect.

Pinholes and blisters are often the result of over or underfiring. If the glaze is applied too thickly or underfired, holes left by gases escaping may not have had time to heal over, resulting in pinholes. A soak at top temperature for 15-30 minutes can heal pinholes. Over-fired or damp biscuit ware can affect the absorption of the glaze and sometimes causes pinholes.

If glazes are over fired, more gases are liberated from the clay and glaze and blisters may form. The blisters can be ground down and the pot refired. The blistered test tile pictured is a glaze containing a large amount of bone ash, which can give off gas.

Another problem with matt glazes is cutlery marking. Matt glazes have a microscopically rough surface that picks up traces of metal from cutlery being scraped across it. This leaves grey marks that can be removed by scrubbing with vinegar, which reacts with and dissolves the metal. Glossy or satin matt glazes are more suitable for tableware. You can change a matt glaze into a more satin or glossy glaze by adding a small amount of silica (quartz) or frit.

GLAZE FIT: HOW TO CORRECT CRAZING

Now we will look in more detail at how to correct crazing. Crazing or crackle is a problem in glazes where the glaze is too small for the clay body. On cooling in the kiln, the glaze shrinks more than the clay and a network of fine cracks develops, accompanied by pinging sounds. Cracks can continue to appear over weeks and months, particularly if there are dramatic temperature changes such as those which occur when the pot is put in the oven or dishwasher. Crackle is often used as a decorative effect in Oriental ceramics, but the cracks can greatly weaken the pot, causing it to crack and break more readily than a pot with an uncrazed glaze. Crazing on earthenware pots can cause them to leak, as the fired clay body remains porous and water can seep through. The cracks can also harbour dirt and bacteria, so are not ideal on functional pots, but cleaning in the dishwasher has been shown to be sufficient to remove any bacteria on stoneware and porcelain.

Top: These porcelain plates have been glazed on one side and have cracked during firing owing to stresses between the glaze and clay, also known as dunting.

Centre: Glaze defects. From left to right: crazing, crawling, blisters and pinholes. The glaze problems are caused by particular materials in the glaze; too much zinc oxide causes crawling and bone ash can cause blistering.

Bottom: Detail of a stoneware crackle-glazed plate by Ali Herbert. ©Matt Austin

Below: Wood-fired Shino glazed jug with both crazing and pinholes. Shino is a white and orange Japanese glaze in which glaze defects are seen as a positive attribute. © Rebecca Proctor. Wood-fired Shino glazed cup with crazing by Rebecca Proctor. © Rebecca Proctor

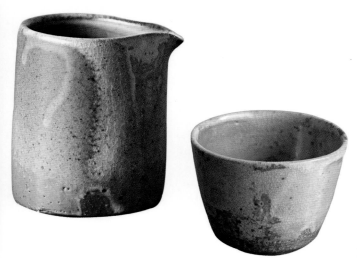

ADDING SILICA AND CLAY

There are several ways to correct crazing. However, changing only one material may change the appearance of the glaze, making it more glossy or matt. A reliable method is to increase both the silica (flint or quartz) and clay in the ratio 1.25:1 silica to clay. This ratio comes from a series of porcelain glaze tests made by R.T. Stull in the USA in 1912. He measured the effect on the glaze of changing the alumina and silica content. He found that a molecular ratio of 1:5 alumina to silica gives a matt glaze, while 1:8 gives a shiny glaze. Alumina is found in clay, which is added to glaze to stiffen it in the melt and prevent it running off the pot. Clay contains silica as well as alumina, and the ratio 1:8 alumina to silica molecules converts to a ratio by weight of 1:1.25 clay to silica. To change your glaze recipe, add increments of 1% clay and 1.25% silica until the crazing disappears. This has the effect of moving along the dashed line in the graph on page 182 from the crazed to the glossy, uncrazed area. You will need to multiply the percentage by the total weight; for example, in a 100 g (3.5 oz) dry batch of glaze, add increments of 1 g (0.04 oz) china clay and 1.25 g (0.04 oz) quartz, then wet sieve and test on a pot to see if the crazing is reduced. If not, add increments of 1 g (0.04 oz) up to 4 g (0.14 oz) clay and up to 5 g (0.17 oz) silica and test again. Test tiles are often too small an area to see crazing, so you may need to test on a larger bowl or plate. Crazing is also affected by the glaze thickness. A thinner application of glaze or the addition of more water is sometimes enough to reduce the crazing.

ADDING FLUXES

Adding too much silica and clay may make the glaze appear underfired, dry and matt. This can make it prone to staining or cutlery marking. Another way to correct crazing is to add a low-expansion flux material such as talc, which is magnesium silicate. Both magnesium oxide and silica have low expansion. Both will decrease the expansion and contraction of the glaze during cooling, so will prevent crazing. Talc is a better choice than dolomite, which contains both magnesium and calcium oxide, the latter of which has a relatively high

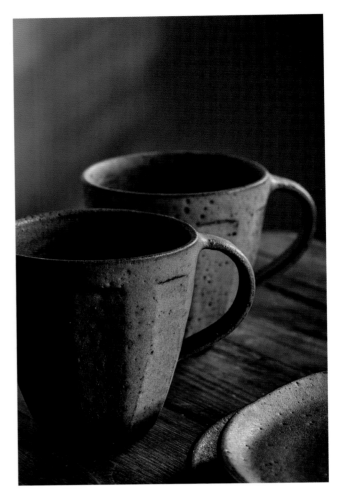

Above: Quarry stoneware mugs with matt glazes by Sophie Moran. The glazes have attractive pin-holing that shows the dark clay underneath. © Sophie Moran

expansion. If you look at the fluxes opposite, listed in order of decreasing expansion, with high expansion at the top and low expansion at the bottom, you can choose the most appropriate low-expansion flux to add to your glaze. It is simpler to increase a material already in the glaze than to add a new one. Stoneware glazes can have the addition of 5% talc or zinc oxide. However, these fluxes may affect the colour of chrome green and chrome-tin pink glazes. Earthenware glazes can have the addition of a flux containing boron, such as low expansion frit. Opacifiers and colouring oxides such as zirconium silicate and tin oxide also help to reduce crazing.

High expansion

↑

Sodium oxide (in soda feldspar and high-alkaline frit)

Potassium oxide (in potash feldspar)

Calcium oxide, strontium oxide

Barium oxide

Titanium oxide, lead oxide

Lithium oxide (in lithium carbonate and petalite)

Zinc oxide

Magnesium oxide (in talc)

Tin oxide, zirconium oxide

Alumina (in clay)

Silica (quartz, flint)

Boron oxide (in low expansion frit)

Low expansion

However, adding a flux will often make the glaze more runny. Alternatively, you can remake the glaze, reducing the high-expansion materials such as feldspar, or substituting low-expansion materials for the high-expansion ones, such as a lithium feldspar for soda feldspar or low expansion frit for high-alkaline frit. It is a good idea to change one material at a time to keep a clear idea of the effect of each individual material on the glaze.

Right: Porcelain mugs and bowls with runny turquoise glaze by Linda Bloomfield. Photograph by Emma Lee.

CHANGING THE CLAY BODY OR FIRING TEMPERATURE

Other ways to correct crazing include changing to a different clay body which better fits the glaze, adding silica to the existing clay body or increasing the firing temperature. In stoneware, the addition of silica sand to the clay body can help prevent crazing. In earthenware, bisque firing to a higher temperature can eliminate crazing.

CALCULATING THE MOLECULAR FORMULA

Glaze recipes can be written either as a recipe by weight percent, or as a molecular formula. To calculate the formula, you need to convert each material in the glaze into a number of molecules, depending on their relative proportions in the glaze recipe. To do this, divide the weight of each material by its molecular weight. Dividing by the total number of alkaline fluxes (sodium, potassium, calcium) gives the unity molecular formula, where the sum of the alkaline fluxes is arbitrarily set to 1. This will give you the ratio of silica to alumina and whether the glaze is likely to be matt or glossy. You can use glazy.org to calculate the molecular formula for your glaze recipe.

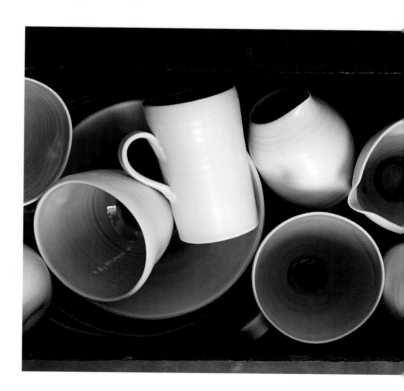

Runny turquoise glaze cone 6–9, 1240-1280°C (2270-2336°F)

This glaze is in the glossy area on the graph (Na_2O 0.25, CaO 0.75, B_2O_3 0.38, Al_2O_3 0.38, SiO_2 3.1)

Soda feldspar	47
Calcium borate frit	16
Whiting	14
China clay	5
Quartz	18
+	
Copper oxide	2

If you can't find calcium borate frit, use low expansion frit instead

High-alkaline turquoise crackle glaze cone 6, 1240°C (2264°F)

This glaze is in the crazed area on the graph (Na_2O 0.7, CaO 0.3, Al_2O_3 0.23, SiO_2 2.5).

Soda feldspar	15
High alkaline frit	47
Lithium carbonate	2
Whiting	6
Quartz	18
China clay	10
+	
Copper oxide	2

DISHWASHER-SAFE GLAZES

It is very important that tableware has food-safe and dishwasher-safe glazes. Glazes are made from three components: silica (the glass former), fluxes to melt the silica, and clay to stiffen the glaze when melted. These components need to be combined in the right proportions to achieve the best melting at the chosen kiln temperature. The choice of fluxes used is also important and affects the glaze durability. It is better to use a combination of several fluxes to achieve melting. The most powerful fluxes are the alkali metal oxides of potassium (K), sodium (Na) and lithium (Li). Their oxides have the chemical formula R_2O where R is the alkali metal K, Na or Li and O is oxygen. They help the silica to melt at a lower temperature than its natural melting point of 1710°C (3110°F). However, sodium silicate is soluble in water so would not make a good glaze on its own. To make the glaze insoluble, an alkaline earth such as calcium must be added. The alkaline earth oxides of calcium (Ca), magnesium (Mg), barium (Ba) and strontium (Sr) are less powerful fluxes than the alkali metals but help to stabilise the glaze, making it more resistant to attack by water, acid or alkali. Their oxides have the chemical formula RO where R is the alkaline earth Ca, Mg, Ba or Sr and O is oxygen. Low temperature metal oxide fluxes lead (Pb) and zinc (Zn) also have the formula RO.

Right: The chart shows the effect of changing the alumina and silica in porcelain glazes fired to cone 11 with constant flux 0.3 K_2O and 0.7 CaO. The ratio of 1:5 alumina to silica gives a semi-matt glaze, while a ratio of 1:8 gives a shiny glaze. The straight lines on the chart represent alumina to silica ratios of 1:4 (matt), 1:5 (semi-matt) and 1:12 (shiny, crazed glaze). The dashed line has a ratio of 1:8 $Al_2O_3.SiO_2$ (bright, shiny glaze). The hatched area shows crazed glazes. By increasing the alumina and silica in the molecular ratio 1:8, you can move a glaze from the crazed area to the glossy, uncrazed area. Graphic by Henry Bloomfield, with thanks to Matt Katz of Ceramic Materials Workshop. Adapted from the Stull chart, drawn by R. T. Stull in 1912. © Henry Bloomfield

Opposite: Porcelain plates with coloured glazes by Linda Bloomfield.

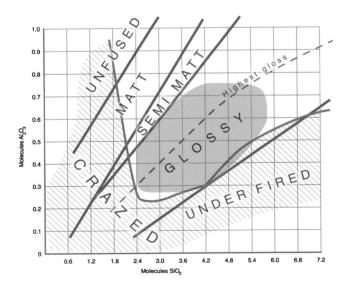

STABLE GLAZES

The proportion of alkali metal to alkaline earth is very important when considering the chemical stability of the glaze. The ratio of 0.3:0.7 R_2O:RO has been found to make the most stable glaze; resistant to attack by acid in food and alkali in dishwasher soap. If there is excess alkali metal oxide in the glaze, it will not be tied up in the glaze structure and it will be likely to leach in acids and corrode in the dishwasher. The excess alkali metal atoms can exchange with the hydrogen ions (H^+) released by acids. Hydrogen ions are much smaller than alkali metal ions, so will leave holes in the glaze structure that greatly weaken the glaze and cause it to break down (see diagrams on p.184). The same process causes fluorine in some porcelain clays to etch the windows of the pottery studio when it becomes volatile during firing and forms hydrofluoric acid in contact with water. Acids found in foods such as vinegar and lemon juice can cause toxic metals in an unbalanced glaze to leach into the food.

The alkali in dishwasher soap supplies hydroxyl ions (OH^-) which attack the silica in the glaze and cause the glaze surface to dissolve if it is not chemically stable. The same process causes glassware to etch in the dishwasher.

GLAZE CALCULATION

To determine how much alkali metal oxide is present in your glaze, you can input your glaze recipe into a glaze calculation program such as the one on glazy.org, where the molecular formula of your glaze can be calculated (see appendix). This will tell you the molecular ratio of alkali metal oxide to alkaline earth oxide R_2O:RO. A ratio of 0.3:0.7 is ideal, but your glaze will also be chemically stable and durable at 0.2:0.8 or 0.4:0.6 R_2O:RO. Glazes become unbalanced and much less durable if the alkali metal is increased to 0.5:0.5 or even 0.7:0.3 (see the high-alkaline turquoise crackle glaze recipe opposite). This glaze will eventually take on a sandblasted, matt appearance if washed in the dishwasher over a large number of cycles (for example, every day for two months).

Copper turquoise glaze cone 6–8, 1240–1260°C (2264–2372°F)

This glaze has a low ratio of sodium to calcium and will be relatively durable (Na_2O 0.3, CaO 0.7, B_2O_3 0.14, Al_2O_3 0.30, SiO_2 2.5)

Soda feldspar	41
Borax frit	19
Whiting	20
China clay	5
Quartz	15
+	
Copper oxide	1

High-alkaline turquoise crackle glaze cone 6, 1240°C (2264°F)

This glaze has very high sodium and is unlikely to be very durable (Na_2O 0.7, CaO 0.3, Al_2O_3 0.23, SiO_2 2.5).

Soda feldspar	15
High alkaline frit	47
Lithium carbonate	2
Whiting	6
Quartz	18
China clay	10
+	
Copper oxide	2

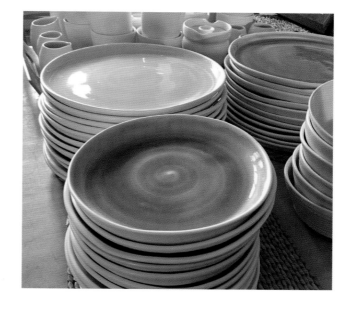

CHOOSING THE RIGHT GLAZE MATERIALS

Alkali metal oxides are supplied in glazes mainly by soda and potash feldspars, or nepheline syenite, a more concentrated source of sodium than feldspar. You could also use lithium carbonate, soda ash (sodium carbonate) or pearl ash (potassium carbonate). However, soda ash and pearl ash are soluble in water, so are not often used in glazes as they dissolve in water in the glaze bucket and can cause problems. These materials can also be supplied by alkaline or borax frits which are insoluble in water. Beware of any glaze recipes with more than 10% lithium carbonate, as these might not form chemically stable glazes. It is better to use a frit containing boron if you want to lower the melting temperature of your glaze.

Earthenware glaze recipe, turquoise glossy cone 04, 1060–1070°C (1940-1960°F)
This glaze has very high boron to enable it melt at a low temperature (Na_2O 0.2, CaO 0.8, B_2O_3 1.0, Al_2O_3 0.32, SiO_2 3.0).

Calcium borate frit	39
Soda feldspar	27
Whiting	5
China clay	6
Flint 2	3
+	
Copper oxide	1

Low temperature earthenware glazes rely on frits to enable them to melt at around 1100°C (2014°F). Frits containing boron will make a more durable glaze than high alkaline frits or lithium carbonate.

UNDERFIRING GLAZES

Another factor which weakens glaze is underfiring. If a glaze is not melted enough to form a glass, it will eventually crumble and break down when washed in the dishwasher and during daily wear when stacking or scraping with metal cutlery. You can tell if your glaze is underfired as it will be a dry, unpleasant matt, not the shiny gloss or stony matt of a properly fired glaze. True matt glazes are those in which the glass has melted and then recrystallised on cooling and can be stony or silky matt. In general, a durable glaze will have the maximum silica and alumina appropriate to a particular firing temperature (see glaze limits in Appendix 3), but it is also important that the glaze has completely melted. Borax frit and calcium borate frit can help to melt glazes fired to temperatures from cone 8 (1260°C or 2300°F) down to cone 04 (1060°C or 1940°F). The lower the firing temperature, the more frit is added, with up to 90% frit for some earthenware glazes. Some frits are almost a glaze on their own but there is always some china clay, ball clay or bentonite in the glaze recipe to help suspend the frit in water.

Below: These diagrams show what happens to an unbalanced glaze in contact with an acid. Acids release hydrogen H+ ions which can exchange with excess sodium or potassium ions in the glaze. As the hydrogen ions are smaller than the sodium ions, this ion exchange process leaves holes in the glazed surface. The opposite process, using larger potassium ions, is used to compress and toughen the surface of glass on mobile phone screens. © Henry Bloomfield

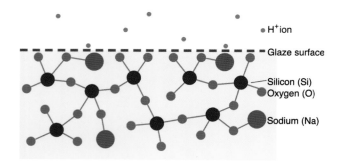

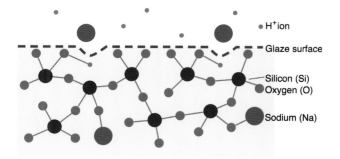

In tableware (particularly mugs and teapots) and ovenware, the glaze fit to the clay body has to be very good and the glaze must be chemically durable, hardwearing and dishwasher safe. There are various tests that can be done to assess durability, including pouring boiling water in to make sure there is no cracking and leaving vinegar in the pot overnight to check for any changes in the glaze colour or gloss.

GLAZES: INDUSTRIAL VERSUS STUDIO POTTERY

Glazes used by studio potters are often very different from glazes used in the ceramics industry. In industry, the glaze needs to be reproducible, durable and dishwasher safe. However, these industrial glazes often lack depth and subtlety. Studio potters often make more interesting glazes, though sometimes with unpredictable effects.

INDUSTRIAL GLAZES

Industrial glazes often combine two frits (industrially produced glaze materials). That way, if there is a problem with glaze fit (crazing or shivering), the ratio of the two frits can be adjusted to correct the problem. Frits are made in industry by melting together silica and fluxes such as sodium carbonate and borax (sodium borate). These materials are soluble in water and would cause problems with the glaze if used in their raw state. The resulting glass frit is ground to a powder and can be mixed with powdered clay and water to make a glaze. The clay helps to suspend the frit in water and prevents it settling. The use of lead bisilicate frit is now diminishing and borax frits are increasingly being used. However, if you buy a 'low-sol' commercial glaze, it will still contain some lead. Borax frits tend to promote cool colours: turquoise, blue and chartreuse green, while lead glazes promote warm colours such as orange, honey yellow and bottle green. Like silica, boric oxide is a glass former but melts at a lower temperature than silica. It also has very low expansion and helps to prevent crazing: cracks which form if the glaze has a higher expansion than the clay body. Low-temperature glaze recipes sometimes use two frits: borax frit and calcium borate frit or low expansion frit. Borax frit is often used at lower temperatures but calcium borate

frit is a more concentrated source of boron. These frits are both used in industrial glazes and are found in many commercially produced earthenware glazes you can buy from pottery suppliers. The reason studio potters are able to buy them is because they are already being made in large quantities for use in the ceramics industry. In the UK, frits tend to have generic names such as 'standard borax frit' or 'soft borax frit', while in the USA, they have brand names and numbers such as Ferro frit 3110 (a high-alkaline frit containing sodium, calcium and boron). Low temperature glazes may contain up to 90% frit. Frits can also be used in smaller quantities (around 10-15%) to convert high temperature cone 9 (1280°C or 2336°F) stoneware glazes to fire at mid-range, cone 6 (1240°C or 2264°F).

Earthenware glaze recipe, transparent glossy cone 04, 1060–1070°C (1940°F–1960°F)

Borax frit	50
Soda feldspar	35
Whiting	5
China clay	4
Flint	6

Stoneware transparent glossy glaze recipe cone 8, 1250–1270°C (2280–2315°F)

Potash feldspar	34
Borax frit	14
Whiting	11
China clay	13
Quartz	23
Dolomite	5

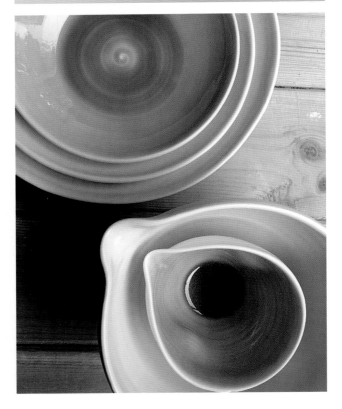

INDUSTRIAL FIRING

In the pottery industry in Stoke-on-Trent, the bisque firing is usually to a high temperature and the glaze firing to a lower temperature, so earthenware glazes are used on bone china and warping is avoided. This makes glaze application more difficult and glazes are flocculated so that they are very thick. Studio potters making stoneware and porcelain often use the Oriental method of low temperature biscuit firing ('biscuit' is the word used for low temperature firings to distinguish from the high temperature 'bisque') and higher temperature glaze firing. However, earthenware potters sometimes fire the bisque slightly higher to avoid crazing. In industry, the fired glaze needs to be perfectly smooth, durable, scratch resistant and dishwasher safe. It also needs to be reproducible and to have a wide firing range and no difficult firing conditions. However, studio potters have more leeway and are always looking for decorative effects which, in industry would be seen as defects. These special effects include drips, crackle, crystalline and crawl glazes.

Top: Terracotta breakfast set with glossy white glaze by Sue Pryke. © Sue Pryke

Centre: Fold bowl in fine bone china with a transparent glaze by Reiko Kaneko. © Reiko Kaneko

Bottom: Porcelain tableware with transparent turquoise and grey glazes made in the studio by Linda Bloomfield.

Below: Glaze tests, transparent glazes fired to cone 8, 1260°C (2300°F), coloured using copper, chromium and cobalt oxides. These glazes have transparency and depth as the colouring oxides dissolve in the glaze.

STUDIO POTTERY GLAZE EFFECTS

Studio potters have an advantage over industry in that they make in small batches and can afford to experiment. Potters should make the most of this ability to make interesting glaze effects. Even a simple transparent glaze like the recipes listed, with added colouring oxides such as 1% copper oxide will have more transparency and depth than a commercial glaze coloured using a commercial stain, which will be flat and opaque. Another advantage of making your own glazes is that you know what is in them so they can be adjusted more easily if there are any problems.

Many potters like to use special effect glazes, such as those with streaks, mottling or crystals. Streaked and mottled glazes can easily be made by adding 5-10% rutile or titanium dioxide to a glaze such as the recipes listed. Crystals are encouraged by adding zinc oxide to a runny glaze and cooling very slowly at the end of firing, holding the temperature just below 1100°C (2014°F) for several hours. It is easy to do this if your have a programmable kiln controller but it does cause the kiln elements to wear out more quickly than in more usual firings. These crystalline glazes are often very low in clay and can run down the pot, so crystal glaze potters often place a small, specially made dish under the pot to catch the excess glaze. Owing to the low clay content, some crystalline glazes may not be durable enough for use on functional ware and are more suitable for decorative pieces.

Another way to obtain rich effects is by layering glazes. Glossy glazes can be applied on top of matt glazes and the resulting glaze can be richly textured. Try layering your glazes one over another on a test tile but make sure they are not applied too thickly or they may crack and flake off. When they melt in the kiln they may react in interesting ways.

Magnesium crystalline glaze, fire to cone 6–8 with natural cooling, 1240–1270°C (2264–2315°F)

Soda feldspar	42
Dolomite	22
Quartz	22
Whiting	3
Zinc oxide	5
China clay	6

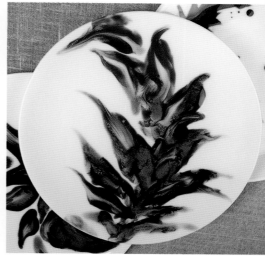

Left: Test tiles made using magnesium crystalline glaze with various colouring oxides.

Right: 'Botanical' bone china plate with brushed-on coloured glazes by Reiko Kaneko. © Reiko Kaneko

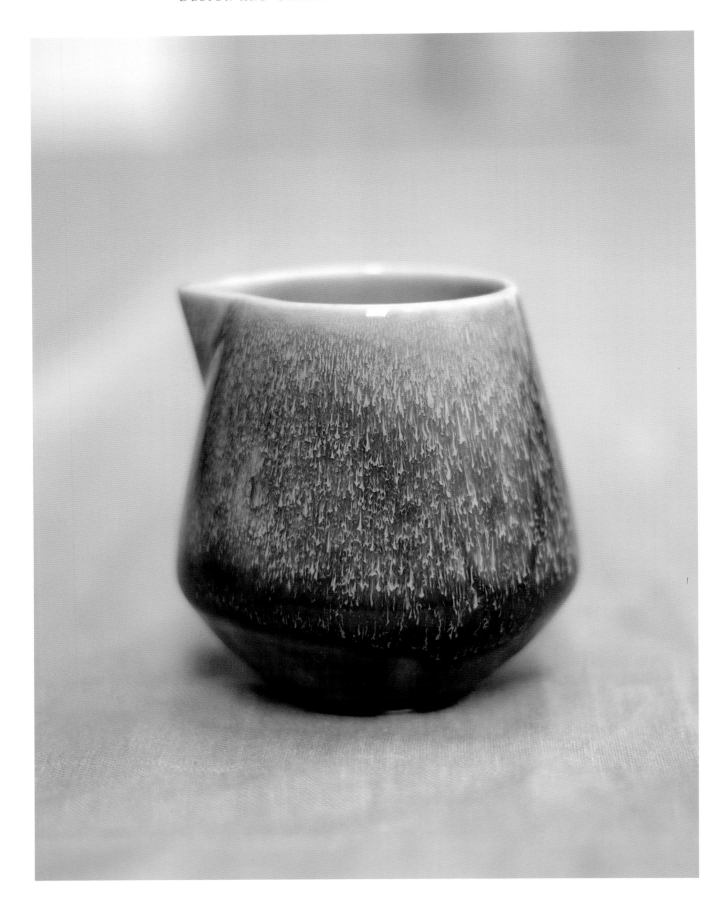

TRANSFERS AND LUSTRES

Transfers, also known as decals, can be added in a third firing to around 800°C (1472°F). They are printed on sheets with a cover coat backed with paper, cut out and soaked in water before applying to the glazed ware. Gold, platinum and mother-of-pearl lustres can also be added at this stage. They are supplied in a resin base which is brushed thinly onto the glazed surface. The firing is just high enough to soften the surface of the glaze so that the lustre sticks to it permanently. However, they may not be dishwasher safe.

Opposite: 'Night Sky' jug slipcast in bone china with layered coloured glazes by Reiko Kaneko. © Reiko Kaneko

Top left: Alice Funge cutting out transfers of recipes in her grandmother's handwriting to apply to her bowls.
© Ben Boswell

Top right: Alice Funge adding transfers to her pouring bowl.
© Ben Boswell

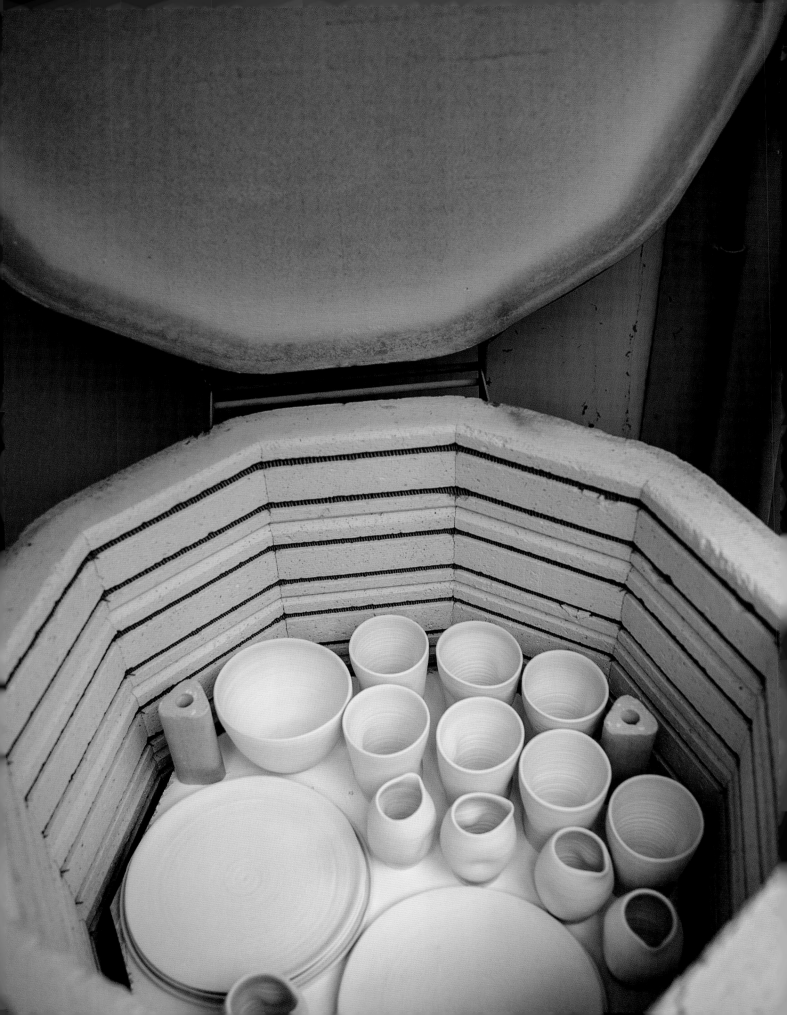

—

FIRING

LINDA BLOOMFIELD

VITRIFICATION

Vitrification is the transformation of a substance into glass: a non-crystalline, amorphous solid. This happens naturally in volcanoes when molten rock is cooled very fast and obsidian forms, a black glass. In pottery, vitrification can occur in the kiln in both clay bodies and glazes. This is what makes the clay body impervious and durable, particularly important for tableware.

If you buy clay from a potters' supplier, you are most likely using a prepared clay body made from a mixture of clays (china clay and ball clay), flint and feldspar. These materials are also the ingredients for glaze, but in different proportions. If the stoneware clay body is fired to a high enough temperature, the flint and feldspar begin to melt into a glass which fills the pores between clay particles; the fired clay becomes dense and vitrified. The porosity of fired stoneware is usually only around 1-2%. You can measure porosity by weighing an unglazed piece of fired clay, boiling in water for half an hour, then weighing again and calculating the percentage increase in weight. Fired porcelain is not porous even when unglazed. When

fired to maturity, the surface of porcelain should have a slight sheen. If underfired, the clay will not be as hard or strong. During firing above 1100°C (2012°F), long, needle-shaped crystals of mullite grow and the clay body becomes very strong.

When earthenware clay is fired, the clay, feldspar and quartz become sintered together, with small pores remaining in between the clay particles. Earthenware clay remains porous when fired and a coating of glaze is needed to prevent water seeping into the pores. The porosity of fired earthenware can be over 5%. If the temperature is raised to above around 1120°C (2048°F), an earthenware clay body may begin to warp and bloat as gases are given off, eventually melting to a puddle on the kiln shelf. This is more likely to occur in red earthenware clays, which include a higher amount of flux in the form of red iron oxide and marls which include calcium carbonate.

It is important to match the firing temperature of the glaze to the maturing temperature for your particular clay body.

Left: Top loader electric kiln packed for a biscuit firing.

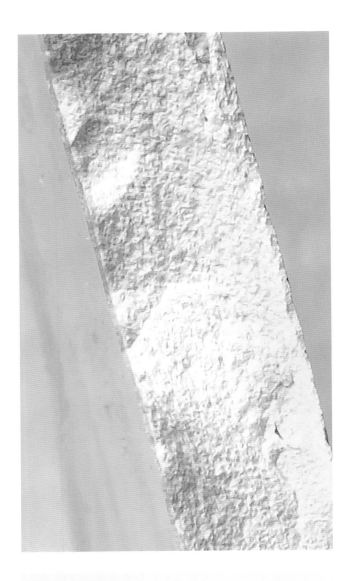

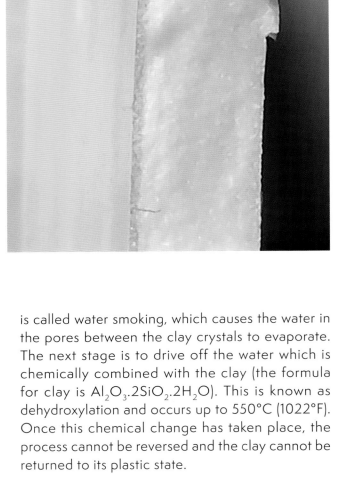

Above: Magnified view of glazed earthenware. The clay body is soft and porous.

Right: Magnified view of glazed porcelain. The clay body is hard and vitrified.

CERAMIC CHANGE

Clay goes through several physical changes when fired. The first step is the evaporation of water from between the clay particles. Pots must be completely dry before firing, otherwise the steam escaping could cause them to explode. Initially, the kiln should be heated very slowly to give time for all the water to evaporate. Drying can be speeded up by pre-heating the ware in the kiln to 80°C (176°F) for a few hours. This part of the firing, up to 100°C (212°F) is called water smoking, which causes the water in the pores between the clay crystals to evaporate. The next stage is to drive off the water which is chemically combined with the clay (the formula for clay is $Al_2O_3.2SiO_2.2H_2O$). This is known as dehydroxylation and occurs up to 550°C (1022°F). Once this chemical change has taken place, the process cannot be reversed and the clay cannot be returned to its plastic state.

At 573°C (1063.4°F), the crystalline quartz in the clay body increases in volume by 1%. This may cause cracking if the temperature in the kiln is increased too rapidly. Organic matter in the clay is burned and oxidised to carbon dioxide, and fluorine and sulphur dioxide from materials in the clay body are driven off at 700-900°C (1292-1652°F). At this point the biscuit firing is completed. The clay particles are sintered or welded together. The ware has undergone little shrinkage since the bone-dry stage, but it is durable enough to withstand handling and glazing.

Above 900°C (1652°F), the clay body begins to shrink and vitrify. The silica starts to melt, filling the spaces between the clay particles and fusing them together. The fired clay is known as metakaolin. At 1000°C (1832°F) the clay crystals begin to break down and melt. At 1050°C (1922°F), needle-shaped crystals of mullite $3Al_2O_3.2SiO_2$ begin to form, giving the fired clay strength and hardness. When mullite forms from metakaolin $Al_2O_3.2SiO_2$, extra free silica is released. Above 1100°C (2012°F), any free silica (not chemically combined) in the clay changes to cristobalite, which has a different structure from that of quartz. When the kiln is cooled down, cristobalite contracts suddenly by 3% at 226°C (438.8°F). This can cause cracking if the kiln is cooled too rapidly by opening too soon, causing some areas to drop in temperature and stressing the ware. It is advisable not to open it until it has cooled down to below 100°C (212°F).

OXIDATION

In oxidation, there is sufficient oxygen available and any iron oxide in the stoneware clay body turns tan (or red brown in the case of red earthenware). Porcelain is creamy white and stoneware is tan or buff when fired in oxidation. Glaze colours are bright and most industrial pottery is fired in oxidation.

REDUCTION

Reduction in fuel-burning kilns is acheived by restricting the air supply so that there is insufficient oxygen for combustion, and oxygen is drawn from the clay and glazes. Iron oxide in the clay body is reduced to black iron oxide (FeO), which acts as a flux. Porcelain turns grey blue and stoneware grey, with orange flashing where it comes into contact with sodium in the glaze or kiln atmosphere. Celadon, tenmoku, Shino and copper red must be fired in reduction to achieve their characteristic colours. Because reduction causes any iron in the clay body to turn grey, colours tend to become muted, unless porcelain is used.

Wood firing is often used for the effects of volatile gases and fly ash. These react with the clay to produce a toasted orange colour and molten rivulets of ash glaze. In sodium-vapour glazing, salt or sodium bicarbonate is introduced into the kiln at a high temperature. The sodium is volatile and flows through the kiln, reacting with silica in the clay surface to form a glaze.

Right: Enlarged view of vitrified stoneware clay body, where the quartz and feldspar have melted into glass and filled the pores.

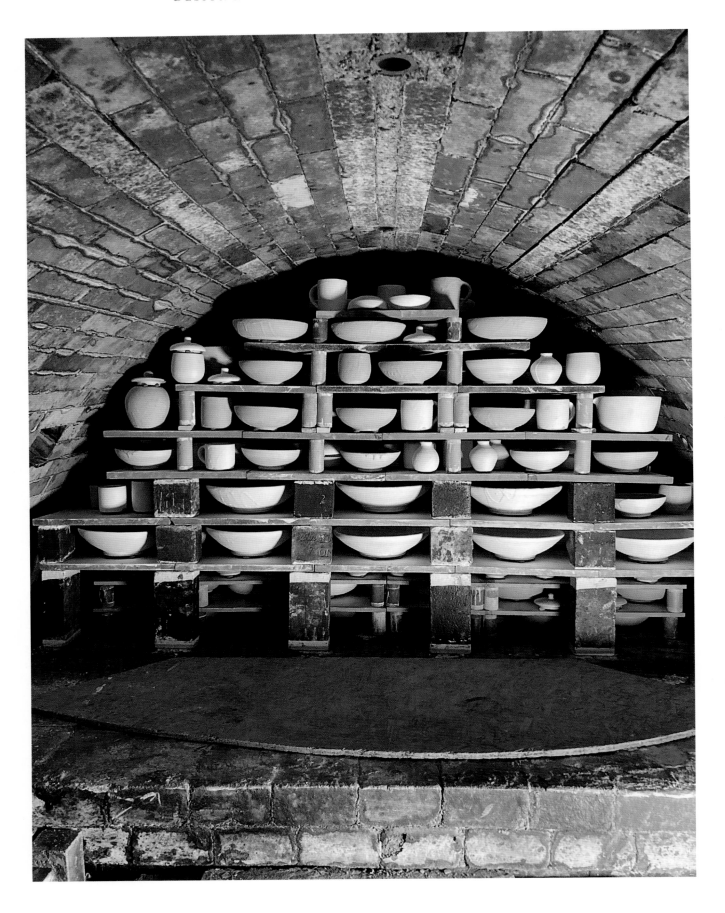

LOADING AND FIRING THE KILN

For biscuit firing, the ware can be stacked and can touch other ware. The firing should proceed slowly to allow water to evaporate from the pores in the clay body. If the ware is damp it can be held for several hours at 80°C (176°F) to drive off water vapour. The chemically combined water is all driven off by 600°C (1112°F), so the firing can proceed at a faster rate after this point. Biscuit firing is usually to a temperature of around 1000°C (1832°F).

Once the ware is glazed, the foot-rings and flat bases of stoneware and porcelain must be cleaned of all traces of glaze. In the case of earthenware, the pieces can be glazed all over but should be placed on three-point stilts in the kiln to prevent them sticking to the kiln shelf. In soda firing and wood firing, the pieces can be placed on shells or three pieces of wadding, a high-alumina clay mix, to prevent them sticking to the kiln shelves.

When the ware is unloaded from the kiln, lightly sand the base using a diamond polishing pad to make sure there are no sharp pieces or batt wash left sticking to the base. Any drips of glaze stuck to the batt wash can be sanded off using a grinding wheel.

CONCLUSION

Vitrification occurs both in stoneware and porcelain clay bodies and glazes, while earthenware clay often remains porous after firing. The type of clay used is an important consideration when making tableware, which should not be porous. It is possible to fire earthenware clays higher, up to 1120°C (2048°F) or in some cases up to 1190°C (2174°F), in order to reduce porosity. However, some marl clays dug from the ground may bloat at these temperatures. The higher the firing, the stronger and more durable the finished ware will be. Porcelain fired to cone 10 (1303°C/2377°F) is stronger than mid-range stoneware fired to cone 6 (1240°C/2264°F), which in turn is stronger than earthenware, which also chips more easily than stoneware or porcelain.

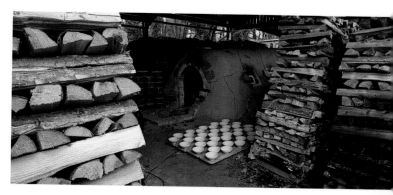

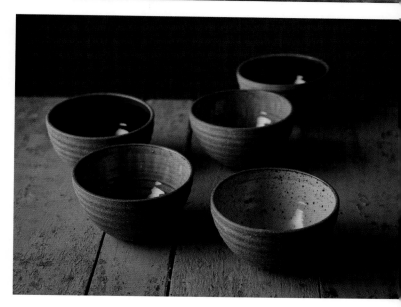

Opposite: Anagama kiln at Kigbeare studios, Devon, packed for wood firing. © Rebecca Proctor

Top: Anagama kiln built by Svend Bayer and the team at Kigbeare studios showing stacked wood for firing. © Rebecca Proctor

Middle: Wood fired 'Everyday' bowl with Shino glaze by Rebecca Proctor. Shino is a Japanese wood-fired glaze made from soda feldspar. The sodium brings out the orange colour from iron oxide in the clay body. © Rebecca Proctor

Bottom: Stoneware bowls with tenmoku and ash glazes fired in a gas kiln by Tom Knowles Jackson. The reduction firing has pulled iron oxide from the clay body through to the glaze surface. © Article Studios

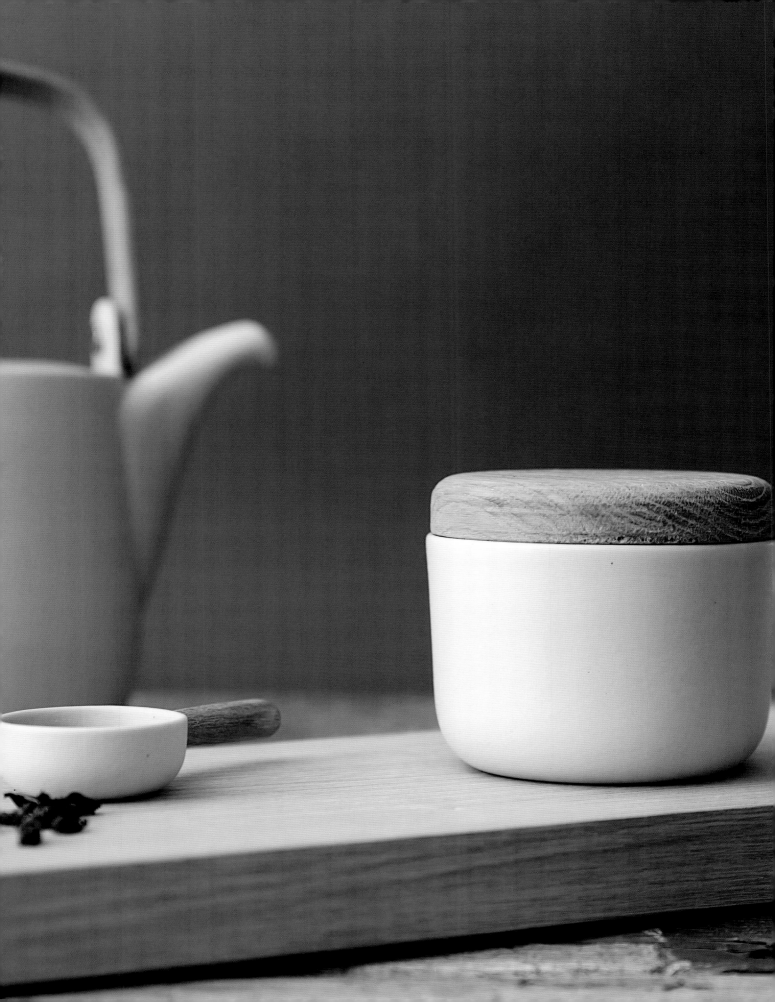

CHAPTER TEN

—

COMBINING MATERIALS

COMBINING CLAY WITH OTHER MATERIALS SUCH AS WOOD, METAL AND LEATHER

SUE PRYKE

Mixing other materials with ceramics is a lovely way to introduce a special twist into a project. Clay, being natural and organic, works well with so many other materials. Wood is a lovely complementary material and it sits so well with many clay surfaces.

I developed a tableware collection with my husband, John Tildesley, which we call our Mr & Mrs Collection. At the time, he was making a lot of products with wood, turning, carving and steam-bending, so we collaborated on a tableware collection to launch at one of the London Design shows. John steam-bent oak handles for my newly launched teapot and turned the oak knob for the lid. He also turned oak lids on a lathe to fit onto my vessels, turned handles for a tea scoop and tea strainer and we added oak serving boards, chopping boards and turned oak plates into the range too. The coloured clay and unglazed body works so well with the natural qualities of oak. The simple, quiet outlines and clean silhouettes give the

range a timeless, almost Scandinavian, style. The early pieces had the addition of leather loops on the teapot; this has remained on the lidded jars but no longer on the teapot. A far more functional oak topper is used in place and the new development is that the teapot handle and knob are available in brass, which works well with the matt ceramic, especially with the coloured black porcelain.

In terms of acquiring extra parts for your work, there are a number of small fabricators that can make parts in a variety of materials; researching companies has become easier with the internet and social media, putting a story on to Instagram and asking for advice can be extremely fruitful. For my wooden handles, these are steam bent to my design and I finish the end shape with a disc sander and by hand. The holes to fit the teapot to the handle are drilled with a pillar drill. I use book binding screws to secure the handle to the lugs on the teapot. For the brass handles, the

Left: Tea set by Sue Pryke and John Tildesley, from the Mr & Mrs Collection with Wild + Wood. © Sue Pryke

fixings are part of the engineered piece. The ends of the handle have pillars at right angles that go through the holes on the ceramic teapot lugs. The engineering company also make the screws to secure the handle to the teapot. I also use rubber O rings to help the handle stay upright.

Teapots with wood or metal handles will obviously need the addition of two clay lugs with holes for attachment of the handle after firing. These can either be added to the body of the teapot at the mould making stage (if slipcasting) or attached later, or if the work is being thrown can be joined directly onto the body of the teapot at the same stage that the spout is attached.

CONSIDERATIONS FOR LIDS

Introducing other materials to ceramic is generally problematic as clay shrinks and often warps in the kiln. I found with some of the ceramic bowls that I made with wooden lids, the most fail-safe method was to turn the wooden lids for each piece, but this is not entirely practical unless you have a lathe.

Most tea and coffee caddies require a rubber seal fitting to the lid. Off-the-shelf rubber seals very often

are supplied in fixed sizes. Knowledge of this ahead of designing or making a coffee jar is a must to ensure that the seals fit. Also understanding of how the lid needs to be made in conjunction with the seal is important. Lids need to have a recess in the vertical flange that fits inside the jar, forming a gallery for the seal to wedge into so it doesn't slip out of place when the lid slides into the jar creating a seal. The gallery also needs to be the right diameter to allow the rubber disc to create a seal. It is therefore fairly critical to know the size and type of rubber seal you plan to use when designing and making your work.

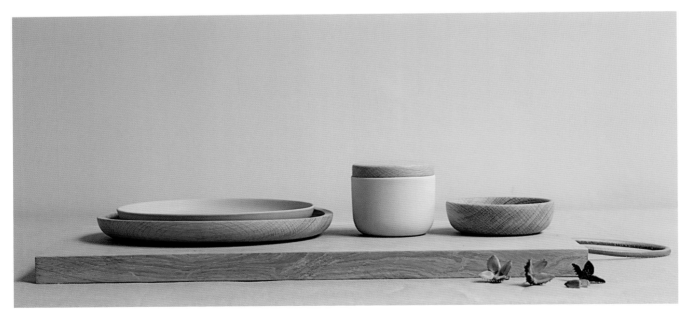

Top: Tea strainer and tea caddy spoon from the Mr & Mrs Collection with Wild + Wood, earthenware and oak. © Sue Pryke

Bottom: A collection of porcelain and oak handmade by Sue Pryke and John Tildesley, from the Mr & Mrs Collection with Wild + Wood. © Sue Pryke

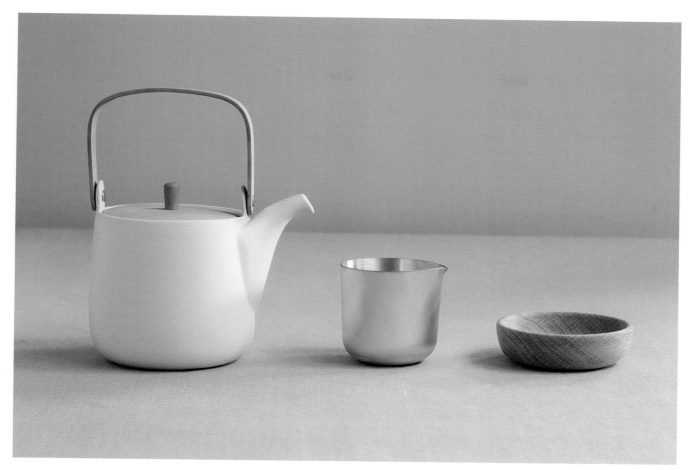

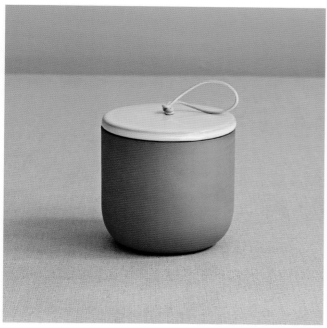

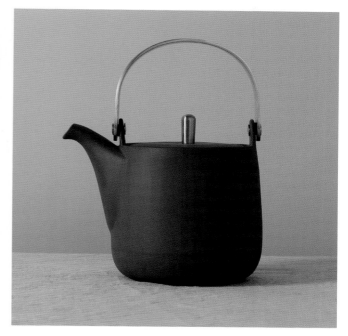

Top: Teapot and pewter jug from the Mr & Mrs Collection with Wild + Wood. © Sue Pryke
Bottom left: Terracotta lidded jar by Sue Pryke. © Sue Pryke
Bottom right: Brass-handled teapot by Sue Pryke. © Sue Pryke

Sandra Haischberger from Feinedinge design studio makes fine coloured slipcast porcelain in her studio in Vienna. Her tiered cake stand is an elegant and understated but glorious centre piece. It is a simple twist on a classic piece that makes this feel contemporary and relevant with a mix of coloured plates and a central wooden column to secure them together. An alternative option available for cake stands are sets of metal rods that you can screw together to make two or three plates into a tiered cake stand. (Make holes in the plates to fit the diameter of the rods but smaller than the diameter of the metal washers.)

Charlotte Storr adds akebia vine, or chocolate vine handles onto her large bowls and other vessels. It is a technique used by many Japanese potters, experienced by Charlotte on a visit to Japan. Coils of akebia are soaked for a couple of days to make them pliable and woven in to place, with the thicker strands inside and the thinner ones coiled around. It adds contrast to the creamy earth stone clay, and the impressed pattern that rolls around the bowls edges gives the pieces an additional element of rustic charm.

Sylvia K's platters are dramatic in style and size, cleverly balancing influences from her cultural background and contemporary style. She brings together a rich and diverse colour palette on terracotta clay and adds in the relaxed leather loop handles to bowls and plates, which mimic her surface pattern and reflect inspiration from her Slovakian heritage and the provincial crafts. The soft leather and toasted terracotta are a great combination and work well with the majolica surfaces.

Aimee Bollu's work focusses on reclaimed and recycled remnants mixed with her ceramic pieces. As Melody Vaughan describes her in her Maker's Profile, she is "an arranger of the things people have discarded and forgotten; Aimee seeks out objects that have fallen out of use and brings them back to life. The found and the made are combined to become a new entity with echoes of a past life."

It is interesting to see how she rearranges found objects, everyday pieces like bottle tops and pieces of string or rusty metal adorn a simple pared back form, looking familiar and suitably matched with the new ceramic counterpart. The ceramic pieces are simple, either coloured glaze or body, matt or shiny - an interesting mix of old and new intending to be playful pieces to make the viewer question the purpose.

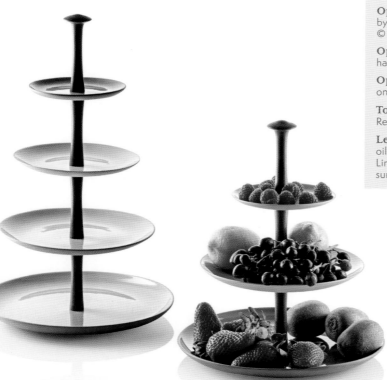

Opposite top: Vegetable bucket with akebia vine handle by Charlotte Storrs. Photograph by Agness Clark. © Charlotte Storrs

Opposite centre: Large round serving bowl with leather handles by Silvia K. © Silvia K Ceramics

Opposite bottom: Chewing gum plastic lid and sponges on porcelain by Aimee Bollu. © Camilla Greenwell

Top: Bone china 'Boat' bowl with spliced rope handle by Reiko Kaneko. © Reiko Kaneko

Left: Three or four-part etageres with central parts made of oiled walnut by Feinedinge. The plates are made of coloured Limoges porcelain, which are unglazed on the underside, all surfaces are transparently glazed. © Feinedinge

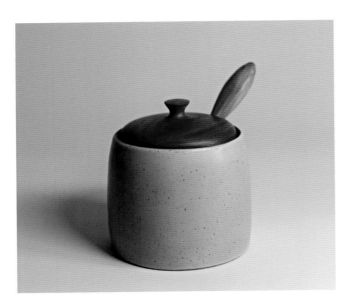
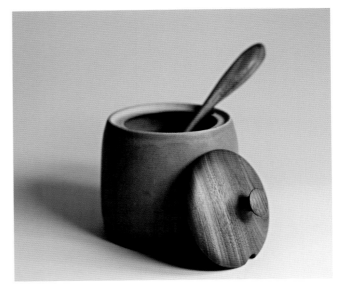

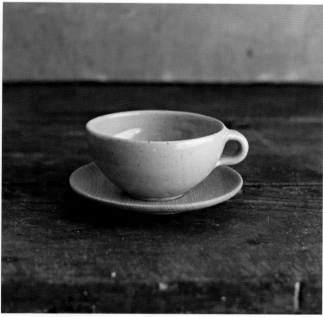

Opposite left and right: Two examples of Kelp glazed stoneware pot with plum wood lid by Adamina Turek. © Adamina Turek

Opposite bottom: Beetle-glazed acorn jar with oak lid by Rebecca Proctor. © Rebecca Proctor

Top: Sarah Pike teapot with wire and wood handle.

Left: Celadon glazed cup with saucer made from beech by Rebecca Proctor. © Rebecca Proctor

Right: Tray table (ceramic and wood) by Melissa Dora. Photo © Alexander Edwards. Stylist Aurelian Farjon

Overleaf: Black-stained Audrey Blackman porcelain pieces, left unglazed by Elaine Bolt. The wood is locally grown and is all willow, the curly frond is wisteria. © Alan Callender

CONCLUSIONS

Handmade ceramic tableware designed and made with care can enhance our everyday lives by giving us a connection to the maker. When designing tableware, it is important to consider form and function. Design decisions might also be led by the materials and making processes used. To ensure the work is economic, make in batches and try to limit the number of steps in the making process.

It is a good idea to use the best materials available. Porcelain and stoneware are fired higher and are stronger and more chip-resistant than earthenware or terracotta. When choosing the glaze, it is very important that the glaze is chemically durable and fits the clay body, to avoid cracking of either the glaze or the ware. This can be determined by testing the ware thoroughly before use.

Contemporary tableware design is diverse in terms of style, colour, pattern and size. Food influences from around the world have had a major impact on how we cook and eat at home and in turn is reflected in the high street, in everyday retailers from supermarkets to high-end retailers who all have their own tableware collections. Makers are moving more into the hospitality sector which historically has been the mainstay of big manufacturers. Shapes have gradually increased in size over recent years with an increase in restaurant dining and gourmet meals at home. Dinner plates used to be a generic maximum 25 cm to 26 cm (10 in); now it's common to find 27cm (10½ in) plates, more of a standard main plate for restaurant ware. The variety of bowls on offer ranges from deep noodle bowls and rice bowls to pasta bowls, reflecting how cosmopolitan we have become. We can all enjoy more of a restaurant experience at home; a simple pasta dish can be enjoyed in a deep, wide-rimmed bowl, of the scale found in restaurants.

Tableware has become far more interesting, and rules that were once set in stone are being replaced by innovation and creativity. Makers as well as tableware designers are developing ideas for serving food, breaking rules and inventing new ones. Standard dinnerware no longer exists. It is no wonder that greater links are being forged between those who create in the kitchen and those who create in the pottery studio. They are both at the forefront of design in their specialisms.

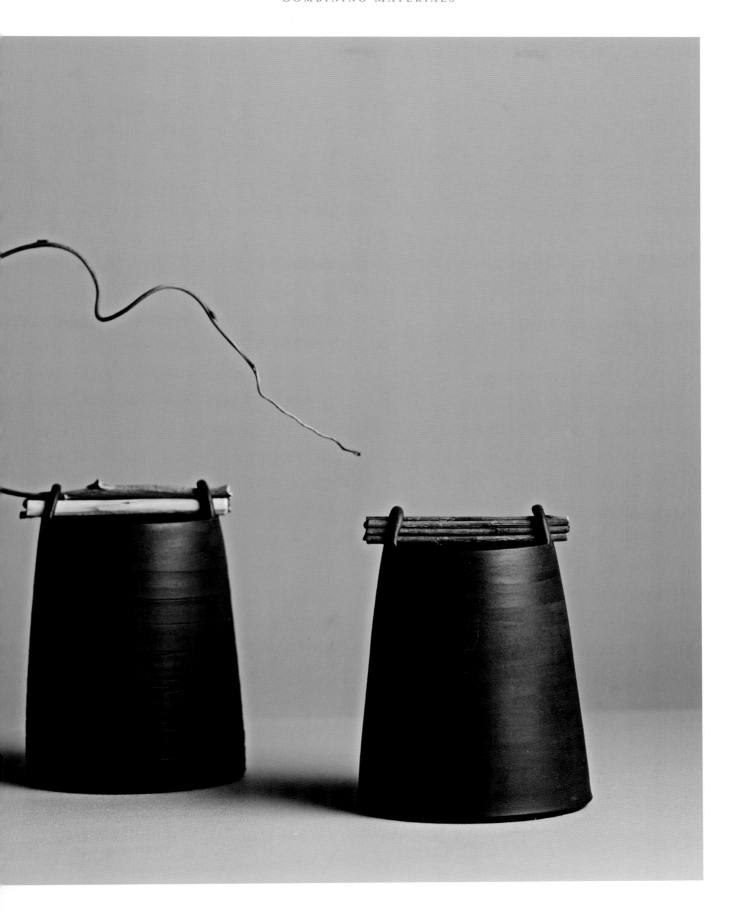

BIBLIOGRAPHY

Atkin, Jacqui, *Pottery You Can Use: An Essential Guide to Making Plates, Pots, Cups and Jugs*, Search Press 2017

Bailey, Michael, *Glazes Cone 6: 1240°C/2264°F*, A&C Black 2001

Bloomfield, Linda, *Contemporary Tableware*, A&C Black 2013

Bloomfield, Linda, *The Handbook of Glaze Recipes*, Bloomsbury 2014

Cardew, Michael, *Pioneer Pottery*, Longmans, 1969

Cooper, E., and Royle, D., *Glazes for the Studio Potter*, Batsford 1984

Currie, Ian, *Stoneware Glazes: A Systematic Approach*, Bootstrap Press 1985

French, Neal, *The Potter's Directory of Shape and Form*, Quarto 1998

Murfitt, Stephen, *The Glaze Book: A Visual Catalogue of Decorative Ceramic Glazes*, Thames and Hudson 2002

Parmelee, C.W., *Ceramic Glazes*, Cahners Publishing Company 1973

Spence, Charles, *Gastrophysics: The New Science of Eating*, Viking 2017

Wardell, Sasha, *Slipcasting*, Herbert Press 2007

REFERENCES

Au, Derek, Glazy.org (online glaze calculation)

Bloomfield, Linda, "The Tables Have Turned", *Ceramic Review*, Issue 287, September 2017

Bloomfield, Linda, "Making Dishes for Masterchef", *Ceramic Review*, Issue 301, January 2020

Bloomfield, Linda, "Making Glazes", *Clay Craft Magazine*, Issue 4, June 2018

Coppage, Ryan, "Techno File: Dirty Dishes", *Ceramics Monthly*, November 2018

Katz, Matt, "Glossed Over: Durable Glazes", *NCECA* vol. 37, 2016.

Katz, Matt, CeramicMaterialsWorkshop.com ("Understanding Glazes" lectures)

Katz, Matt, Gebhart, T., and Carty, W. "The re-evaluation of the unity molecular formula limits for glazes", Ceramic Engineering and Science Proceedings 24 (2), 2003, p.13

Stull, R.T., "Influence of silica and alumina on porcelain glazes", *Transactions of the American Ceramic Society* 14, 1912, p.62

Vaughan, Melody, maker profile on Aimee Bollu, 2016 – melodykvaughan.wordpress.com/2016/08/09/maker-profile-aimee-bollu

GLOSSARY

3D printing The construction of three dimensional form using computer technology to print a shape in layers using composite materials or clay.

Anagama Japanese style single-chamber kiln.

Ball clay Fine-grained, plastic, secondary clay

Ball mill A rotating drum containing ceramic pebbles for grinding colouring oxides in glazes.

Banding wheel A turntable which is rotated by hand, for hand building and decorating.

Batt Circular wooden board for fixing to the wheel, plaster slab for drying clay, or fireclay kiln shelf.

Batt wash A mixture of alumina hydrate and china clay, which prevents glaze from sticking to the kiln shelf.

Bentonite A very plastic clay used to add plasticity to clay bodies and to suspend glazes.

Body stain A stain for colouring clay body or slip.

Bone china A fine, translucent clay body containing up to 50% bone ash.

Biscuit A first firing to around 1000°C (1832°F) The term is also applied to fired ware.

Bisque A first firing to high temperature before glazing and firing at a lower temperature, a process most often used in industry.

Blistering Blisters in a fired glaze, caused by gas escaping during firing.

Bloating Blisters in the clay body caused by trapped bubbles of gas.

Blunger A large tank to blend clay for making slip. It has rotating blades to help disperse the clay in water to form slip.

CAD Computer Aided Design Technology for design, replacing manual drawing with an automated process.

Calcining Heating in a kiln to drive off volatile compounds, for example, heating calcium carbonate to produce calcium oxide.

Casting Pouring of liquid clay into a porous plaster mould.

Celadon A type of pale grey-green or blue-green glaze containing iron, first developed in China.

China clay Pure, white clay. Kaolin.

China stone A type of feldspar found in China. Similar to Cornish stone.

Chuck A form shaped to fit the inside of an inverted pot, used to support the pot during turning on the wheel.

Chun (or Jun) A pale blue opalescent glaze used in reduction fired stoneware.

Cone A small, slender pyramid of glaze material set at an angle in the kiln which bends over when fired to the correct temperature. Developed by Seger, also made by Orton.

Cornish stone A type of feldspar found in Cornwall, used in clay bodies and glazes.

Cottle A cylinder used to surround a master for making plaster moulds.

Crank A coarse-textured clay containing grog, for sculpture.

Crawling A defect where the glaze pulls away from the body, leaving bare patches, caused by dust or grease on the biscuit ware or high surface tension in the glaze.

Creamware Cream coloured earthenware with a transparent lead glaze, first developed by Josiah Wedgwood.

Crazing A network of fine cracks in a glaze. Caused by poor glaze fit, the glaze contracting more than the body.

Crystalline glaze A glaze in which zinc silicate crystals form on slow cooling.

Deflocculant Sodium silicate and sodium carbonate, used to make casting slip more fluid.

Drop out mould A one piece plaster mould without any undercuts.

Dunting Cracking caused by stress in thick or crazed glazes or by cold air entering the kiln.

Earthenware Clay which is fired to a low temperature, below 1150°C (2102°F)

Engobe Vitreous slip, containing flux, for painting on biscuit ware.

Extruder Equipment for forcing lengths of clay through a shaped die.

Feldspar Mineral derived from granite, containing potassium, sodium, calcium and alumino-silicate.

Fettle Trim away excess clay from seams and edges of slip cast or thrown pots.

Filter press A press with cloth bags for removing water from clay slurry.

Fireclay High-alumina clay able to withstand high temperatures, used in kilns.

Flashing Colour resulting from volatile compounds released during firing.

Flange A foot-ring added to the under side of a lid to prevent it from sliding off.

Flocculate To cause fine particles in suspension to attract each other and clump together.

Flux A material which helps to lower the melting temperature of a glaze or vitrify a clay body.

Foot-ring An unglazed ring of clay on the base of a pot.

Frit Glaze flux melted with silica in a furnace and ground into a powder.

G-code A programming code for CNC machining and mainly used in Computer Aided Manufacture. It is a complex set of instructions telling the machine where to move.

Gallery A ledge inside the rim of a pot to support the lid.

Greenware Pots which have not yet been fired.

Grog Coarsely ground, fired clay, added to clay bodies to reduce shrinkage.

Hakeme Japanese word for slip applied with a rough brush, showing the body colour beneath.

Inglaze Colouring oxides, stains or glazes applied to an unfired glaze. These sink into the surface on firing.

Jigger Mechanical method for making plates, using a wheel-mounted hump mould and a metal profile, which shapes the foot of the plate.

Jolley Mechanical method for making bowls and cups, using a wheel-mounted press mould and metal profile, which shapes the inside of the pot.

Kaki A type of Oriental red iron glaze, the orange-red colour of persimmons.

Kaolin China clay; pure, white clay.

Lathe A piece of machinery used for turning plaster when model making on a horizontal axis.

Leather hard Clay which is firm enough to handle without distorting.

Levigate To separate fine from coarse particles by suspending in water.

Lustre Metallic decoration obtained by reducing precious metal salts.

Model The original solid shape from which a plaster mould is made.

Molochite Finely ground, fired china clay.

Mould A hollow plaster form used to make tableware.

Natch A location or positioning marker used in model and mould making.

Onglaze Coloured enamel applied on top of fired glaze.

Opacifier A mineral such as tin oxide, titanium oxide or zirconium silicate, which when added to a glaze makes it opaque.

Oxidation Firing in the presence of sufficient oxygen, usually in an electric kiln.

Paper clay Clay with up to a third fibrous paper pulp added for strength.

Pinholes Small holes in glaze, caused by burst bubbles which have not healed over during firing.

PLA Polylactic acid (PLA) A plant based material made from renewable sources, usually corn starch.

Plaster of Paris Calcined, hydrated calcium sulphate (gypsum) used for making moulds.

Plasticity Property of clay enabling it to hold its shape when worked.

Porcelain A white clay fired to 1250–1400°C

Power whirler An electric wheel type piece of machinery used for model making on a vertical axis.

Pug mill Machine with rotating blades which mixes and compresses clay ready for use.

Pyrometer A device used to measure the temperature inside a kiln.

Reduction Limiting the air available during firing so that oxygen is drawn from the clay and glaze, usually in a fuel-burning kiln. Oxides in the glaze may be reduced to metals.

Refractory Able to withstand high temperatures.

Reservoir or **Spare** A well or overflow area in the pouring part of a mould.

Riffler Metal carving tool with shaped ends.

Salt firing Using salt thrown into the kiln at high temperature, where it combines with the silica in the clay to produce a glaze on the surface.

Seam Line The lines created by two parts of mould coming together.

Sgraffito Scratching pattern through slip to show the clay body beneath.

Shelling Glaze flaking off slip-coated earthenware due to a poor bond between glaze and clay body.

Shino White Japanese glaze made from feldspar and clay, used in reduction firing.

Shivering Glaze flaking off at rims and edges of handles. Caused by poor glaze fit, the glaze contracting less than the body.

Silica (silicon dioxide), found in quartz, flint or sand

Slake Add water to dry clay and soak until all clay particles are wetted.

Slip Liquid clay, made from clay mixed with water.

Slipcasting Liquid clay poured into porous plaster moulds.

Slip trailing Drawing lines or dots of thick slip with a nozzle.

Snip A short spout, the sort you find on a jug, rather than a long spout found on a traditional teapot.

Soft soap or **potter's size** A liquid which when applied to the surface of set plaster will provide a layer of resist to another layer of plaster.

Soak Maintain the top temperature in a firing to mature the glaze evenly throughout the kiln.

Soda firing Using soda (sodium carbonate) sprayed into the kiln, where it combines with the silica in the clay to produce a glaze.

Spare See Reservoir.

Sprig Applied relief decoration, sometimes made in a mould.

Stain industrially-made ceramic pigment containing colouring oxides and opacifiers.

Stoneware Clay which is vitrified or non-porous, fired to a high temperature, above 1200°C (2192°F).

Surface gauge A tool for finding the centre line of a model or a mould. The tool has a vertical axis and a horizontal tool to mark on the centre of a shape

Tenmoku A type of Oriental high-iron glaze, which is usually black, breaking to brown.

Terra sigillata A finely-levigated slip used for coating and burnishing pots.

Thixotropy A property of casting slips and porcelain, which become more fluid when agitated.

Underglaze Colouring oxide or stain applied under a transparent glaze.

Viscosity The measurement of the flow rate of glaze, liquid clay or casting slip.

Vitrified A property of clay when fired to a non-porous, glassy state.

Whirler A hand-driven turntable.

Wreathing Uneven trails left across a slip cast surface caused by too little sodium silicate.

APPENDIX 1:
UK/US MATERIALS SUBSTITUTIONS

Some materials have no direct equivalent, but they can be substituted with a combination of several other materials.

UK	USA
Ball clay HVAR	Tennessee ball clay
Ball clay Hymod AT	Kentucky OM-4 ball clay
Ball clay Hyplas 71	Kentucky stone
Bentonite	Bentonite, Macaloid, Veegum
Borax frit	Ferro 3124, Pemco P-54, Gerstley borate
Calcium borate frit	Ferro 3134, Ferro 3195, Colemanite
China clay	Edgar plastic kaolin (EPK), Tile 6 kaolin, Georgia kaolin
Cornish Stone	Cornwall stone
Dispex	Darvan
Feldspar FFF	Custer feldspar plus Minspar or nepheline syenite
Feldspar potash	Custer feldspar, G-200, Mahavir feldspar
Feldspar soda	Kona F-4, NC 4, Minspar 200
Flint	Silica
Fremington red clay	Redart clay, Alberta slip
High-alkaline frit	Ferro 3110, Pemco P-25
Low-expansion frit	Ferro 3249
Quartz	Silica
Zirconium silicate	Zircopax, Superpax, Ultrox

APPENDIX 2:
ORTON PYROMETRIC CONE TEMPERATURES

Pyrometric cones measure heatwork, and so they depend on the heating rate.
A slower temperature rise will cause the cone to bend at a lower temperature.

CONE NO.	60°C/HOUR	108°F/HOUR	150°C/HOUR	270°F/HOUR
09	917	1683	928	1702
08	942	1728	954	1749
07	973	1783	984	1805
06	995	1823	985	1852
05	1030	1886	1046	1915
04	1060	1940	1070	1958
03	1086	1987	1101	2014
02	1101	2014	1120	2048
01	1117	2043	1137	2079
1	1136	2077	1154	2109
2	1142	2088	1162	2124
3	1152	2106	1168	2134
4	1160	2120	1181	2158
5	1184	2163	1205	2201
6	1220	2228	1241	2266
7	1237	2259	1255	2291
8	1247	2277	1269	2316
9	1257	2295	1278	2332
10	1282	2340	1303	2377
11	1293	2359	1312	2394
12	1304	2379	1324	2415
13	1321	2410	1346	2455
14	1388	2530	1366	2491

APPENDIX 3: LIMITS FOR STABLE GLAZES IN THE UNITY MOLECULAR FORMULA

Calculating the unity molecular formula. Glaze recipes can be written either as a recipe by weight percent, or as a formula. To calculate the formula, you need to convert each material in the glaze into a number of molecules, depending on their relative proportions in the glaze recipe. To do this, divide the weight of each material by its molecular weight. Dividing by the total number of molecules of alkaline fluxes (sodium, potassium, calcium) gives the unity molecular formula, where the sum of the alkaline fluxes is arbitrarily set to 1. This will give you the ratio of alkali metal to alkaline earth oxides and determine whether your glaze is likely to be durable. You can use glazy.org to calculate the molecular formula for your glaze recipe.

Stable glazes (those that are dishwasher safe and food safe) will generally have a ratio of alkali metal (potassium, sodium) to alkaline earth (calcium, magnesium) oxides of around 0.3:0.7 (±0.1). The amounts of silica and alumina will increase with firing temperature. For glazes fired below cone 9 (1280°C or 2336°F), enough boron is needed to fully melt the glaze (0.1 B_2O_3 for cone 8 glazes to 0.5 B_2O_3 for cone 04 earthenware glazes).

ALUMINA AND SILICA LIMITS (COOPER AND ROYLE, 1984)

CONE NUMBER AND TEMPERATURE.	NUMBER OF MOLECULES IN UNITY FORMULA.			
CONE 04 1060°C (1940°F)	Al_2O_3	0.1-0.45	SiO_2	1.375-3.15
CONE 5 1200°C (2192°F)	Al_2O_3	0.275-0.65	SiO_2	2.4-4.7
CONE 6 1225°C (2237°F)	Al_2O_3	0.325-0.70	SiO_2	2.6-5.15
CONE 8 1250°C (2282°F)	Al_2O_3	0.375-0.75	SiO_2	3.0-5.75
CONE 9 1275°C (2327°F)	Al_2O_3	0.45-0.825	SiO_2	3.5-6.4
CONE 10 1300°C (2372°F)	Al_2O_3	0.50-0.90	SiO_2	4.0-7.2

RECOMMENDED MAXIMUM FLUX IN MOLECULAR UNITY FORMULA (COOPER AND ROYLE, 1984)

Cone	Temp °C	MgO	BaO	ZnO	CaO	B_2O_3	K+Na
5	1200	0.325	0.40	0.30	0.55	0.35	0.375
6	1225	0.330	0.425	0.32	0.60	0.30	0.35
8	1250	0.335	0.45	0.34	0.65	0.25	0.325
9	1275	0.340	0.475	0.36	0.70	0.225	0.30
10	1300	0.345	0.50	0.38	0.75	0.21	0.275

APPENDIX 4:
SUPPLIERS

UK

BATH POTTERS SUPPLIES

Unit 18, Fourth Avenue
Westfield Trading Estate
Radstock, Nr Bath
Somerset
BA3 4XE
Tel: +44 (0)1761 411077
www.bathpotters.co.uk

CERAMATECH

16-17 Frontier Works
33 Queen Street
London
N17 8JA
Tel: +44 (0) 208 885 4492
www.ceramatech.co.uk

CLAYMAN

Morrells Barn
Lower Bognor Road
Lagness, Chichester
West Sussex
PO20 1LR
Tel: 01243 265845
www.claymansupplies.co.uk

CTM POTTERS SUPPLIES

Unit 10A, Mill Park Industrial Estate
White Cross Road
Woodbury Salterton
Exeter
Devon
EX5 1EL
Tel: +44 (0)1395 233077
www.ctmpotterssupplies.co.uk

POTCLAYS

Brickkiln Lane
Etruria
Stoke-on-Trent
Staffordshire
ST4 7BP
Tel: +44 (0)1782 219816
www.potclays.co.uk

POTTERYCRAFTS

Campbell Road
Stoke-on-Trent
Staffordshire
ST4 4ET
Tel: +44 (0)1782 745000
www.potterycrafts.co.uk

SCARVA POTTERY SUPPLIES

Unit 20
Scarva Road Industrial Estate
Banbridge, County Down
Northern Ireland
BT32 3QD
Tel: +44 (0)28 406 69699
www.scarvapottery.co.uk

SPENCROFT CERAMICS

Holditch Industrial Estate
Spencroft Road
Stoke-on-Trent
Staffordshire
ST5 9JB
Tel: +44 (0)1782 717305
www.spencroftceramics.co.uk

SNEYD CERAMICS LTD

Sneyd Mills
Leonora Street
Burslem
Stoke on Trent
ST6 3BS
Tel: +44 (0) 1782 814167
www.sneydceramics.co.uk

VALENTINE CLAYS LIMITED

Valentine Way
Stoke-on-Trent
ST4 2FJ
Tel: +44 (0)1782 271200
www.valentineclays.co.uk

USA

AMACO BRENT

6060 Guion Road
Indianapolis
IN 46254-1222
Tel: +1 (317) 244 6871
www.amaco.com

BAILEY CERAMIC SUPPLIES

62-68 Tenbroeck Avenue
Kingston
New York 12401
Tel: +1 (845) 339 3721
www.baileypottery.com

BRACKER'S GOOD EARTH CLAYS,

1831 E. 1450 Road
Lawrence
KS 66044
Tel: +1 (785) 841 4750
www.brackers.com

CLAY PLANET

1775 Russell Avenue
Santa Clara
CA 95054
Tel: +1 (800) 443 2529
www.clay-planet.com

COLUMBUS CLAY CO.

1080 Chambers Road
Columbus
OH 43212
Tel: +1 (866) 410 2529
www.columbusclay.com

GEORGIE'S CERAMIC & CLAY CO

756 NE Lombard
Portland
OR 97211
Tel 503 283 1353
www.georgies.com

HAMILL AND GILLESPIE

420 Clermont Terrace
Unit D
Union
NJ 07083
Tel: 973 822 8000
www.hamgil.com

LAGUNA CLAY CO.

14400 Lomitas Avenue,
City of Industry, CA 91746
Tel: +1 (800) 452 4862
www.lagunaclay.com

MINNESOTA CLAY CO

2960 Niagara Lane
Plymouth
MN 55447
Tel: 763 432 0875
www.mnclay.com

CANADA

PLAINSMAN CLAYS

702 Wood Street SE
Medicine Hat
Alberta
Canada
T1A 1E9
Tel: 403-527-8535
www.plainsmanclays.com

AUSTRALIA

POTTERY SUPPLIES BRISBANE

51 Castlemaine Street
Milton
Queensland 4064
Tel:07 3368 2877
www.potterysupplies.com.au

WALKER CERAMICS

5 McLellan Street
Bayswater
Victoria 3153
Tel: 03 8761 6322
www.walkerceramics.com.au

Laboratories for leach-testing of glazes

LUCIDEON

Queens Road
Penkhull
Stoke-on-Trent
Staffordshire
ST4 7LQ
UK
01782 764428
www.lucideon.com

NORTHERN TESTHOUSE

Scraptoft Business Centre
Main Street
Scraptoft
Leicester LE7 9TD
01162 418811
www.nthleicester.co.uk

BRANDYWINE SCIENCE CENTER

204 Line Road,
Kennet Square,
PA 19348,
USA
www.bsclab.com

Credits

Adamina Turek
www.2hungrybakers.com

Adraina Christianson
www.adrianachristianson.com.au

Aimee Bollu
www.aimee-bollu.squarespace.com

Alexandra Nilasdotter
www.nilasdotter.com

Alice Funge
www.alicefunge.co.uk

Ali Herbert
www.aliherbert.com

Anna Thomson
www.annathomson.weebly.com

Arran Street East
www.arranstreeteast.ie

Ben Boswell
www.benboswell.co.uk

Carla Sealey
www.nakedclayceramics.com

Carolyn Tripp
www.bio.site/carolyntceramics

Charlotte Storrs

www.charlottestorrs-stoneware.co.uk

Duchess China
www.duchess-china1888.com

Ed Bentley
www.edbentley.co.uk

Elliott Denny
www.elliottceramics.com

Eva Radulova
www.eraduceramics.co.uk

Feinedinge
www.feinedinge.at/aktuell.ht ml

Feldspar Studio
www.feldspar.studio.com

Georgie Scully
www.georgiescullyceramics.co.uk

Helen Johannessen
www.helenjohannessen.co.uk

Holly Burton
www.hollyhomewares.co.uk

Jaejun Lee
www.leejaejun.com

James and Tilla Waters
www.jamesandtillawaters.co.uk

Jessica Thorn
www.jessicathorn.co.uk

Joris Link
www.jorislink.nl/portfolio/

Juliet Macleod
www.julietmacleod.com

Katie Lowe
www.katie-lowe.com

Keeley Traae
www.keeleytraae.com

Kira Ni
www.kiraniceramics.com

Kristy Noble
www.kristynoble.com

Laura Plant
www.lauraplantdesign.co.uk

Lesley Doe
www.lesleydoeceramics.com

Lilith Rockett
www.lilithrockett.com

Linda Bloomfield
www.lindabloomfield.co.uk

Louisa Taylor
www.louisataylorceramics.co.uk

Lucy Burley
www.instagram.com

Lucy Fagella
www.lucyfagella.com

Makiko Hastings
www.makikohastings.com

Melisa Dora
www.melisadora.com

Miles Moore Ceramics www.
milesmooreceramics.com

Monika Patuszynska
www.patuszynska.art.pl

Natalie Bell
www.nataliebellceramics.co.uk

Natascha Madeiski
www.nataschamadeiski.com

Nico Conti
www.nicoconti.com

Odd Standard
www.oddstandard.no

Owen Wall
www.owenwall.co.uk

Patia Davis
www.patiadavis.co.uk

Pottery West
www.potterywest.co.uk

Rebecca Proctor
www.rebeccaproctor.co.uk

Reiko Kaneko
www.reikokaneko.co.uk

Repeat Repeat
www.repeatrepeat.co.uk

Ryan Barrett
www.rbceramics.com

Sarah Pike
www.sarahpikepottery.com

Sasha Wardell
www.sashawardell.com

Saskia Rigby
www.saskiarigby.com

Silvia K
www.silviakceramics.co.uk

Sophie Moran
www.sophiemoran.studio

Sue Pryke
www.suepryke.com

Sue Ure
www.sueureceramics.com

Susan Frost
www.susanfrostceramics.com

Tina Marie Bentsen
www.tinamariecph.dk

Tom Butcher
www.tombutcherceramics.co.uk

Tom Knowles Jackson
www.tkjceramics.com

Vallari Harshwal
www.vallariharshwal.com

INDEX

ACKNOWLEDGEMENTS

The authors would like to thank Henry Bloomfield, Ben Boswell and Yeshen Venema for photography. Many thanks to all the potters who contributed images. Thank you to Miles Bloomfield for the drawings. Many thanks to Gordon Brooks and Duchess China, Ed Bentley and Owen Wall for help with model and mould making.

Many thanks to Jayne Parsons of Herbert Press and Alison Stace for editing.